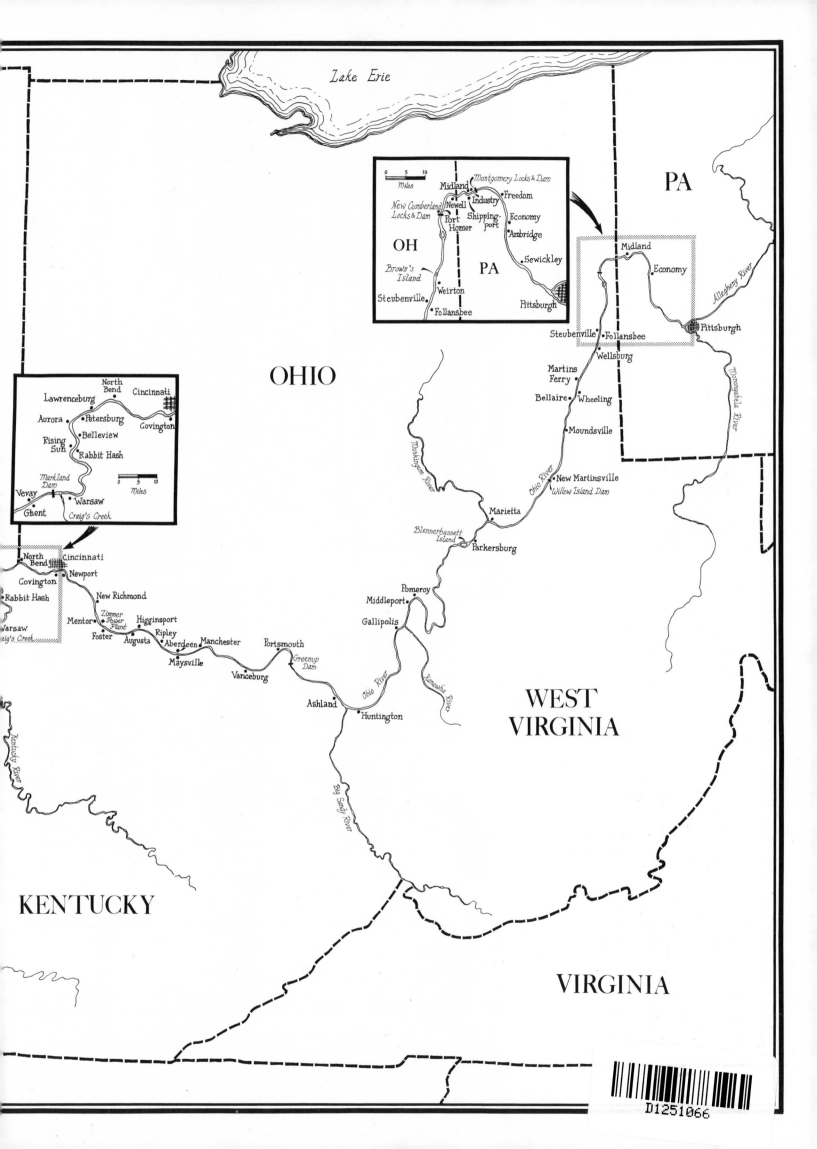

Lake Erie

PA

OHIO

OH

PA

0 5 10
Miles

Montgomery Locks & Dam
Midland
New Cumberland
Locks & Dam
Newell
Industry
Freedom
Port
Homer
Shipping-
port
Economy
Ambridge
Sewickley
Brown's
Island
Steubenville
Weirton
Follansbee
Pittsburgh

Midland
Economy
Steubenville
Follansbee
Wellsburg
Martins
Ferry
Bellaire
Wheeling
Moundsville
New Martinsville
Willow Island Dam

Allegheny River
Pittsburgh
Monongahela River

Muskingum River

Marietta

Blennerhassett
Island
Parkersburg

North
Bend
Cincinnati
Lawrenceburg
Aurora
Petersburg
Covington
Rising
Sun
Belleview
Rabbit Hash
Markland
Dam
Vevay
Warsaw
Ghent
Craig's Creek
0 5 10
Miles

North
Bend
Cincinnati
Newport
Covington
Rabbit Hash
New Richmond
Mentor
Zimmer
Power
Plant
Higginsport
Warsaw
Foster
Ripley
Craig's Creek
Augusta
Aberdeen
Manchester
Maysville
Vanceburg
Portsmouth
Greenup
Dam

Pomeroy
Middleport
Gallipolis

Ohio River
Kanawha River

WEST
VIRGINIA

Ashland
Huntington

Kentucky River

Big Sandy River

KENTUCKY

VIRGINIA

THE
OHIO RIVER

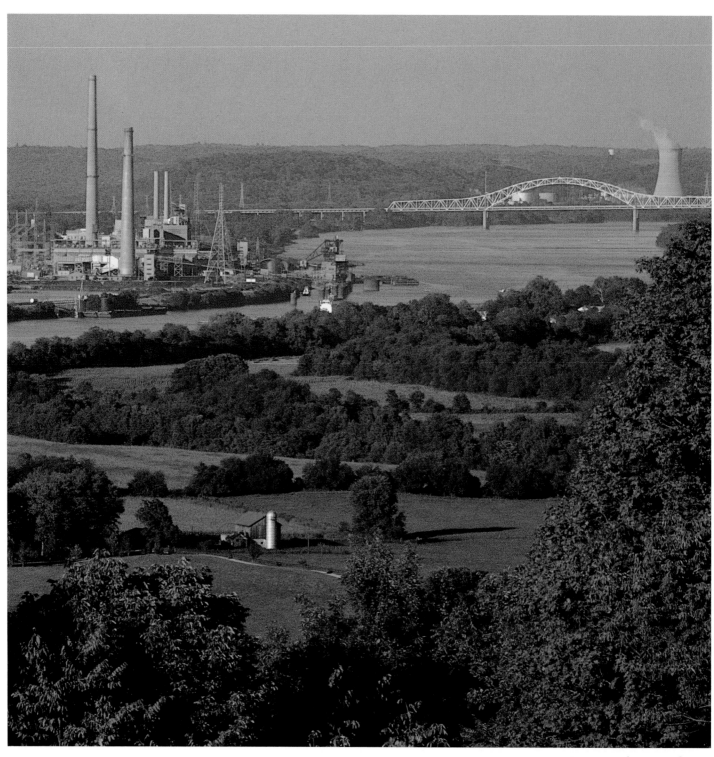

Lawrenceburg, Indiana.

THE
OHIO RIVER

JOHN ED PEARCE
Photographs by RICHARD NUGENT

THE UNIVERSITY PRESS OF KENTUCKY

Library of Congress Cataloging-in-Publication Data
Pearce, John Ed
 The Ohio River / John Ed Pearce; photographs by Richard Nugent
 p. cm.
 ISBN 0-8131-1693-7
 1. Ohio River—History. 2. Ohio River—Description and travel—
 Views. 3. Ohio River Valley—History. 4. Ohio River Valley—
 Description and travel—Views. I. Nugent, Richard, 1949-
 II. Title
F516.P33 1989
977—dc20 89–14830

Printed in Hong Kong by Everbest Printing Co., Ltd.

Historians speak of the discovery of the Ohio as if men had not known it for centuries before the Europeans finally arrived. Actually, we don't know who the first inhabitants were. Men of some sort were in the region not long after the glaciers retreated. There are curious legends about a race of "white Indians" who lived downriver around what is now Evansville, Indiana, and fought a great battle with redskin Indians in which they were exterminated. Historians tend to scoff at this, but the Adena Indians apparently had a fairly advanced civilization along the Ohio centuries before Columbus sailed. We know that Scandinavian explorers reached the continent well before Columbus, but there is no proof they got this far inland. Legends tell of Welsh and Irish sailors who came up the Mississippi and Ohio, even up the Kentucky River. The Spanish may have come up from Florida and through Kentucky to the Ohio in the 1500s. We don't know. Much legend, little evidence.

Most river historians give the honor of discovery to René Robert Cavelier, Sieur de La Salle. Not all. R.E. Banta, whose word on the Ohio is usually regarded as gospel, expressed solid doubts about LaSalle. It isn't illogical, though, to assume that he was in the valley fairly early. The French in Canada had been probing into the central American wilderness since the early 1600s, eager to get in before the English. French trappers had ventured as far as the Great Lakes and down the Illinois River, and it would not be surprising if LaSalle heard from Indians reports of the great river to the south called the Oyo that was said to run into the South Sea. According to some accounts, LaSalle sold his considerable holdings, outfitted an expedition, and found his way down from Lake Erie, probably along the Allegheny, to the Ohio around 1667-70. Reports say he went down the Ohio as far as the Falls (now Louisville), where he became discouraged and turned back. But the following year he returned, negotiated the Falls, and made his way down to the Gulf of Mexico—which turned out not to be the South Pacific after all.

Question marks pepper this account. Why did the proud, literate, aristocratic LaSalle leave no diary of this journey? Why was he stopped, on his first run downriver, by the Falls? Then, as now, they were nothing more than a series of rapids; the Indians navigated them all the time. LaSalle apparently did as much the following year. And if he made the trip of exploration, why were the French so long in following up with settlement of the area?

The English too had an eye on the possible riches and strategic value of the valley. Yet they did little more about it than the French. After Pierre Joseph de Céloron de Bienville left inscribed lead tablets along the river claiming it for the French crown in 1749, the English finally bestirred themselves and sent George Croghan to explore as far as the Mississippi. And Virginia sent Christopher Gist, who had been scouting the transmontane region, sometimes with Croghan, to guide into the valley in 1753 a twenty-one-year old planter and surveyor named George Washington. With that, you might say, the Ohio became part of U.S. history.

Tall, slender, reserved, the young Washington was considered by most Virginians too dandified to challenge the wilderness. (Later they would doubt his ability to lead an army.) Washington not only saw the Ohio but quickly grasped its possible significance. Hurrying home, he persuaded Virginia's Governor Dinwiddie to show some interest, and Dinwiddie established a puny Fort Prince George near the present site of Pittsburgh. A year later the French walked in, threw out the Virginians, and built Fort Duquesne, named for the French commander in America.

Miffed, Dinwiddie in 1754 sent Washington with a small force to order the French to leave. The French not only declined but attacked and defeated Washington's troops and captured Washington, though he was released and sent home. The English crown then stepped in and in 1755 dispatched an army under General Braddock to throw the French out. Young Washington was an officer on Braddock's staff. Looking fine in their red coats and

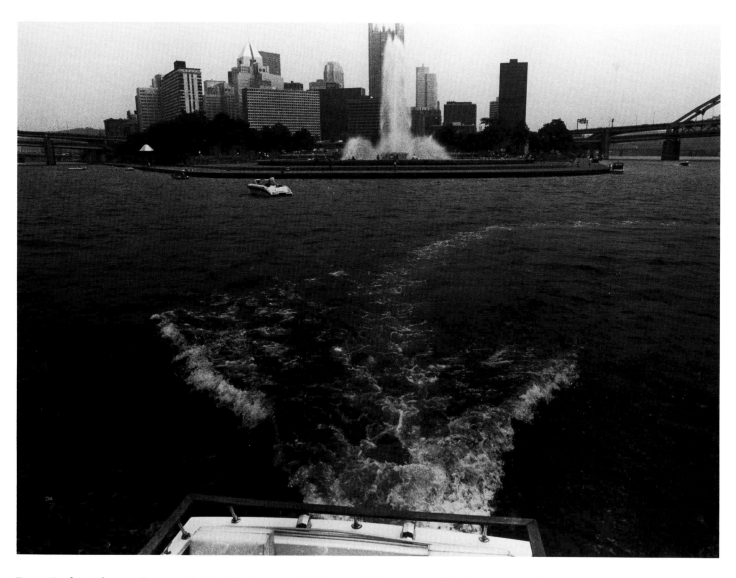

Point Park at the confluence of the Allegheny and Monongahela rivers — the beginning of the Ohio.

marching in column four abreast, the English made splendid targets. The French and Indians, hiding behind trees and rocks, slaughtered them. Braddock was killed, his army decimated, and Washington helped lead the retreat.

But he had seen enough to realize that the Ohio was the key to the raw continent. He came back in 1758 with a better army, led by General John Forbes, but, surprisingly, found Fort Duquesne burned, the French gone. Deserted by their Indian allies and short on food and supplies, the French had apparently decided they could not put up a defense, and left. Whatever the reason, it was a costly decision for the French. With the fort, they had surrendered the river, and with the river the continent. Washington knew a prize when he saw one. For the rest of his life he remained interested in the security and development of the Ohio.

At the point where the Allegheny and Monongahela met, the English built a five-sided fort large enough to house a regiment. Trappers and traders moved in nearby, some with their families. A trading post developed. Thus was Pittsburgh launched. Today remnants of the fort are preserved in the Fort Pitt museum in Point State Park. It draws tourists in swarms.

And well it might. It was from this point that George Rogers Clark launched the daring campaign that won the northwest territory for General Washington's Revolutionary army. From here Kenton, Harrod, Bullitt, and Campbell shoved off to help open Kentucky. Putnam sailed to establish Marietta, the pathetic French Five Hundred set out for Gallipolis, and poor, silly Harman Blennerhasset left for Paradise. From this point of land, hundreds and thousands of settlers—hungry for land, hoping for wealth—set out for the frontier and opened up a continent.

It is always good to begin at the beginning. Here at Pittsburgh is the beginning of the Ohio.

For most of its life, Pittsburgh, Pennsylvania, has had a poor image. Stephen Collins Foster lived here, but he never went out of his way to write songs about Pittsburgh. Tony Bennett never left his heart here.

For a century Pittsburgh got dirty looks. Because it was dirty. The character of the town was determined when, in the nineteenth century, coal, oil, and iron were discovered in nearby valleys. By the beginning of the twentieth century Pittsburgh had become a factory town—steel, glass, and boat-building. By World War I it was the steel capital of the world, its stacks belching smoke that blackened the town and the valley. Asked to draw up a plan for its renovation, famed architect Frank Lloyd Wright snorted, "It would be easier to tear it down and start over."

In developing its factories, Pittsburgh inadvertently helped to develop the Ohio. Before 1885, coal barges coming down the Monongahela to the steel mills were sometimes slowed or grounded by low water, and people began agitating for a dam that would back up deeper water for navigating the "Mon," as it is still known, and the Allegheny. A site was chosen at Davis Island, a few miles down the Ohio. Not everyone wanted the dam. Some charged that it would impound stagnant ponds; others feared it would stifle highway development. But the Army Corps of Engineers had begun canalizing the Ohio in 1869, shippers pressured Congress to include Davis Island, money was voted, and in 1885 the Davis Island Lock and Dam was opened to river traffic. The lock measured 600 by 110 feet, and the dam assured an upriver channel depth of at least six feet the year around.

Through the years, smoking factories laid a black mantle over Pittsburgh, but as World War II ended, the city fathers decided to clean up the place. In two remarkable decades they did. Today Pittsburgh is known for its beautiful homes, parks, streets and public buildings, for Point Park, Three Rivers Stadium, and such cultural institutions as glittering Heinz Hall, home of the famed Pittsburgh Symphony. Recently a national sociological survey declared Pittsburgh "the country's most livable city," a designation that surprised practically everyone—including the suddenly proud people of Pittsburgh. Today airport signs welcome passengers to "Dynamic Pittsburgh, America's Most Livable City." Workers swarm through the place sweeping and polishing, as if to make sure the old dirt, and the old reputation, are expunged forever.

Incredibly, Pittsburgh has become an inland Fun City. It has a half-dozen really first-class hotels. LeMont is widely known for its French cuisine, and along Grandview Avenue, on Mt. Washington, several other restaurants offer good food as well as terrific views of the city. If you like football, there are the Panthers and the Steelers. If you want baseball, take in the Pirates. Lovers of

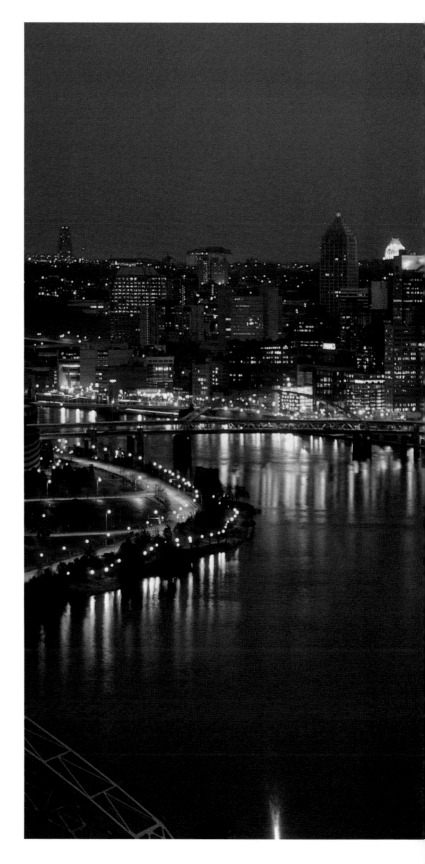

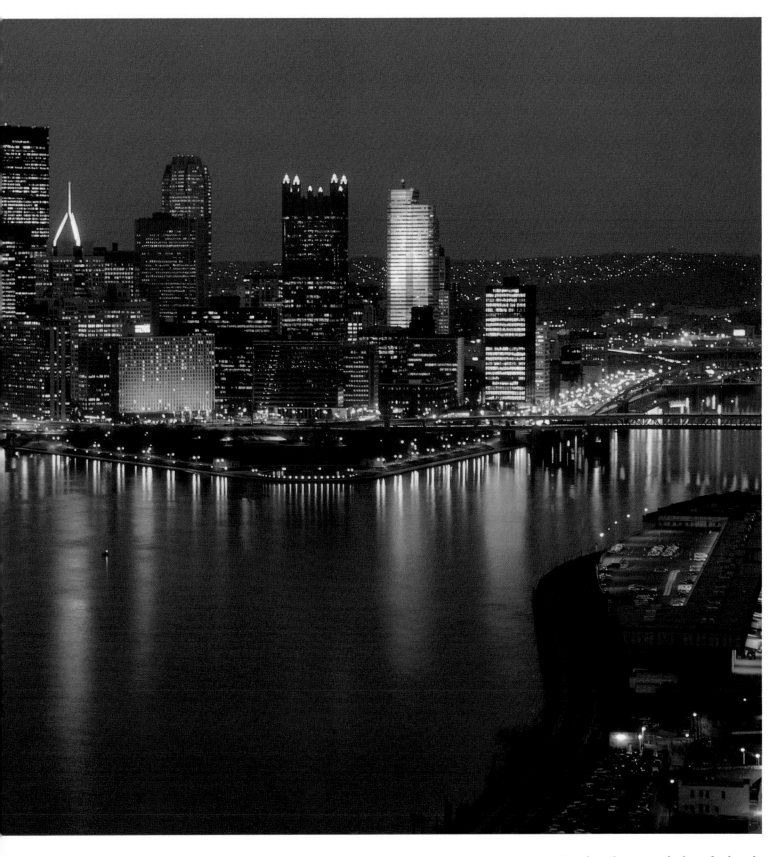

Pittsburgh — just before daybreak.

culture can hear the symphony or see one of the country's better ballet companies. Point Park, where the rivers meet, is the site of ethnic festivals, concerts, and boat races. There are incline railways that take you quickly from the lower to the upper city and are guaranteed to make your hair stand on end the first time you ride one. The riverside is lined with excursion boats and floating restaurants. Good place to visit, and you can have a nice weekend without going broke.

Point Park is also the spot where the Ohio begins its long run to the sea. One thing that impresses you right away is how big the river is. It doesn't have to mess around, growing from a little stream to a big river. It's big to begin with—wide and deep from the point where it leaves the confluence. But for a river heading for the Gulf of Mexico, it seems to get off on a confused foot, and for a dozen miles heads north by northwest until it gets a grip on itself and turns west to Wellsville and finally south, heading for Steubenville and Wheeling. This northward flow of a southbound river probably reflects the impact of the glaciers during the most recent Ice Age, when the great ice cap pushed south to a line marked today by the Ohio's course.

Along this first stretch it's hard to remember that this is La Belle Rivière. The scenery along the banks is grim—steel mills, many apparently empty; chemical, oil, and boat-building plants. Fifty years ago this was big-steel valley, but a shift in global economies and the rise of new technology brought a stillness to the mills. Quiet now are the rail cars that once carried coal and ore to the furnaces, the giant cranes that groaned with their loads of hot metal. Gone is the flare of furnaces, the shriek of warning whistles, the army of sweating, smoke-grimed workers pounding out the nation's steel.

This is a surprising stretch of river. One minute we're in dead-mill valley, the next we're sliding through a wilderness, nothing on either side but hills and trees. It's hard to see where Fort Davis Dam stood, but just a mile or so downriver looms Emsworth, the first of the big dams that now turn the Ohio into a series of lakes.

The river was probably prettier in the old days when it was free-flowing, before the locks and dams were built, but it was a lot rougher on shipping. In flood it would sometimes rise sixty feet and tear through the valley like a mad thing. In the summer months it often dried to a trickle, and boats went aground and had to wait for rain to put some water under their keels.

Visitors to Point Park fountain.

The once busy rail lines now lie quiet and rusting—
victims of the declining steel industry, a casualty itself
of shifts in global economics and new technology.

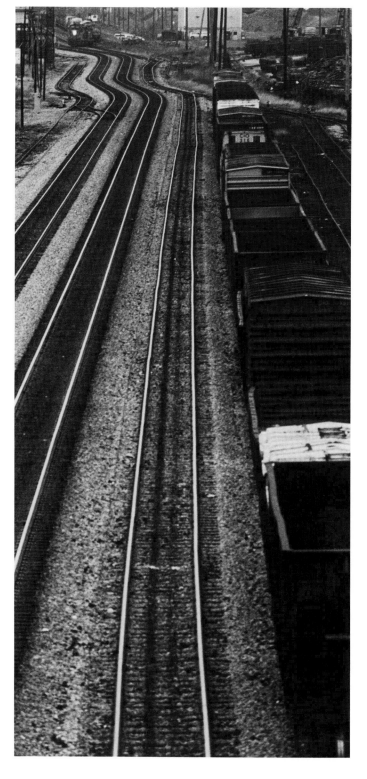

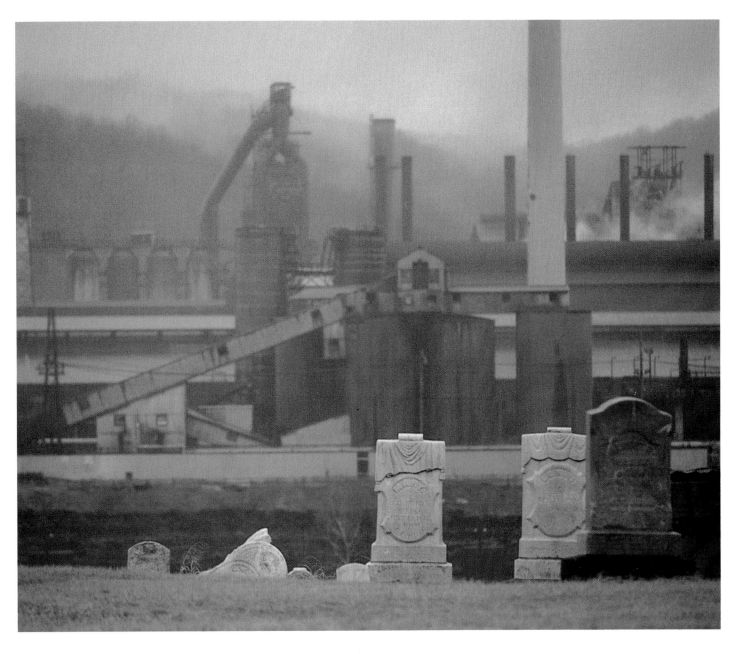

Cemetery and partially closed mill near Ambridge, Pennsylvania.

Captain Frederick Way, Jr.

We hardly get started downriver when it's time for the first stop at Sewickley, Pennsylvania, a fine-looking town of impressive homes that is worth the stop, if only because it's the home of Captain Frederick Way, Jr. Anyone who knows anything about the Ohio warns that you can't write about the river until you've talked to Captain Way.

That's about right. Wiry, bald, pipe-smoking Captain Way, whose family has been in Sewickley since 1797, was born just after the turn of the century and has been totally involved in the Ohio since he was in knee pants. When he was ten his mother took him to Cincinnati, where he went aboard the steamboat *Queen City* and was completely captivated. She tried later to persuade him to go to college, but it was no use. At eighteen he got a job with a coal company that had boats on the river, and never looked back. By the age of twenty-three he was purser on a steam packet, and the following year, with his father's help, bought a boat of his own, the *Betsy Ann*, a 165-foot packet running from Cincinnati to Pittsburgh.

From Pittsburgh to Cairo to New Orleans, up and down every tributary of the big rivers, Fred Way has watched the rivers, the towns, the boats and the river traffic change, seen the packets replaced by diesels, the sternwheelers survive as excursion boats, seen the channel deepen, the locks and tows grow bigger. From the big, rambling home on Sewickley's River Avenue where he has lived for fifty-three years, he watches the big tows go by, carrying the bulk cargoes of petroleum, grain, and coal for which, he says, there will always be a demand. "The river made the valley, and it will always need the river."

In 1945 he began publishing an annual of every boat on the rivers, but sold it to the *Waterways Journal* in 1984. He still publishes *Way's Packet Directory, 1848–1983*, has written seven books about the river, and edits—in his cluttered basement office—his famous *S&D Reflector*, the quarterly published by the Sons and Daughters of Pioneer Rivermen and distributed to devoted subscribers around the world. People throughout the valley send him clippings and stories about the river and its people, and he boils it all down for the *Reflector*.

Eight years ago, when his wife Grace died, Captain Way thought of moving to smaller quarters, but he hasn't been able to leave the rooms whose walls are lined with paintings and photographs of the famous river boats, shelves full of river books, and mementoes of his years on the river—a handsome plaque, the achievement award presented to him in 1987 by the National Rivers Hall of Fame, a large silver tray given to him as Pittsburgh's Riverman of the Century in 1988. Spry and bright-eyed as he nears ninety, he delights in plans for meetings of the Sons and Daughters and gatherings of the "tall stack" boats.

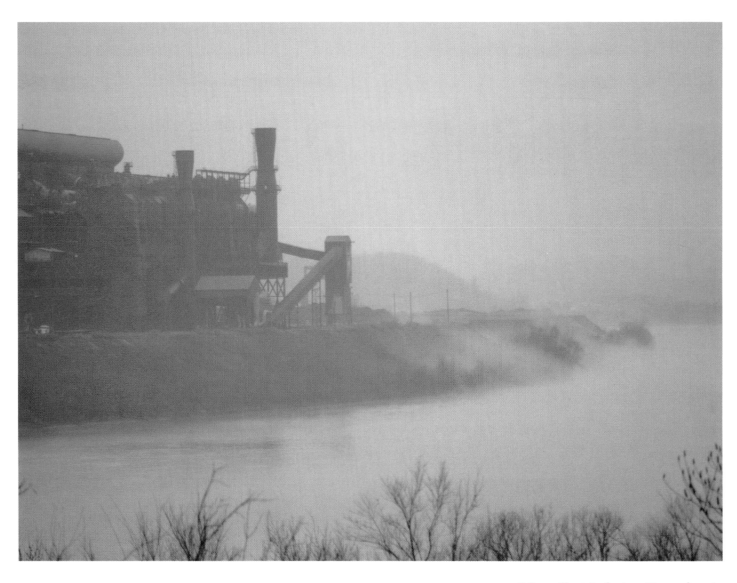

Idle mill at Industry, Pennsylvania.

"It was more fun on the steam packets than on the diesel tows," he admits. "We ran on regular schedules then, and people knew when we were coming, and we had time to fool round at every stop. You stopped everywhere, and everywhere you stopped you shook hands with friends."

But new boats are still being built, and for Captain Way there are still friends to see and hands to shake along the big river.

As we move on downriver, Ambridge, Pennsylvania, pops up on the right bank. Ambridge doesn't look like much from the river, but in its day it was both a big steel town and the home of George Rapp's Harmony Society. Rapp was an idealistic grape-grower and Lutheran minister who believed that Jesus was due back at any minute and thought people should have the place ready for him. Rapp came over from Germany in 1803 and gathered about 700 followers who were willing to hand over their earthly goods to the Society and abide by its rules, which included honest dealings, hard work, and celibacy. Rapp first founded a village where the Beaver River flows into the Ohio, but suddenly sold out and moved down to New Harmony, on the Wabash, then sold that to fellow-Utopian Robert Owen and moved back upstream to what is now Ambridge, where he founded another town and named it Economy. It, too, was doing well until a rival promoter arrived offering salvation without celibacy, and Rapp's members began slip-sliding away. By the time Rapp died in 1847 almost half of his followers had fallen to temptation. In the meantime Ambridge (an abbreviation of American Bridge Corporation) became a roaring steel town and slowly grew up around Economy. But the town fathers preserved six acres of the village, and it's open to the public today.

Below Ambridge the river is dirty as it turns south, and the banks sprout the gray sides of old steel mills. No smoke, no lights, no glare of fires. Grass grows along the rails, though here and there a single light bulb glows eerily, telling of watchmen, caretakers. But there is little to watch over, little to steal except rails and rusting wheels, and the echoes of yesterday.

The day is heating up. From the remains of an old dock along the shore, boys dive and splash in the river, and on a tall, concrete slab are emblazoned the immortal words: "Fuzzy Farley. October."

The massive, empty factories along the shore engender a feeling of a land injured and left to die, perhaps the casualty of a nuclear war. Below the confluence of the Beaver River, a black clamshell bucket hangs from a rusting crane into a storage bin now empty of coal, overgrown with weeds. And on a rail line beyond the plant a string of railroad cars move slowly, loaded with Japanese cars. Mile after mile, the river flows by these tombstones to an era. On the roof of a cavernous LTV

plant, great ventilator tubes that once carried merciful fresh air down to the sweltering caverns below now reach silently upward like bent, beseeching arms, grasping nothing.

On the right bank a town, a very small town named Freedom, slips past. What do you suppose prompted people to name their towns Freedom, Liberty, Independence? Was it a sense of pride in their new land? A feeling of gratitude, a remembrance of other times and places? What had they known to want the word, like a blessing, planted in the land?

A note, incidentally, about right and left bank. Rivermen refer to the right bank, when going downstream, as the right bank; coming upstream, it is still the right bank, though it is on the left.

The afternoon lies heavy on the river. The rumble of trucks along the right bank is muffled. American flags, flown on lawns along the way, droop in the still air. An osprey wheels slowly above the river ahead, and the growl of the boat's engine, the curve of its wake, are an intrusion in the calm. Then suddenly, a few miles above Montgomery Lock and Dam, the scenery is shifted, as if by some local Potemkin—Pennzoil, Shell Chemical, Duquesne Power.

La Belle Rivière is getting a lot less belle. A big outfall pipe discharges a foamy, poisonous-looking liquid into the river, staining the green water a yellowish-brown, with small bits of debris floating sluggishly in the current. This is startling. The Ohio used to be filthy, but over the past thirty years the Ohio River Sanitation Compact has done a good job of cleaning it up. You see a lot more people swimming along the shore than you did a decade ago, and the growing number of birds indicates more aquatic life. Something seems wrong here.

You have to keep an eye on debris when you're in a boat. Not the small plastic stuff, but logs, limbs, lumber. A discarded door can put a prop out of action permanently. Ordinarily it's not a problem, but sometimes snags and junk pile up at a dam until the lockmaster has to flush a bunch through to keep it from becoming a hazard.

Occasionally a snag gets into the screws of a tow, but it's seldom a problem. The pilot can tell by the vibration the minute something is in the screws, and he can usually dislodge it by reversing the engines for a few seconds.

It wasn't so simple in the old days. Before the Corps of Engineers took over, snags were a major menace. The river bed was full of them, and these weren't small limbs. They were tree trunks washed down by high water and pounded into the bed by the current, some of them six to eight feet in diameter, over a hundred feet long, and weighing tons. It took almost x-ray vision to see them resting just below the surface, and if one wasn't spotted it could ram a fatal hole in the toughest boat. By 1824, when Congress approved the first rivers-and-harbors

Maintenance work by the Corps of Engineers on a lock at McAlpine Lock and Dam in Louisville, Kentucky.

bill, boats carrying half a million tons of freight a year were threatened by an estimated 50,000 snags, and the Engineers, given the job of improving the inland waterways, began offering valuable contracts to anyone who could devise a plan to get rid of them.

Several contractors tried and failed. Then the legendary Captain Henry Shreve took over. In 1814, Shreve, a native of Shippingport, near Louisville, had piloted the steamboat *Enterprise* from Pittsburgh to New Orleans with a cargo of ammunition. Shreve not only delivered the ammunition but took part in the Battle of New Orleans and then returned upriver, the first pilot to take a steamboat upstream. For his trouble he was sued by the firm headed by Robert Fulton, sometimes regarded as the inventor of the steamboat, who had been granted a monopoly on the Mississippi in 1811 by New Orleans, and later by Louisiana. Shreve fought back and won the suit, the Supreme Court ruling that the rivers belonged to the federal government, not to the states, and the states could not restrict their use. It was a historic case and made Shreve a hero on the rivers. From 1826 to 1841 he served as superintendent of Western Rivers Improvement for the Corps, and during that time designed and built snagboats that finally cleared the snags from the rivers.

The need to remove the snags and find a way around the Falls of the Ohio at Louisville prompted Congress to vote $75,000 in 1824 for improvement of the Ohio and Mississippi. The Corps of Engineers has had responsibility for the rivers ever since, including construction and maintenance of the present system of locks and dams. What the dams have meant to the region's economy has not been peanuts. The system has meant not only low-cost shipping and subsequent low-cost fuel for industries along the banks, but a stable water supply and a stable river on which boats can operate in all kinds of weather. Infrequently, ice may close the river for a few days, but low water almost never does. During the severe drought of 1988, for example, no boat was grounded by low water on the controlled section of the Ohio above Dam 53. This stability has accounted for much of the industrial investment in the valley—$142 billion over the past quarter century—and for the $447 million paid out in salaries every year to people engaged in navigation and commerce on the river.

Thirty-two miles below Pittsburgh, Montgomery Lock and Dam looms and the radio grinds out conversations between boat captains and the lockmaster. You don't have to have a marine radio to run on the river, but it sure helps. All commercial vessels have them. If you don't have a radio, there's a chain hanging down from the end of the lock wall; you pull it to signal the lockmaster, though he will probably have seen you by the time you get that close.

Repairing the bottom of a lock gate.

There's also a set of traffic lights on top of the lock—red meaning the lock is busy, yellow means it's being made ready, and green means come on in. But nearly all captains just tune to channel 13 and something like the following takes place:

"Hello, Montgomery, this is blank, blank, blank [his call number] towboat coming down with fifteen barges over."

"Yeah, this is Montgomery. Hello, there, Ernie, that you?"

"Yeah, still here."

"Yeah, well, how's it going there, cap?"

"Oh, 'bout same, guess. How's with you?"

"Yeah, 'bout same. Where you now, cap?"

"Oh, 'bout four miles up, oughta be there twenty minutes so. How's it looking?"

"Yeah, well, good, good. Got a tow in the chamber, about ready to leave. Oughta be ready time you get down here."

"Yeah, well thanks. This is blub, blub. . . . "

The pilot and the lockmaster understand each other. They know the routine but they don't take chances on a misunderstanding. Locking a big tow through is nothing to take casually.

Basically, a lock is a big concrete box, typically 1,200 feet long, 110 feet wide, and 83 feet deep, with gates at either end that open out from the middle. If a boat is going downriver, the gates open and the boat moves in and ties up to one of the mooring devices along the lock wall. A lock operator, sitting in a little concrete pillbox of a house at the upstream end of the lock wall, pushes two levers and the gates close. He pushes two buttons and opens the huge valves that let about 37,000,000 gallons of water drain out of the lock chamber into the lower river. The lock operator then gets into a small electric cart and rides down to the similar pillbox at the other end of the lock, where, when the water in the lock is even with the water in the river, he pushes levers that open the lower gates, and the boat steams out on the river. The levers are kept in separate buildings for safety reasons. If something should happen to the operator after the gates are shut and the lock is filling—if he should slump forward against the levers and open the gates ahead of time—all hell would break loose.

The river pool above the average Ohio River dam runs from eighteen to thirty-four feet higher than the pool below, and the locks serve to raise or lower craft that much. The locks can raise or lower a boat as much as thirty-seven feet, but the average is thirty-two.

Below Montgomery Lock and Dam and around a bend loom the two towering stacks and three massive cooling towers of a Pennsylvania Power Company plant. Sitting out in the open, the cooling towers seem immense, unearthly, dwarfing everything else on the landscape. Actually, the average cooling tower is only 350

Opposite: Tow going through the McAlpine Lock, Louisville.

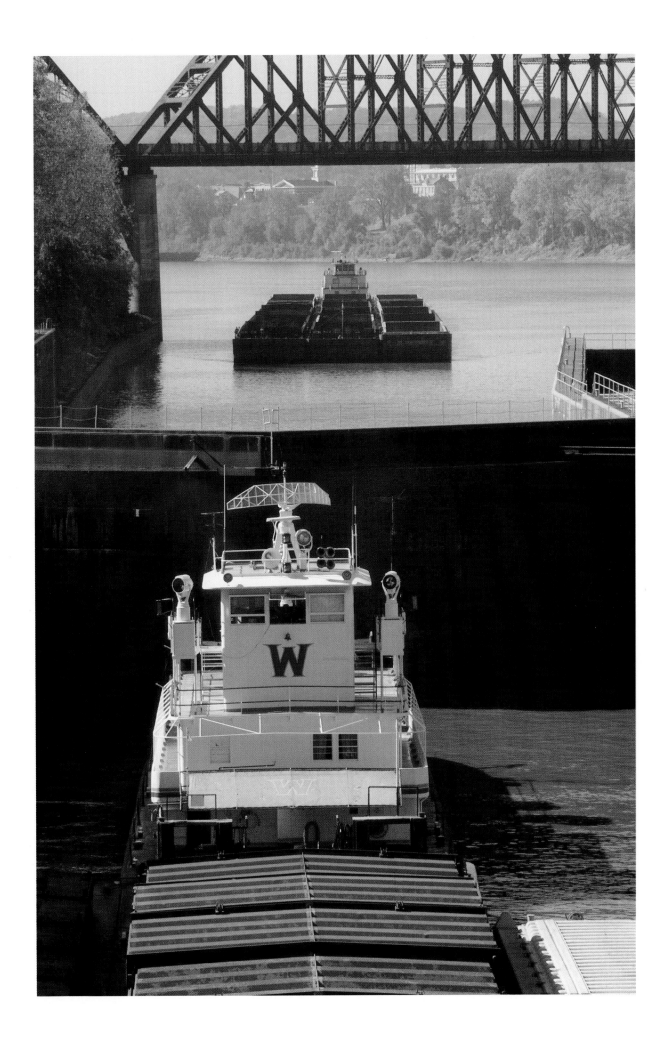

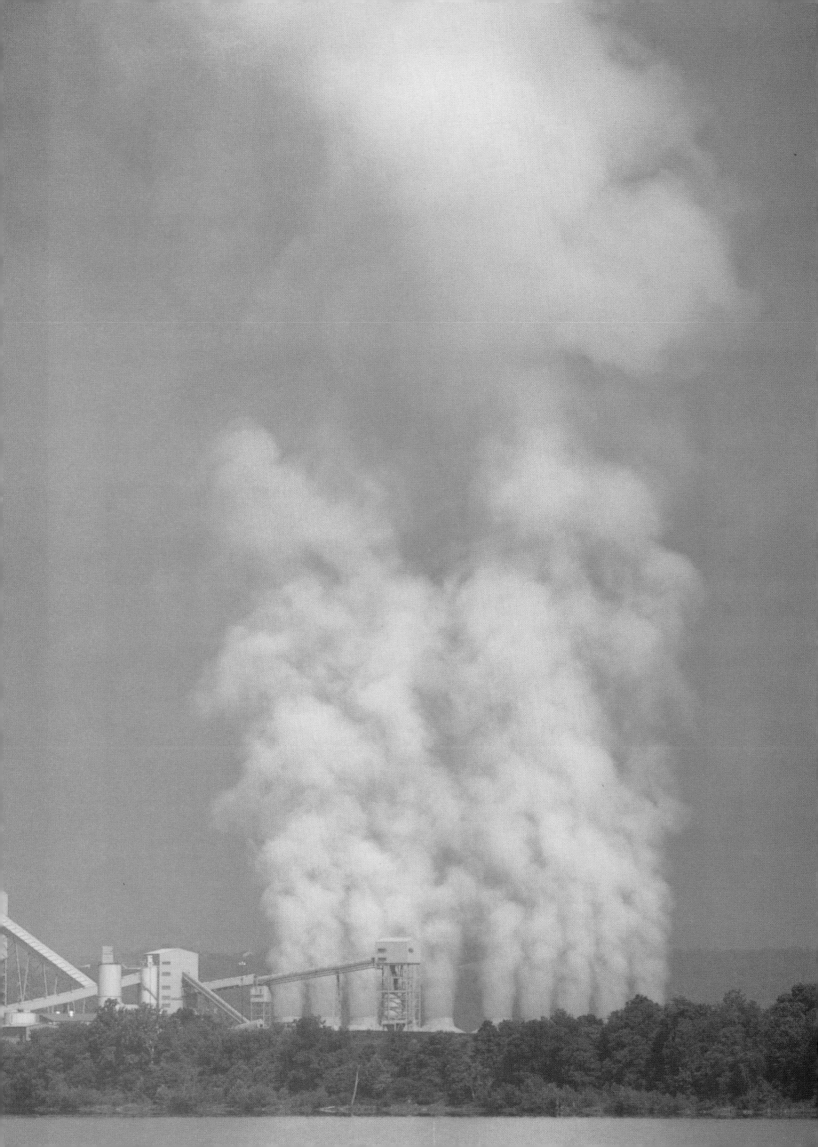

feet high and half that wide at the bottom. But they dominate the skyline.

On the right bank, Industry, Pennsylvania, slips past, then Midland–Shippingport Highway Bridge, two more cooling towers, and the unmistakable dome of a nuclear power plant. We are in power plant valley. The plants are here because the river is here, with its water to produce steam to turn the turbines and to float the strings of barges carrying coal for the furnaces that produce the steam.

Downstream, past Midland, the river turns from rust to rustic, with green hills on both sides, the hills on the horizon blue with haze.

Near Wise's Landing, Kentucky.

Cruising down the river, we are not aware of state lines, and we have to check our charts to see that we are now running between West Virginia and Ohio, having left Pennsylvania without so much as a fond farewell. We approach a bridge at Newell, West Virginia, on which there is a huge sign with an arrow pointing south and announcing "HOMER LAUGHLIN CHINA OUTLET." The sign appears to be bigger than Newell. You can't see much of Newell, but you can see plenty of the sign. Five minutes later, on a bluff above La Belle Rivière looms a long yellow-brick building adorned with another sign: Homer Laughlin China Co. But a closer look justifies the size of the signs. Laughlin China is the biggest single china plant in America. It's more than a century old, having been started by Homer and his brother Shakespeare, back in 1871. It employs over 1,200 people and in a good year will ship more than 35 million pieces of chinaware. The Laughlin people give guided tours and show you how china is made. It is a long process. Did you know that after they mold a plate and trim it, they put it in a kiln for two days at 2,200 degrees? That's just the first time. They fire it three times.

Just downriver from the china connection, some people are picnicking at a little park near the Quaker State Oil plant. Nice little park—grove of trees, picnic tables, swings. Women are sitting around in folding chairs fanning themselves, men are off to one side, apparently drinking beer, while children run around screaming, bumping into each other, falling down, rolling, getting dirty. Other women are putting food out on tables.

A tow pushing twelve barges comes thumping up the river and rumbles by. The pilot in his air-conditioned pilot house waves. Most of the new towboats have air-conditioned pilot houses; in fact, most of them are air-conditioned throughout the crew's spaces. La Belle can get hot during a nice drought, with the temperature up around 98° and the breeze—what there is of it—coming upriver about as fast as the tow.

There have been lots of birds around the river all day, a sign that the water is clean enough to support a thriving fish population. Ospreys, those big, beautiful fish hawks that became scarce a few years ago during the DDT crisis, seem to be almost common along some stretches. You can see great blue herons, singly or in pairs. Ducks paddle in small flotillas along the shore, and as the sun starts sliding down the sky, swallows begin swooping along the surface.

A long, calm stretch of river at Port Homer, Ohio, is broken by the tow *Bill Style*, heading upstream. Four tall stacks announce the Ohio Edison Company power plant, and the *Edison Queen* pushes coal barges into position for unloading at the conveyor leading to tall coal stockpiles near the riverbank.

A mile or so downstream the river suddenly sprouts plastic bottles, scenic styrofoam cups, all sorts of junk

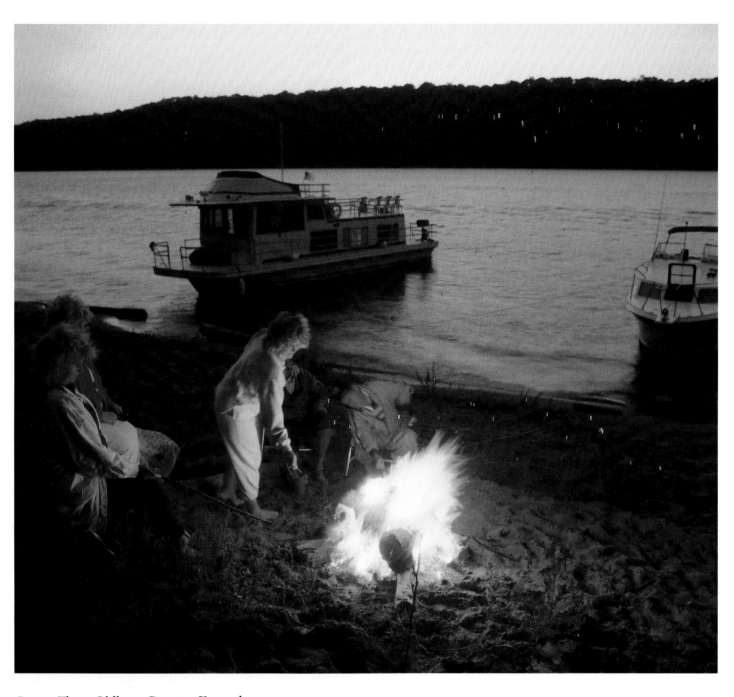

Grassy Flats, Oldham County, Kentucky.

dirtying up the place. A shame. This is a wide, scenic section of river, impounded by New Cumberland Lock and Dam, which is itself an imposing, rather handsome structure. It's hard to look at this garbage without a feeling of shame, without thinking how poorly we treat this river that serves and nurtures us, repaying its blessings with poison and sewage and trash.

Beyond New Cumberland, another Ohio Edison plant steams and pants in the summer evening. But the sun has dipped below the hills, silhouetting the steel towers carrying their power lines across the valley. At such a time it's a good idea to find a place to tie up for the night.

There are several ways to deal with night on the river. You can tie up at a marina, go into town and look for a motel, saying little prayers along the way that your boat is safe. This is for the cowardly. Or you can sail in a big houseboat and commune with nature in air-conditioned comfort—the way of the rich and soft. You can travel in a flat-bottom outboard job, go ashore at night, and face the mosquitoes, snakes, raccoons, skunks, and drunks from a sweaty sleeping bag. Or you can take the sensible middle course in a 26-foot cabin cruiser, like ours, that offers food, drink, and reasonable bunks.

Only idiots drink and drive boats, and the Ohio has its share of them, though they kill off themselves—and too often others—at a goodly clip. No one in a half-right mind wants to join that nutty throng, but even the bluest of bluenoses will concede that a sip at twilight, when the lights are low and the anchor is down, is a good idea. The sky is glowing softly, a crescent moon hangs in the west, and a breeze stirs the mist along the river. If you don't look upriver at the white stacks of Edison Power, their strobe light blinking in the dusk, man and his works and the clamor of cities are easy to forget.

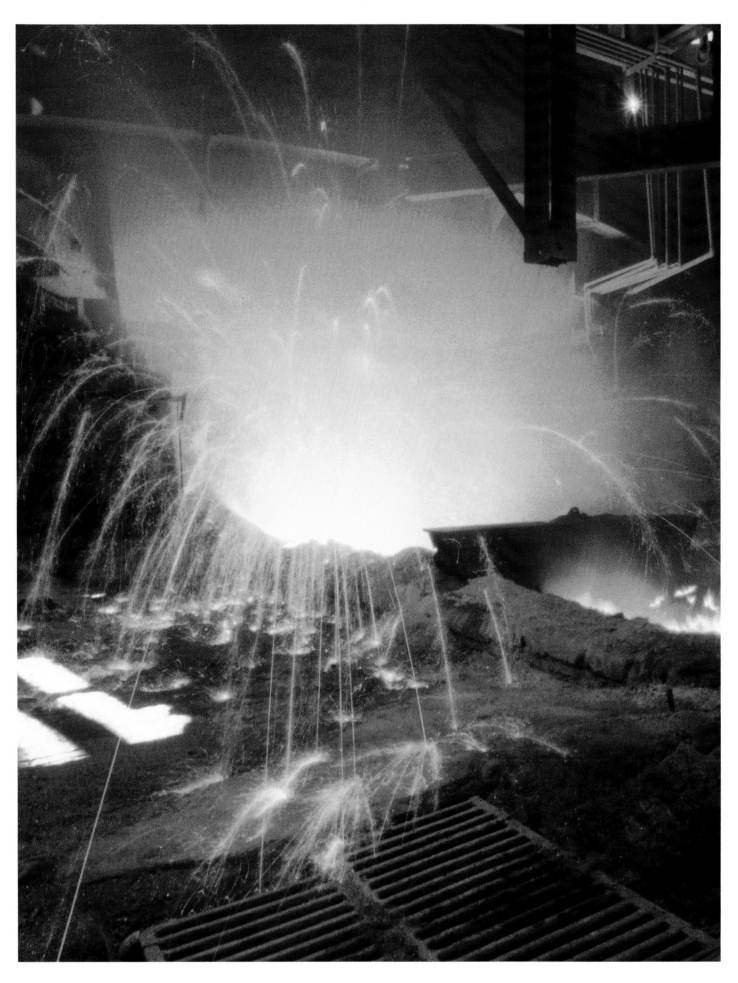

A cup of coffee, man's greatest discovery, and we're under way through a soft, muggy morning, with mist rising like steam from the pond-like river, the bright sun at our backs. We pass Brown's Island, which resembles a dump with scrubby trees on it, while across the river an outfall pours a smelly brown liquid into the unoffending river. Then the *Princess Margie,* a colorful sternwheeler, passes, headed upstream, and brightens the morning.

And suddenly we are in the midst of working steel mills. None of the old rust belt here. On our left, Weirton Steel, which was closed for a while but has sprung back to hopeful life, bustles and smokes. A few miles farther downstream, on our right, Steubenville, Ohio, another working steel town, comes into view.

Steubenville appears to be a good-sized town, with big homes along the tops of hills, all red brick and white trim. There are also a few empty plants along the riverside, but Wheeling Pittsburgh Steel Corporation has working plants on both sides of the river, with rail cars carrying coke across a bridge and smoke pouring from stacks. Seems like old times.

Over in East Steubenville and Follansbee, West Virginia, barges line the banks. Two clamshells lift coal from them and dump it on a conveyor that carries it to the coke ovens on the hill, where the coal is turned into coke and shuttled across the river to the mills of Steubenville, where the furnaces roar and men make quality continuous-cast flat steel. The tar that's sweated from the coal in the ovens is sold to the Koppers Company plant just downriver near Follansbee. The whole place throbs with movement and energy.

Why has this mill survived when others have failed? Actually, it didn't survive for a while. Back in 1985, pinched between high costs, a tight market, and labor trouble, Wheeling Pittsburgh took bankruptcy under Section Eleven, finally settled a ninety-eight-day strike, and began reorganizing. "We've had three real good years," says spokesman Ray Johnson. "Cars, appliances, machinery, almost anything that uses steel has been doing well, and our order books are full. And we're turning out a quality product. We can compete with the overseas producers and with the big boys here at home—U.S. Steel, Jones and Laughlin, Bethlehem."

Towns along the river tend to ebb and flow rather like the river itself. Some spring into booming life, then falter, decline, and die. Some rise, find their place in the socioeconomic scheme, and reach a plateau. Others rise, decline, and then struggle and rise again. Steubenville is one of the latter. It slumped but it has a new vitality now.

It's an old town. From the name you might conclude that it was settled by Germans. But it was an Englishman, Jacob Walker, who came down the river in 1765, liked the broad plain above the Ohio, and bought 400

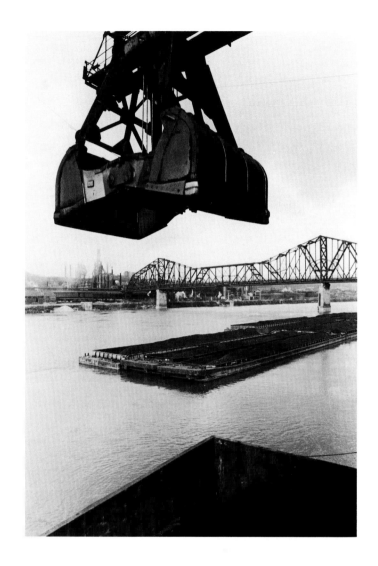

acres of it for sixteen cents an acre. A few years later the government was looking for a site for a fort and settled next door to Walker's land, naming the fort for Baron von Steuben, who had helped the colonies during the unpleasantness with the English. A small community grew up around the fort, and its citizens, looking upon the river, named the settlement La Belle. Later, however, the fort was abandoned and the town took over the area and was renamed Steubenville.

Steubenville used to have a boat-building plant. Among its prize products was the steamboat *Bazaleel*, whose career, sad to say, was more sensational than successful. It was the traditional steamboat in all ways but one: its smokestacks were made of brick, local brick. They were, in short, chimneys. On its maiden voyage, the *Bazaleel* ran aground and the impact knocked down the stacks and the crash ruined the boat. At least, that's the story. You'd think a stout boat could survive the crash of a couple of chimneys, but that's what they say. Maybe that's why the town turned to steel.

At any rate, Steubenville is bustling now. It has a lot of good-looking homes. Andrew Carnegie once worked here. Edwin Stanton, Lincoln's secretary of war, was born here. So was Dino Crocetti, a handsome prince who kissed a frog and turned into singer Dean Martin.

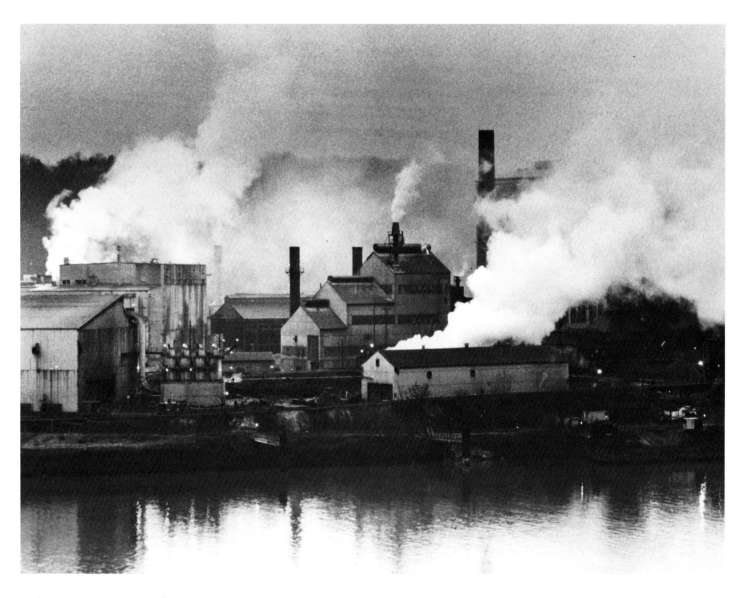

Industry at Dravo Island, Pennsylvania.

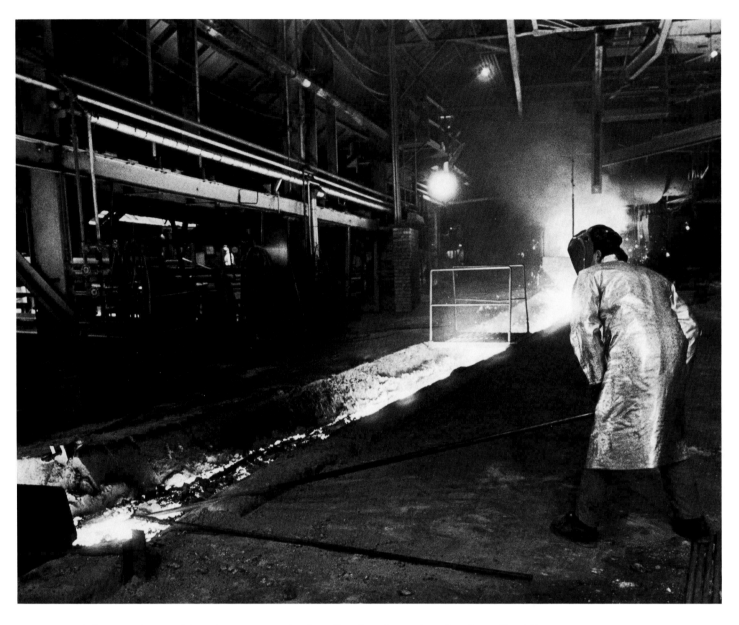

Molten steel flowing from a blast furnace at Wheeling Pittsburgh Steel in Steubenville, Ohio.

Worker unloading a coke furnace at the Wheeling Pittsburgh Steel Corporation plant in Steubenville, Ohio.

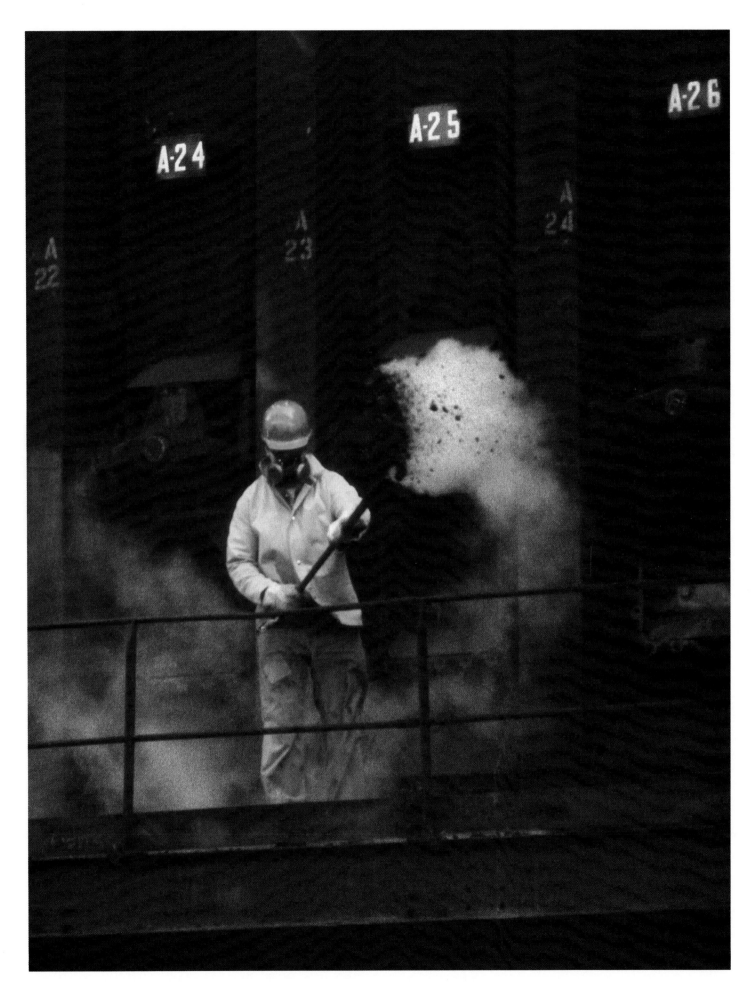

Martins Ferry, Ohio, climbs the hill to the right, a clean-looking town of solid homes and an attractive waterfront, and Wheeling, West Virginia, comes up downstream. It's hard to miss Wheeling. Part of it's on the West Virginia shore, part over in Ohio, and part on an island in the middle of the river. From the river, Wheeling looks as though it's seen better days, and according to some of its citizens, it has. Wheeling got caught in the steel transition.

"Yeah, this used to be a busy town," says the pleasant young man at the Forty-eighth Street Boat Club who introduces himself as Gary Scarberry. "We had the Wheeling Pittsburgh plant down at Benwood, but it closed down, and a lot of us got laid off. It doesn't look like chances for getting back on are real good. Some moved away, looking for work. Some of the older ones got pensions, and a lot of them live right here, right along that street there. I get work. Right now we're expanding the club here. That building there is going to be a restaurant, and we've got the dock here."

People along the business district say things are on the upswing in Wheeling. Tourism, they say, is booming; 2,500 people came in just for the Tour of Lights at Christmastime. Weirton Steel and Wheeling Pittsburgh Steel up in Steubenville are working, and that has meant jobs for some of the unemployed in Wheeling.

Wheeling is a comfortable-looking town. There are some remarkable old Victorian homes in the town proper, back from the river, and two unusually pretty parks. One of them, Oglebay Park, has a 200-room lodge, a restaurant, and a museum in the mansion that used to belong to Colonel Earl Oglebay, who made millions in coal. On summer Saturday nights Wheeling also offers "Jamboree USA" for those who fancy country music. Jamboree officials claim it's older than Nashville's Grand Ole Opry (though music historians disagree).

Along the street facing the river the small brick homes are neatly painted, and even the smallest lawn has a bright patch of flowers. There are swings and chairs on the porches and lace curtains at the windows. The Croatian Neighborhood Club, says the sign over a prominent building in the next block. It too is a solid, self-respecting looking place. Still, a lot of life goes out of a neighborhood like this when "the mills" start laying off and the men no longer come wearily down the sidewalk at quitting time.

But there's more in Wheeling's background than steel. Originally West Virginia was part of Virginia, the proud Old Dominion, mother of presidents, leader of the South. But the aristocratic tradition never really took root in the hilly back country, and in 1861 the people here rebelled. Many hated the idea of slavery, others refused to secede from the Union. So after secession the citizens of the regions around Wheeling formed a government in the old Customs House, claiming the Rich-

mond government was illegal, and asked the Union for statehood. Virginia had its hands too full fighting the Civil War to whip them back into line, and in 1863 Congress granted statehood to the Wheeling petitioners. Many Virginians have since looked upon West Virginia as the unfashionable end of town. Which doesn't bother West Virginians.

Two girls are diving off the dock and seem to be enjoying the water, which looks dirty. But it's cool. Along the bank and under the board steps leading down from the street to the dock, a mother groundhog and two young ones scurry along, ignoring the people and boats around them. Give wildlife half a chance and it will survive.

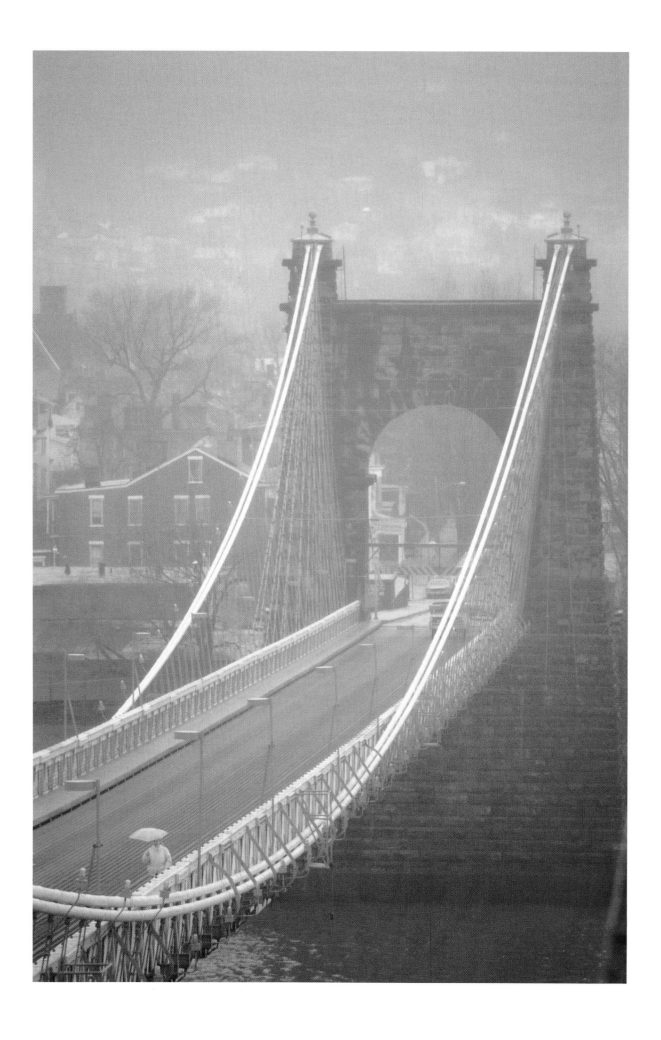

Below Wheeling, the river twists around as it turns south toward Moundsville, West Virginia, which lies on a large curve, just before the river turns sharply northwest. If you're going down this way you might like to stop off at Moundsville, if only for the mound.

The mound, say local officials, is a burial mound built by the Adena Indians, an early tribe or race who were in the Ohio Valley before the arrival of the "redskin" Indian tribes who were here when white men arrived. Some archaeologists have speculated that the Adena may have been the "white Indians" who, according to legend, had a fine civilization in the valley before the red Indians arrived. According to this legend, the two groups once fought a great battle near the present site of Owensboro, Kentucky, in which the Adena were virtually wiped out, leaving only burial mounds to mark their civilization. Most historians deny this.

The mound here is the tallest if not the largest in the valley, eighty feet high and 900 feet around. For many years the people of Moundsville considered it nothing more than a curious hill. Several houses were built on it. Once a saloon was built right on top, but people didn't care to walk that far for a drink. Then someone started digging into the mound and uncovered bones and small artifacts and a stone with strange lettering on it that has never been deciphered. Some think it could be a rune-stone left by Norsemen who arrived long before Columbus and who, some believed, got as far west as the valley. Whatever it is, the mound is now carefully protected and quite a tourist attraction.

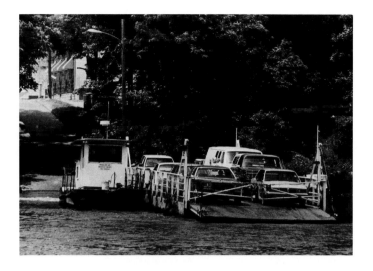

The Moundsville Ferry.

The 10th Street Wheeling Highway Bridge.

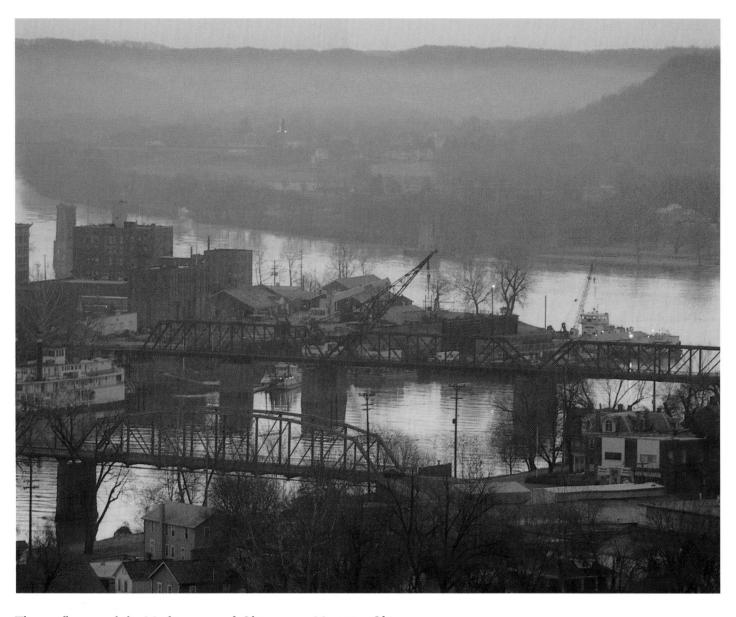

The confluence of the Muskingum and Ohio rivers, Marietta, Ohio.

A sparkling morning on the Ohio is a wash-job for the soul. Several times this morning, flights of butterflies have crossed the river, white or orange and black or small yellow ones. As we get under way I watch a raccoon watching us, and a few minutes later spot what appears to be an eagle or very large hawk high in a sycamore tree. A mother duck leads her small convoy of ducklings across our bow, scolding, casting fearful eyes on us. As we come up on Marietta, Ohio, two great blue herons cross from south to north and a flock of pigeons wheels by, seeming somehow out of place out in the country, so accustomed are we to seeing them in town.

At Marietta we head up the Muskingum, looking for gas. If you're running the Ohio, top off your tanks when you get a chance. Marinas are few and too far between. It gets to be a nerve-jangler. We meet the *Valley Gem*, an excursion sternwheeler, coming out of the Muskingum and heading up the Ohio with a full house. The Muskingum, flowing down from central Ohio, is a handsome river with a beautiful park on the right and on the left the Marietta Crew Headquarters. The banks are shaded by towering trees, and the hills sloping back from the river are lined with fine-looking homes. Good-looking town.

We may become citizens if we don't find gasoline soon. There are several pumps at docks along here but they belong to private clubs and are locked.

Even where the view from the river is less inviting, Marietta is a town any tour of the Ohio must include. In 1787 the Northwest Ordinance, one of the four great documents on which the United States was founded, was passed by Congress establishing rules for governing and for creating states in the vast territory north and west of the Ohio River. It contained many of the fundamental freedoms later contained in the Bill of Rights, including freedom from slavery, which was not written into the federal Constitution until 1865. This signal of a free people's opposition to the denial of freedom was evidence of the innate revulsion to slavery that would later tear the country apart. And thus, mercifully, the tone of the new territory was set. Three months later General Rufus Putnam led a company of forty-eight men ashore from a flatboat, a barge, and three dugout canoes at the confluence of the Ohio and Muskingum and founded the first city in Ohio. It was later named Marietta, for Marie Antoinette, in gratitude for the help France had given the colonies during the Revolution.

Ever since, there's been something special about Marietta. It's hard to point to a single, specific characteristic. It seems to have what southerners used to call "quality." You seldom find people speaking fondly of wealthier neighboring towns, but an editor in Pomeroy, downriver from Marietta, once told me, "You can have Florida; I'd like to retire to Marietta. A lot of people do. I'll tell you, Marietta isn't a small town; it's a small city."

It has a tone about it, culture, that fine library, the college. It's pretty, clean. A certain air."

When Putnam came ashore, Indians were still a very real threat, so his company built a fort a few hundred yards up the Muskingum and named it Campus Martius, Latin for field of war, or military ground. Today the site is a handsome museum that houses, among other things, General Putnam's cabin that holds many of his possessions and furnishings. It's fascinating to realize how the pioneers really lived, to imagine being thrown suddenly into such a situation.

Just below Campus Martius, on the banks of the Muskingum, the Ohio River Museum consists of three separate buildings housing riverboat paraphernalia, two dugout bateaux of the type used by French explorers, and models of river steam packets, including the famous *Robert E. Lee* (which won fame on the Mississippi but was built at New Albany, Indiana, on the Ohio). And on the grounds stands a replica of an early flatboat—the most ungainly boat you've ever seen, hardly more than a long wooden box with a big sweep oar aft to steer it. It must have been hideously uncomfortable. But it was the settler's friend—cheap, easy to build, could carry a lot of cargo, and could be broken up to make houses when it got people where they were going.

Perhaps these things, along with Marietta College (the oldest in Ohio), the tree-shaded residential streets, the unusual number of historic homes, and the impressive library are not unique. But for a town of 17,000 people they're certainly unusual. Marietta College looks like the set from an old Bing Crosby movie, all shady campus and white-columned, red-brick buildings. It's not only a big factor in the local economy but a big part of local cultural life and adds a young, colorful note to the atmosphere. "I went to college there," a city official down in Gallipolis recalled wistfully, "and I still just love it. Marietta is so clean and pretty. The people are so nice."

Marietta has a regatta, as does, apparently, almost every town on the Ohio, but this one is that remarkable thing, a regatta that neither smokes nor roars nor stinks. It's one of the few inland crew races in the country. The town also has some fairly substantial industries and a shopping strip along the east side of town that's about as garish and unappealing as the average motel-hamburger-mini-mall strip. But then, when the Lord created Eden, he also created the snake.

Marietta faces the river. The *W.P. Snyder*, one of the last of the big steam-powered sternwheelers to push barges on the Ohio, is docked down on the Muskingum at the foot of the River Museum and is open to the public. It gives you a chance to see what the pilot house of an old steamboat actually looked like. The ninety-eight-passenger *Valley Gem* runs throughout the summer months. And the Becky Thatcher Showboat and Restau-

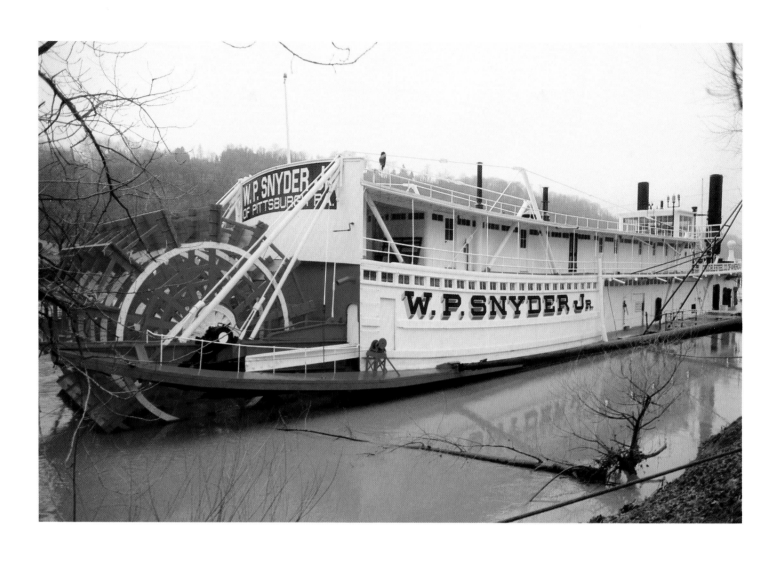

rant offers better food than you might expect, along with heart-wrenching melodrama.

In September the American Sternwheel Association, based here in Marietta, throws its annual Ohio River Sternwheel Festival, with a race, lots of food and fireworks, and even a calliope concert—no treat for sore ears but a bit of yesterday and a lot of fun.

But we still need gas, and finally a man sitting on a dock directs us across the river to Bean's Landing, where we encounter Bob and Donna Friedler. They insist on going to find the operator of the marina, though Bob is working on his boat and Donna is working on a suntan. Why are people along the river so helpful? So polite?

Bob is from Cleveland, but Donna is a native and happy to be. "It's a nice town," she says. "I love it. There's not a terrible lot to do, but more than you'd think. For a big night we go to Cincinnati or Columbus or Athens. That's where Ohio University is, and has some good places. And we always have the river here."

Bob comes back with Mrs. Bean, who supplies us with gas and ice. We leave a quality town, quality people.

Glassblower at the Dalzell–Viking Glassworks in New Martinsville, West Virginia.

Opposite: The view of the Ohio from Blennerhassett Island.

There are many places on the Ohio worth visiting, and one is Blennerhassett Island, just downriver from Parkersburg, West Virginia. The island is not Parkersburg's only offering; the city has a large artists' colony, throws a West Virginia Honey Festival in August, with a 10,000-meter "Honey Run," and an arts and crafts festival in September. For over a century the Ohio Valley has been the center of American glass-making, and there are still many factories you can visit. One is the Fenton Art Glass Company, a short drive north, where you can see skilled craftsmen blowing glass.

But the island is the main attraction. It was once an amusement park, another time a major-league ball park. And it was also once called "Paradise."

The people of Parkersburg are not going to let you ignore the name. There is Blennerhassett Island, with its Blennerhassett Mansion. In town there is the Blennerhassett Museum. Blennerhassett Heights Road takes you to the Point of View Restaurant, which offers a fine view of Blennerhassett Island and a fair menu, though not appreciably better than the nearby Holiday Inn or the downtown Blennerhassett Hotel.

The island itself is owned by the DuPont Corporation but leased to the Blennerhassett Historical Park Commission, an agency funded by the state and private groups concerned with the island. Prehistoric tribes lived here 12,000 years ago, there was a Shawnee village here about 1100, and in the eighteenth century, when white men began pushing down the river, bloody fighting erupted on the island. In March 1798 Harman Blennerhassett came down the Ohio, fell in love with the island as violently as he usually fell in love, and bought the upriver end of it.

Blennerhassett was the son of a well-to-do Irish family, born in County Kerry on October 8, 1765. When his older brothers died suddenly, he fell heir to a considerable fortune but scandalized his family and outraged society by marrying his young niece, Margaret Agnew, despite family accusations of incest. In 1796 the two, with a retinue of servants, shrugged off the furor and sailed for America. They traveled from New York to Pittsburgh and soon set sail down the Ohio, Harman having developed the belief that he was destined to find his fortune in the wilderness. And there in 1798 they found the island.

Harman had decided to operate a plantation, for which he would need slaves, and the island, being part of Virginia, permitted slavery. It also offered rich soil and a grand view of the Ohio. The Blennerhassetts were a handsome, romantic couple—tall, blonde, athletic Harman, and tall, beautiful, and equally active Margaret. They built a white mansion beneath the tall trees, filled it with the finest furnishings, employed a chef, and developed a reputation for the cultured hospitality extended to anyone coming down the river. They spent,

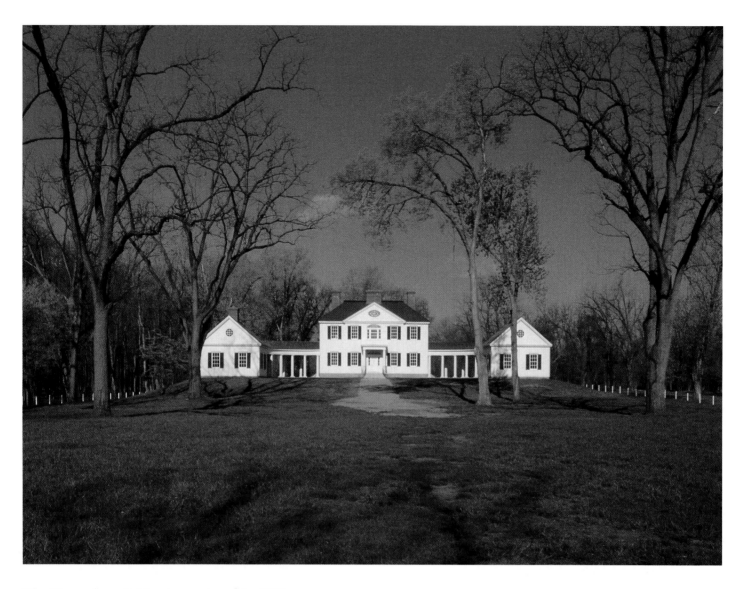

The Blennerhassett Mansion, restored in 1975.

indeed, more than they could afford, but you don't pinch pennies when you're building paradise. They loved to ride along the trails they built around the island, and to boat on the river, and they were as delighted with each other as with their treasured island, which neighbors named "Paradise."

Alas, even Paradise must have its serpent. Among the many famous visitors to the island—George Rogers Clark, the future King Charles of France, Henry Clay, Walt Whitman, Johnny Appleseed (who planted an entire orchard in the center of the island), there came Aaron Burr, the magnetic, foppish eccentric who had lost the presidency to Thomas Jefferson and was gnawed by thwarted ambition. He was under a cloud for having killed Alexander Hamilton in a duel and was watched with suspicion born of dislike by Jefferson when he dropped in on the Blennerhassetts. He soon left for a downriver rendezvous with the insidious General James Wilkinson but returned to entrap the credulous Harman in his web of intrigue.

What, exactly, was Burr's plan? Historians disagree. Some say he wanted to found a new nation in the southwest, on the pattern of Texas, headed by himself. Burr claimed that he intended to establish a colony and win territory for the United States (this could have accounted for the fact that Andrew Jackson was for a while a supporter.) Some say Burr fired Blennerhassett's imagination by promising to make him the new nation's ambassador to Great Britain, enabling him to return home in triumph.

Burr was apparently depending on Wilkinson, who was then governor of the District of Louisiana, to supply the firepower for this adventure, and poor, romantic Harman had already begun supplying the money. It is strange that a man as shrewd as Burr should have confided in Wilkinson, of whom Theodore Roosevelt later said that he was "so ingrainedly venal, treacherous and mendacious that nothing he said or wrote can be accepted as true." In the summer of 1787 Wilkinson had persuaded Kentuckians to finance him as emissary to the Spanish in New Orleans, with the aim of opening New Orleans to Kentucky commerce; he is said to have then sworn allegiance to Spain, taken money and a promise of commercial rights on the river, and promised to work for the union of Kentucky with the Spanish colonies. He was supposedly on the Spanish payroll—and soon to be territorial governor for the U.S.—when Burr came down the Ohio (after winning the support of Blennerhassett) and told him his plans. Wilkinson showed an interest, made vague promises, and promptly betrayed him to Jefferson. Burr was siezed and held for trial. Harman and Margaret tried to flee but were taken by the Virginia militia. Harman was thrown into the penitentiary and languished there for weeks, while Margaret dashed frantically about the Ohio Valley trying to find help.

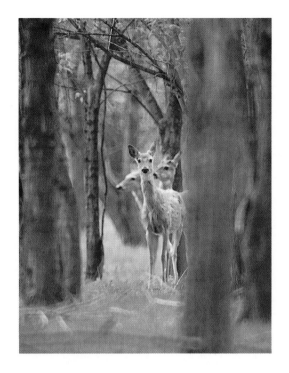

Deer at Blennerhassett.

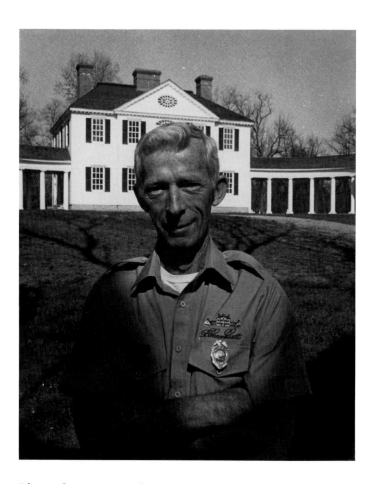

Blennerhassett caretaker Don Vandergrift.

Eventually Harman, like Burr, was acquitted, but he was a beaten, confused man. His wealth depleted, his reputation clouded, he retreated down the river with Margaret and the sons who had been born to them in Paradise, and attempted to recoup his fortunes with a Mississippi cotton plantation. Three disastrous growing seasons in a row ruined him. Clinging to each other for comfort and hope, he and Margaret moved to New Orleans where for a while he nursed hopes of a judgeship in Canada. It went to another man. Finally, almost penniless, Margaret and Harman sailed for England, where he died in poverty in 1831. Years later Margaret died while visiting Harman Jr. in New York.

The island fell into decay. The mansion burned. From 1868 to 1912 an amusement park flourished, heavyweight boxing champion "Gentleman Jim" Corbett fought there, major league baseball teams played on its diamonds. After that the land lay unused, the woods thickened, and wildlife multiplied. But interest in the island never died, and in 1975 the West Virginia legislature created the Blennerhassett Island Historical Commission. The following year, with help from the Friends of Blennerhassett, it began restoring the mansion, which today welcomes visitors. A sternwheeler takes visitors from Parkersburg to the island, and horse-drawn wagons take them around the island where Harman and Margaret rode together. The birds and other wildlife, especially the deer, which often come up to the mansion in the evening, are major attractions. Dr. Ray Swick, author and historian, gives guided tours and lectures, and craft shops near the mansion offer reminders of the time when Harman and Margaret found Paradise on the frontier, before evil and folly shattered their dream.

Cruising down the Ohio in a comfortable cabin cruiser, it is interesting to speculate on life aboard a flatboat—surely one of the most uncomfortable vehicles ever devised by man. Its leaky deck let rain filter down on the poor travelers trying to cook, eat, sleep, and keep their possessions dry in the dark, smoky hold. Indians and bushwhackers were a constant menace, and even if a sharp-eyed captain could spot the snags lurking beneath the surface, he couldn't always swing his clumsy craft in time to avoid them.

A flatboat crew consisted of from three to five men plus the captain, who manned the steering oar, usually sixty to seventy-five feet long, and kept the crewmen, often little more than cut-throats, under control. Keelboats, with keels, rounded sides and sometimes pointed bows, were easier to steer and could be poled against the current. When a flatboat got to New Orleans it was usually broken up and sold as lumber, often to make homes for the settlers. Keelboats could make the round trip, though going upstream was hard. Sometimes the boat could be poled, more often the crew had to go ashore

and haul it along with ropes. Some keelboats had sails, but with crewmen who knew nothing about sailing, the sails usually proved more danger than help. Flatboat men usually walked back to home port, having to run the danger of killers who lay in wait for rivermen with pay in their pockets.

That pay does not sound lavish, but was not bad for the time. During the early 1800s, for a three-month trip down the river the captain was paid $100, deckhands from $20 to $50. On the steam packets that began replacing the floating boats after 1820, the captain was paid $115, his pilot and first clerk $80, the first mate $60, the cook $50, and a roustabout or common laborer $20. There was sexual discrimination that would probably prompt a suit today; chambermaids were paid $15 a trip. Such seemingly paltry wages were not bad at the time, being worth more than ten times the amount today.

The captain was in charge of the security of boat and passengers, finances, discipline and welfare of the crew, comfort and feeding of the passengers, and dealing with customers and public officials along the way. A captain working for a boat owner usually made around $800 a year, but a captain operating his own boat could make thousands, and many of them retired young and built mansions on the bluffs overlooking the river. Until 1852 a man was a captain if an owner would hire him as such, but in that year Congress passed a law requiring all beginning pilots to train under a licensed pilot.

Mutiny on the river was rare, but crews often just walked off, leaving a captain in bad straits. The ability to whip the crews, or at least the toughest man in the crew, was an enormous asset for a captain. The legendary Captain John Russell, who once commanded much of the western river system for the government, is reputed to have picked up a 1,264-pound engine shaft and to have carried two 1,200-pound anchors across a deck, but was best known for whipping the famous French pirate Jean LaFitte in a barroom fight. Captain Russell had few disciplinary problems.

Deserted shantyboat near Harrod's Creek, Kentucky.

You run into some strange town names along the river. Lodi, Fly, Springtown Fly, Upper Sister Island, Toronto. And weird creek names. Cow Hollow Run, Owl Run, Deadhorse Run, Polecat Run. Do you suppose anyone lives on Polecat Run?

It's been a good morning for hot coffee, with a slight overcast and a bumpy chop on the river. Finding a good place to anchor or tie up for the night isn't always easy, and last night it took a while. What you want is a soft, sandy shore that slopes off steeply into deep water, allowing you to tie up close to shore with plenty of water under your keel. Too often you spot a nice, sandy bank and find that the water offshore is about a foot deep, grounding you dangerously if you approach too fast. Or you find a bar of rocks that can put a permanent hole in your bottom, lying just under water off a safe-looking cove. Or you find a perfect spot that already has mosquitoes-in-residence.

But all's well that can get under way. It's a long stretch from Parkersburg to Pomeroy, with less industry than along the upper river. We pass Ashland Oil's *Super-America*, a big new towboat, sister to the new *Valvoline*, heading upstream. We see two blue herons, an osprey, some ducks. And then Pomeroy, Ohio, comes up on our right.

Pomeroy is unusual, built on a narrow shelf of land rising sharply from the river but at the foot of a tall cliff. It's over a mile long but usually two blocks wide because it doesn't have anywhere to grow unless it can climb the cliff. It could spread down to the river but it would be in danger of floods; it suffered badly in 1913, 1937, and 1978, and people say high water still gets to East Main Street, in spite of the floodwall.

The big white Meigs County courthouse towers above the town and is exceptional for at least one reason—it is built against the cliff and can be entered on three levels. To the east of the courthouse stands the jail, with a large sign beside it reading "DO NOT TALK TO THE PRISONERS." A small group of men sit or lean against the sign, talking and laughing with the prisoners. On the west side of the courthouse stands a tall granite column topped with the figure of a Union soldier. The plot is neatly mowed.

Pomeroy is a fairly old town, having been settled in 1821. It was named for Samuel Pomeroy, of Massachussetts, who owned coal land nearby and the mines in which a lot of people worked. In 1841 he came down to look over his property but didn't think enough of it to stay and instead moved down to Cincinnati. But he left his son-in-law, Valentine Horton, to run the mines, and Horton named the town for his wife. Southern Ohio Coal Company still has three mines in Meigs County, and a lot of townspeople still work there or at the Kyger Creek Generating Plant north of town. Pomeroy has only 2,683 people but it's something of a shopping center and has

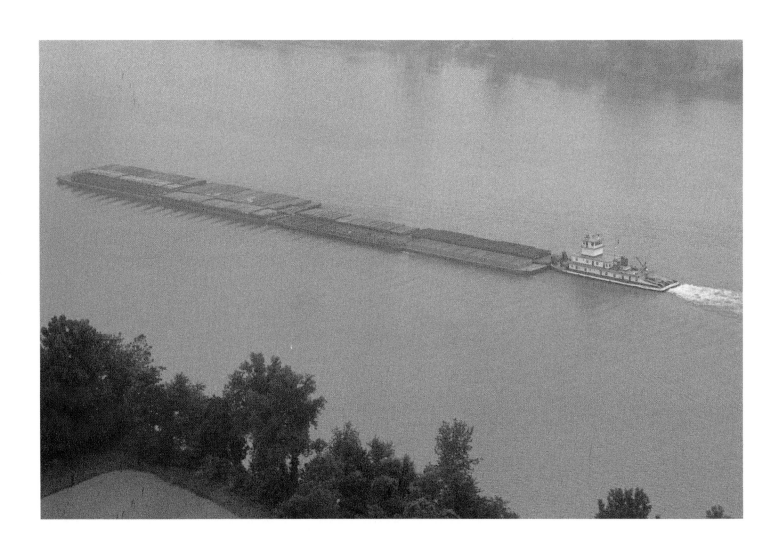

an attractive library and a newspaper, *The Sentinel*, which has a circulation of 1,400—pretty good for a town of this size. The town is served by the Blue Streak Cab Company, which seems to be moving not quite that fast today.

Middleport's city limits lie about a mile downriver from Pomeroy, but to a stranger the two seem to be one town; run out of one and you're in the other. Like Pomeroy, Middleport is two miles long and seldom more than two blocks wide. In its day it enjoyed some prosperity as the halfway stop between Pittsburgh and Cincinnati, but that proved to be small advantage. It has one thing Pomeroy doesn't have, though—a bookstore. Pretty good bookstore, too.

Just before the river passes under the Silver Memorial Highway Bridge above Gallipolis, it receives the waters of the Kanawha River, one of the four largest rivers to join the Ohio between Pittsburgh and Cairo. The Kanawha is unusual for at least two reasons.

Formed when the Gauley River of West Virginia joins the New River flowing up from North Carolina, it is the only river that traverses the Appalachian Mountain range from east to west. Other rivers with headwaters east of the Continental Divide flow east to the Atlantic, but the New River, starting in the mountains east of Asheville, North Carolina, flows north and then west, cutting through the Blue Ridge to join the Ohio as the Kanawha.

At one time the New River was the largest river on the continent and probably in the world. It's older than the Appalachian range through which it flows, and it was formed, geologists believe, when the African and American continental plates collided million of years ago, pushing up mountains higher than the European Alps. These were drained, geologists say, by the ancestor of the New, called the Teays. The Teays flowed north and west from the center of these Alps past what is now Huntington, West Virginia, and followed more or less the course of the present Ohio to the great inland sea that began just south of what is now St. Louis. The Teays, geologists tell us, was more than fifteen miles wide when it received the waters of the south-flowing stream that would one day be the Mississippi.

The Teays existed until the last Ice Age, when glaciers filled much of its valley with drift, forcing it into a narrower course, but throughout its existence it managed to hold to the deep channel it had cut, which is why it still runs north and west. Shortly after it enters West Virginia and emerges from Bluestone Lake, the New flows through the New River Gorge, a spectacular stretch of white water and a favorite of rafters. A few miles north of the New River Bridge, it is joined by the Gauley and becomes the Kanawha, taking on its Indian name. It seems a shame it could not have kept its original name— a reminder that it was once the mightiest river on earth.

Dredging operations on the Ohio.

A mile or so below the handsome Silver Memorial Bridge, Gallipolis, Ohio, sits on a high bluff and impresses visitors with a block-long park located in the heart of town and overlooking the river. It has other points of pride—nicely renovated historic homes, a good museum, a fine library. But it's the park that snags the imagination. It's an attractive place of grass and towering shade trees, walks and benches and flower plots, a brightly painted bandstand, and a white-and-pink marble fountain. The people seem to enjoy it, but it is hard to dispel a certain feeling of sadness when you consider its history.

Gallipolis (which means Place of the Gauls and is pronounced Galley Police) got its name because it was founded, in 1790, by a group of French immigrants known as the French Five Hundred. Actually, there were only about 493 of them, and they were there because they had been victimized by an early American real-estate swindle. The French Revolution was making middle-class Frenchmen fear for their holdings and their hides, so the Five Hundred banded together and bought several thousand acres of paradise in the New World from a devious character named the Reverend Joel Barlow, a common crook despite the title. The land, according to the Rev., was crowded with game, so rich that crops sprang from the earth, was situated on a beautiful stream jumping with fish, and enjoyed a subtropical climate the year round. They were horrified when they landed in Virginia and learned the truth about their "paradise."

Heartsick, they appealed to George Washington for help, and he arranged for wagons to take them to the Ohio and boats to take them downstream. General Rufus Putnam recruited men to go before them, clear the site they had bought, and build some cabins. After a harrowing journey, they arrived in the middle of winter to find four rows of twenty cabins each, with blockhouses at the corners and low breastworks to help defend against the Indians. Beyond the little clearing was a stretch of swamp, and beyond that, forest. These were not hardy sons of the soil. Most were artisans, shopkeepers, businessmen, even a dancing master. But they were French. Unpacking their finest clothes, they threw a dance.

But brave gestures were not enough. They didn't have title even to the rough acres, and those who couldn't pay for the land again soon found other newcomers claiming their land. By 1820, when Gallipolis began to assume some prominence as a river port, most of the French had gone home or moved downriver, many settling around New Orleans. Today the pretty city park is the site of their original cabins. It is a pleasant place to sit on summer afternoons and watch the river, though it is not hard to imagine on the breeze a note of sadness for the shattered dreams of those disillusioned Gauls who danced and wept here in the wilderness.

But Gallipolis is not a town for gloomy memories. There are some pretty good places to eat—Oscar's and the Down Under and the two Bob Evans restaurants, which are better than you might expect of chain or fast-food places. Bob Evans, incidentally, is perhaps Gallia County's most famous citizen, and the huge Bob Evans Farm Festival is held each October on—naturally—the Bob Evans farm.

Not that the Gallic heritage has disappeared. The French Art Colony, one of the town's chief points of pride, is a regional multi-arts center offering a range of classes, performances, galleries, and exhibits remarkable for a town of 5,600. It is housed in Riverby, a Federal-style brick home that boasts a suspended circular staircase and a 1790 sunburst chandelier.

Gallipolis broke into the news on a grisly note back on December 15, 1967, when, during the evening rush hour, the Ohio River bridge between Gallipolis and Point Pleasant, West Virginia, fell, carrying forty cars and seventeen trucks into the river and killing fifty people.

"For a town of this size, it was a terrible tragedy," says Beth Vandawalker, executive director of the Chamber of Commerce. "The river was up and cold, and the current was so swift divers had a hard time reaching the sunken cars. For two years afterward we had to use the ferry to get to West Virginia. There's a lot of traffic between here and Mason County, and it really worked that ferry. But the new bridge is a much better bridge, four lanes wide and 1,800 feet long."

Gallipolis seems pretty and pleasant, if somewhat slow.

"Oh, it's not so slow," says Vandawalker. "We have fine schools, a sound, varied economy, a medical center and clinic that hire almost 1,000, two power plants, and factories that make everything from men's trousers and marine engines to computer chips. That's not so slow."

And always the memory of the Frenchmen—lonely, betrayed, but dancing in the wilderness.

Colorful storefronts, interesting architecture, and nicely renovated historic buildings and homes grace the town of Gallipolis.

The morning is overcast, the river smooth, and already it's getting hot. A lot of birds swoop and dip—swallows, sparrows, grackles, crows, ospreys, herons, gulls. It always seems strange to see gulls on the river, away from the sea where we expect gulls to be. Not to mention jays, a beautiful hawk, some woodpeckers, ducks, and a covey, or whatever, of buzzards.

In the fields above, dogs are barking. They were barking last night while we were trying to sleep. We weigh anchor and head downstream toward Huntington, West Virginia, where we had better find some gasoline. We're running on fumes again. There are two things you don't want to do on the river: break down and run out of gas. Go floating around out in midstream waiting for a good Samaritan, and a good towboat will come along and run over you. I've never talked to a man who had been run over by a towboat.

The day runs on and the gas runs out. No marinas, no pumps anywhere. Interesting suspension bridge just above Huntington, with a towering pier in the middle supporting half a spider's web of cable on either side. There are a lot of interesting bridges on the Ohio, some very pretty, artistic, graceful. On the left we spot Showboat Marina and—get out the prayer rugs—GAS! Nice folks, Dana and Bob Cales, to the rescue. We must be pure of heart. Every time we slam into a crisis, good folks ride to the rescue.

Dana and Bob are natives. "Yes, both from right here," says Dana. "Started the marina here in 1985, and then the restaurant. We lease out the restaurant, which operates the year around, but we run the store. Also sell houseboats, sailing equipment, whatever. I teach school in the winter, fifth grade, which is what I really like to do. But a few years ago we took a cruiser down the river to Kentucky Lake and then on to the Mississippi. It's interesting, here on the river."

Bob and Dana prove good Samaritans of many facets.

"You need money?" asks Bob, when we complain that the treasury is in danger of showing a deficit. "Hold on. I'll call Doug Duncan up at the bank." Sure enough, Dana provides wheels to the bank, Doug Duncan approves cash on the credit card, and with a smile. Once more, nice people. It's a fact that people on the river seem unusually generous, helpful. Nice town, too; worth a walk.

People in Charleston say it's the biggest city in West Virginia. No, says the lady at the Huntington Chamber of Commerce, that's wrong. Huntington is the biggest. The encyclopedia says Charleston has 60,993 people, Huntington 60,964, but those, as the C of C lady points out, are 1980 figures. At any rate, I am, as they say in the hills, not going to put my dog in that fight.

Huntington loads more river tonnage than any city on the Ohio with the exception of Pittsburgh, according to a data sheet thrust into my hand. More than Cincin-

The Cabell County Courthouse in Huntington, West Virginia.

Opposite: The East Huntington Highway Bridge.

nati, more than Louisville. That doesn't seem unreasonable. There are more coal loading and unloading facilities on the river here than I've seen anywhere else, and in a single year more than 20 million tons of coal, oil, and such pass through the port. On summer afternoons the waterfront buzzes with pleasure boats, postcards sold in the stores here show the Huntington skyline as photographed from the river, and they hold a big power-boat regatta the first of every August. The Ohio is a very big deal.

So is Marshall University. It used to be called Marshall College and had about 2,500 students. Now it has more than 12,000 and people here follow its football and basketball teams as though life, love, and national security hung on the score. And well they may. It's a handsome school, right in the center of town, and dresses up the place.

Huntington is not an old city. The first settlement here, known as Holderby's Landing, struggled to life around 1790 but didn't amount to much—a few cabins where supplies were sold to boaters. It disappeared. The people of the area seemed to have good intentions, though, and in 1837 founded Marshall Academy, named for Chief Justice John Marshall. The academy did better than the town.

Huntington, however, didn't burst upon the scene until 1871, when railroad mogul Collis P. Huntington decided it would be a good terminal for his Chesapeake and Ohio Railroad, located as it was on the banks of the Ohio where West Virginia and Kentucky meet. He thought up an original name for the place and sent a C&O surveyor, Rufus Cook, to draw up plans for a town. Cook did a first-rate job. His long, wide streets and numerous parks gave the new town an attractive plan to grow into.

Huntington is a business town, with more than 200 plants that produce about 400 different products. The people have time for culture, too, and the Museum of Art, West Virginia's largest, is located on a hill above town in a building designed by famed architect Walter Gropius. Huntington is also, apparently, a religious town. It has 150 churches, which figures out to about one for every 400 souls. I think.

And so it is that, with grateful hearts and brimming tanks, we bid farewell to busy Huntington and head out onto the Ohio to seek our fortune.

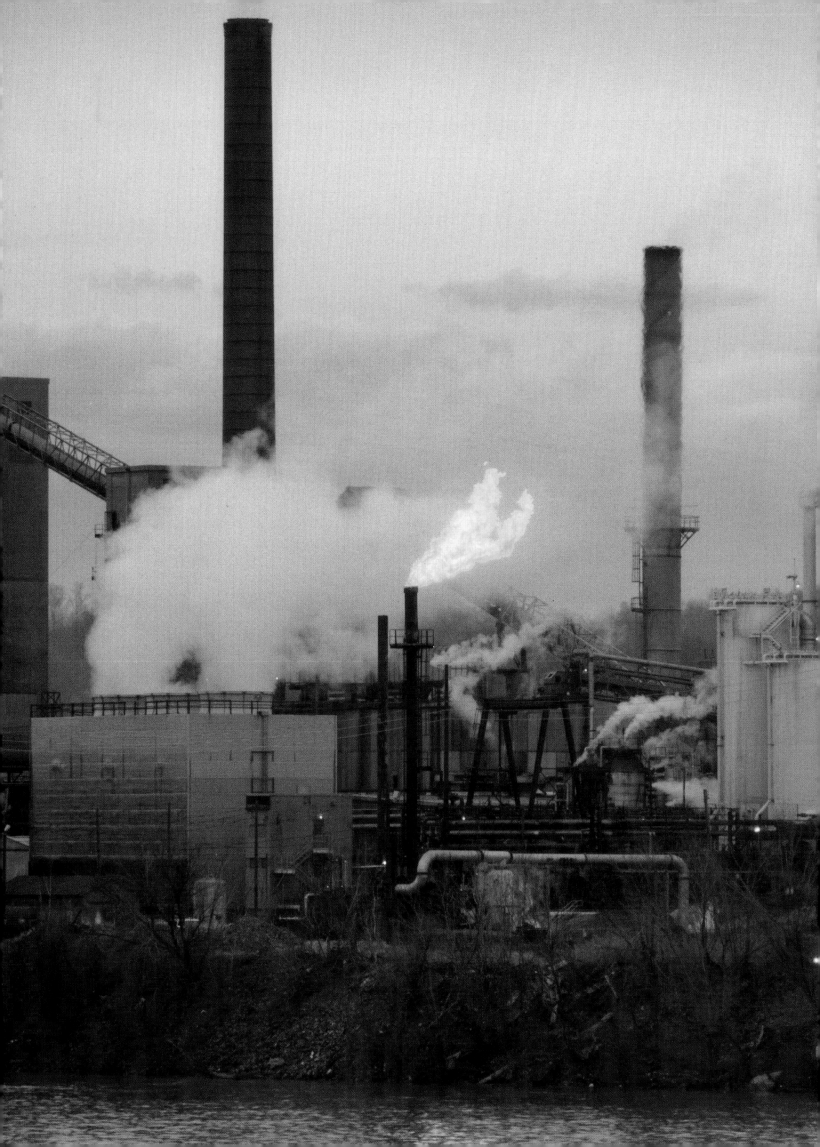

On both sides of the river industrial plants, fleeting stations (where barges are lashed together to form tows), oil storage tanks, sand and gravel pits, oil refineries, steel mills, and coal dumps line the shore as we approach the confluence of the Big Sandy River and the Ohio. The Big Sandy, which for most of its life is the boundary line between Kentucky and West Virginia, is a good-sized river, almost as big as the Kanawha. In the years after the turn of the century, huge rafts of logs were floated down the Big Sandy from the timber-rich hills of Eastern Kentucky, and coal was barged down to the Ohio and to cities along its banks from the mines that still supply coal to power plants along the river. A lot of history has been written in the land along the Sandy—the bitter divisions of the Civil War, the equally bitter mine wars of the Thirties. It was along one of the tributaries of the Big Sandy that the Hatfields and McCoys waged their famed (if brutal and stupid) feud, and its waters have been sullied by blood as well as coal washings and the soil from overcut hills.

Ashland, Kentucky—with 27,000 people the largest town in northeastern Kentucky, and a major shipping center—is and looks like an industrial town. The Poage brothers came down the river from Virginia and established the first settlement here in 1815, and by 1850 the region was noted for its coal, iron ore, and lumber, and more recently for its petroleum plants and steel mills. Until a few years ago, Ashland presented a curious scene each afternoon at quitting time, when droves of workers would stream from the mills and promptly head across the bridge toward Huntington, where they could have a drink of cool beer, Ashland being legally dry. The business interests of Ashland, wincing at the sight of good Ashland money flowing to West Virginia, finally overcame the dry forces and voted the town wet. They can now enjoy a cold one at home, and the town points proudly to the new Quality Inn hotel in the middle of town, which has a bar as well as a better-than-average restaurant.

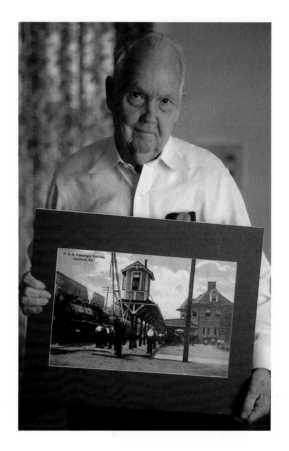

Harold Hanners, past president of the local historical society, has made a lifetime avocation of collecting historical information and prints of Ashland.

One of the many oil refineries along the Ohio at Ashland, Kentucky.

The Ohio is noisy around the confluence. Along the Sandy the big refineries of Ashland Oil Company pound and roar, as does the big Armco (American Rolling Mill) plant. Power boats of all descriptions snarl around the waterfront at Ashland, trucks grumble in and out of the plants and across the bridges linking Kentucky and Ohio, and towboats pushing long strings of barges rumble by, kicking up wakes, causing smaller craft along the shore to bounce around.

Tows like Ashland Oil's *Valvoline* are vital parts of this industrial complex and essential to the Ohio Valley economy. The *Valvoline* is a new boat, launched in 1987, with twin screws and two six-cylinder diesel engines that together generate 4,400 horsepower and burn 2,400 gallons of fuel a day, 3,000 if the boat is working upstream with a full string of barges. It's a big boat, four decks high counting the pilot house, 150 feet long and 42 feet wide. It has two stacks and under good conditions makes seven miles an hour.

The pilot house bears little resemblance to the bridge of steamboat days with its big wheel and speaking tube and a deckhand on the bow calling out water depth. It is air-conditioned and quieter than you'd expect, only a low rumble and vibration from the engines as the long, thirteen-barge tow moves out into the river. Settling into his seat in front of the boat's control panel, Pilot John Dalton places his cup of coffee on the panel shelf, lights his first cigarette, and casts a glance at his gauges. He moves the steering levers slightly, and the tow, almost a quarter-mile long, swings its bow slowly out into the channel.

Dalton's practiced eye takes in the hoses, valves, and pumps on the decks of the low-riding barges up ahead, filled with 6,900,000 gallons of gasoline and diesel fuel. On the barges, the mate and two deckhands turn rachets tightening the thick steel cables ("wires") that lash the barges together until they're practically a unit, and tie them to the *Valvoline*. Barges run in various sizes with various capacities, but this tow measures 1,190 by 105 feet, which means that Dalton will have to fit it into the standard 1,200 by 110-foot lock with five feet between his bow and the gate, five feet at the stern, and two and a half feet on each side. No room for error.

On deck, Mate Vic Howard looks up toward the pilot house and speaks briefly into the radio. "That's good," replies Dalton. "Stow them back here." Howard motions to the two deckhands working on the lead barge, and they begin stowing the hoses, wires, and mooring lines, readying for the trip up to Marietta and Pittsburgh.

There isn't much talk between the pilot and deck crew or with the engine room. Dalton knows what's going on. The pilot house is crammed with electronic gear to help him. He has radio connections with his deck crew, the engine room, even the galley, and with the home office, other boats, and lockmasters. A hand mike and squawk

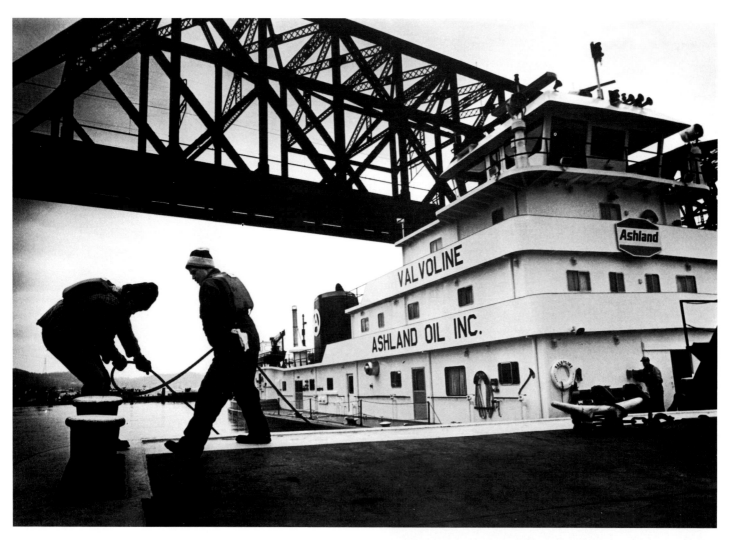

Above: Deckhands tie the *Valvoline* to barges after having lashed the barges together with thick steel cables. *Right:* The engine room with its two six-cylinder diesel engines which generate 4,400 horsepower.

box are within easy reach to his right. In front of him are two sets of levers that are the ship's rudders, one for steering when the tow is going forward, one for backing or "flanking," and two throttles controlling the two engines. Radar sets flank his chair for help at night or when running in rain or fog. Overhead levers let him turn on and direct the boat's powerful searchlights and the running lights required by law, or sound the boat's whistle. Lights on a panel over the forward window let him know if there's trouble with the engines, generators, or electrical circuits. A fathometer, or depth finder, tells him how much water he has under the keel. Loaded, the barges draw eight and a half feet; the boat, with a full load of fuel and water, draws from nine to nine and a half.

"If it reads eight feet," says Dalton, with a grin, "you know you're on the bottom. Not a real good idea to be on the bottom." Dalton also has a gauge that tells him if his bow, the nose of the tow, is swinging right or left. "Sort of a pilot's crutch," he says. "But we usually know the attitude of the tow."

The fleeting stations above Ashland slide by. Huntington is on the starboard bow. The wind, coming downriver, has put a chop on the water, and now and then a wave sends a splash across the bow. Having nothing to do for the moment, the mate and one of the deckhands come aft and go into the lounge for coffee and to smoke, which is forbidden on the fuel barges. Slender, dark-haired, bespectacled Jim Chittenden, the ship's cook, comes up the stairs at the rear of the pilot house carrying hot coffee and a bowl of fruit. He is, everyone agrees, the most important man aboard next to the captain.

"Here," he says, handing Dalton his coffee, "don't want people to think I don't take care of you." He gets a cup for himself, lights a cigarette, and the two of them smoke and talk, watching the river.

Each boat has a basic crew of captain, pilot, engineer, cook, two mates, and four deckhands. One deckhand is called an engineer striker. This doesn't mean he's striking, only that he's an apprentice and spends as much time as possible in the engine room, learning under the supervision of the engineer. Sometimes a boat will have a deckhand who wants to become a pilot and serves in the pilot house as steersman until the captain decides he's ready for his examination by the Coast Guard to become a certified pilot. Boats may also carry deck trainees, men with no river experience who work for three to six months under the eye of the mate to qualify as deckhands. Crews tend to stay together for years.

"The idea," says Dalton, "is for everybody to work his way up. Not all deckhands want to be pilots. You take Vic [Vic Howard, the first mate]. He's been asked a couple of times to come up as steersman—a deckhand steers, runs the boat under the supervision of the pilot until the captain figures he's ready for his examination;

Above: The *Valvoline*'s cook, Jim Chittenden, sees to it that no one goes hungry. *Lower:* A moment of relaxation.

by that time, most make it. Vic didn't want it. Likes being mate, likes the deck. Some men try it and don't like it. Handling the boat makes them nervous. They don't want the responsibility.

"I've got the same duty here as the captain," says Dalton, "but I don't have responsibility for the boat. If I want, I can go to relief captain and then to captain. Say a captain's sick, a relief captain comes on and he's captain as long as the regular captain is off. Some pilots and relief captains are freelancers, work when they get a call. That is, if they want to. Some, you know, have farms, businesses, don't want to be on the river all the time. They're in demand, make good money."

"Guess I'd better go down and see if we've got something to eat," says Chittenden. Riverboats are famous for their food, and their cooks pride themselves on quality as well as quantity. Each boat has two watches. The forward watch gets up at five, eats breakfast at 5:30 and relieves the after watch at six. The men going off watch go down to breakfast, after which most will take a shower and go to bed and sleep until 11:30. The captain, pilot, engineer, and cook have private rooms. The rest of the crew bunk two to a room.

For breakfast, the men file past a sideboard loaded with three kinds of fruit juice, milk, fruit, dry cereals, and sweet rolls. As each man enters Chittenden asks, "What'll it be?" and fixes eggs to order. Bacon, sausage, fried apples, grits, potatoes, biscuits, gravy, and pitchers of milk are on the table, and a gleaming urn just inside the galley offers hot coffee twenty-four hours a day. The forward watch, just out of bed, tend to eat with few words and go to their stations. The watch being relieved is more relaxed, and the men usually sit for a few minutes, drinking coffee and talking. At 11:30 they troop in to eat before relieving. Sometimes crew members watch a few minutes of television before eating, but the reception isn't good, as the boat moves from one region to another. The men are relatively young, most of them from small towns along the valley, and bear little resemblance to the rough, crude-talking rivermen of lore.

Lunch usually consists of pot roast, ham, roast pork, or spaghetti and meat sauce, three vegetables, potatoes, a vegetable salad, a fruit salad, biscuits, cornbread, milk, coffee, and dessert. Dinner is much the same, although Saturday traditionally features steak. If the crews get hungry between meals there is always fruit, crackers, cookies, coffee, and milk. No one goes hungry. Chittenden, who comes from southern Kentucky and "just picked up cooking" when he was young, enjoys his job and always dresses in a spotless white uniform.

At six, Captain Harvey Kiser, heavy-set, balding, quiet-spoken, relieves Dalton and settles into the pilot's seat. There is little ceremony. Dalton goes to the desk on the starboard bulkhead and writes in the ship's log his account of his watch and the condition of the tow.

Captain Harvey Kiser in the pilot house.

Captain Kiser guides the *Valvoline* through the lock chamber with only inches to spare on either side.

Out on the barges, the deck crew walks forward, checking wires. Being a deckhand is easier in warm months; in winter the men wear heavy padded clothing, steel-toed, ridge-soled shoes to cope with icy decks, heavy gloves, and bill caps to shade their eyes from the boat's searchlight. And life vests, at all times, in case they go overboard. As they sometimes do.

"We had a new deckhand," Vic Howard recalls, "a trainee. And the first day he was carrying a line, going along the starboard side, when he slipped right off into the water. We got him out. Wasn't hurt, but it scared hell out of him. When we tied up, he just took his clothes and left. Didn't wait for his pay."

"The river's nothing to mess with," says Captain Kiser. "There's still accidents. The wind can catch a tow, whip it into the bank and break a barge or two loose. A loose barge going down the river is like a bomb ready to go off, and hard to get a line on before it runs into something. And then there are collisions. One captain won't hear the other's whistle, or he'll have his radio off and not hear the other man giving his position around the bend. He'll be in the same water and not able to swing his tow in time.

"Any collision is serious. It'll break up a tow just about every time, often both of them, and then you've got trouble. It's worse if you've got extra water [rivermen refer to high water as "extra"] and a strong current. Every now and then you don't get to a runaway barge and it crashes into a dam and burns. The danger depends some, too, on your cargo. Say you've got a load of fuel, like we do. If the barges are loaded, they'll probably just burn, but if the barges are empty, the fumes will sometimes explode, and that could get the boat as well as the tow."

No matter what the damage, an accident is serious. "The Coast Guard always holds an inquiry," says Kiser, "and a man can lose his license." And for a river pilot, that's disaster.

Soon after Kiser takes over, another tow, loaded with coal, comes downriver, and he talks for a minute with its pilot. From long years on the river, these men know each other. They share things.

As dusk deepens, he turns on his running lights and switches on his radar. The panel instruments glow in the dark pilot house. Ahead on the left, lights tell that we're approaching a lock, and Kiser talks briefly to the lockmaster, giving his position, getting permission to lock through. He reaches up and flips on the searchlight, a tube of white lances through the darkness, revealing the outlines of the lock and dam, and the mate up on the bow begins talking him in.

"Three hundred down, seventy-five out," he says, meaning that the bow of the tow is three hundred feet downstream of the wall marking the entrance to the lock, and seventy-five feet from shore. Kiser presses the button of his microphone to signal his acknowledgement.

He moves the steering levers gingerly, pulls the throttles back a bit. "Two hundred down, fifty off," says the mate. Almost a quarter of a mile back of the bow, Kiser calls on experience and memory as much as on the voice of the mate to ease the tow into the lock chamber with inches to spare on either side.

Captain Kiser has been on the river all of his adult life. He's comfortable in his job and comfortable with the prospect of retirement, when he can spend more time with the one thing that brings a note of excitement to his voice—the Gideons, the national organization that places Bibles in hotels, motels, rooming houses, anywhere that people with spare time may read them. His religion keeps meaning and joy in his life.

He's accustomed to the routine of boat life: six hours on, six hours off for thirty days. Then he and the crew pack their bags and leave to catch planes or buses home, where they spend their thirty days of off-time. As they leave, another crew comes aboard, another set of orders is received, another tow is made up, and the *Valvoline* once more moves off into the busy waters of the Ohio.

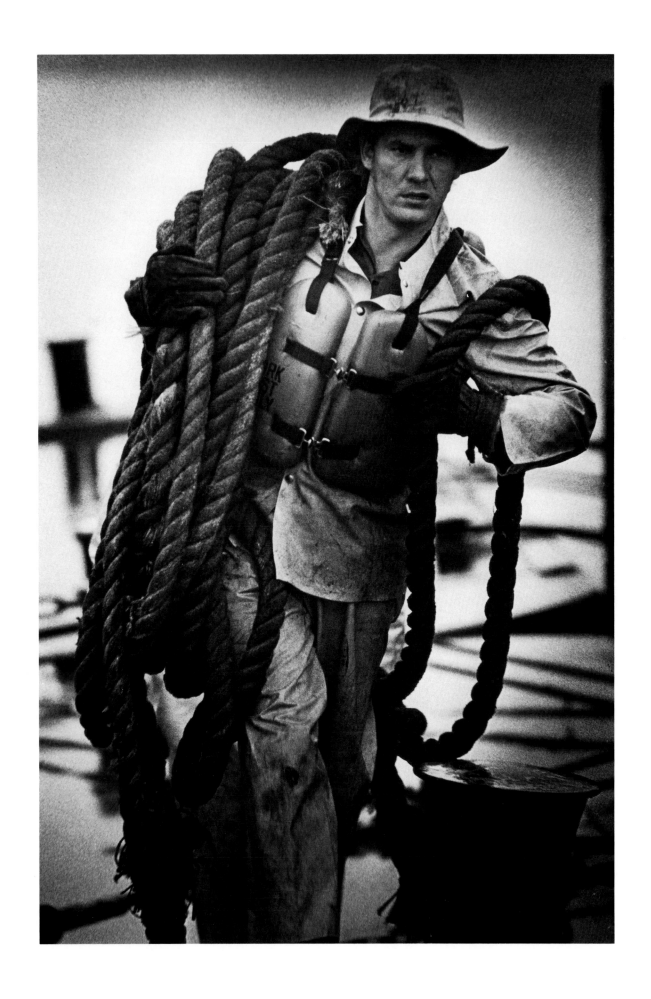

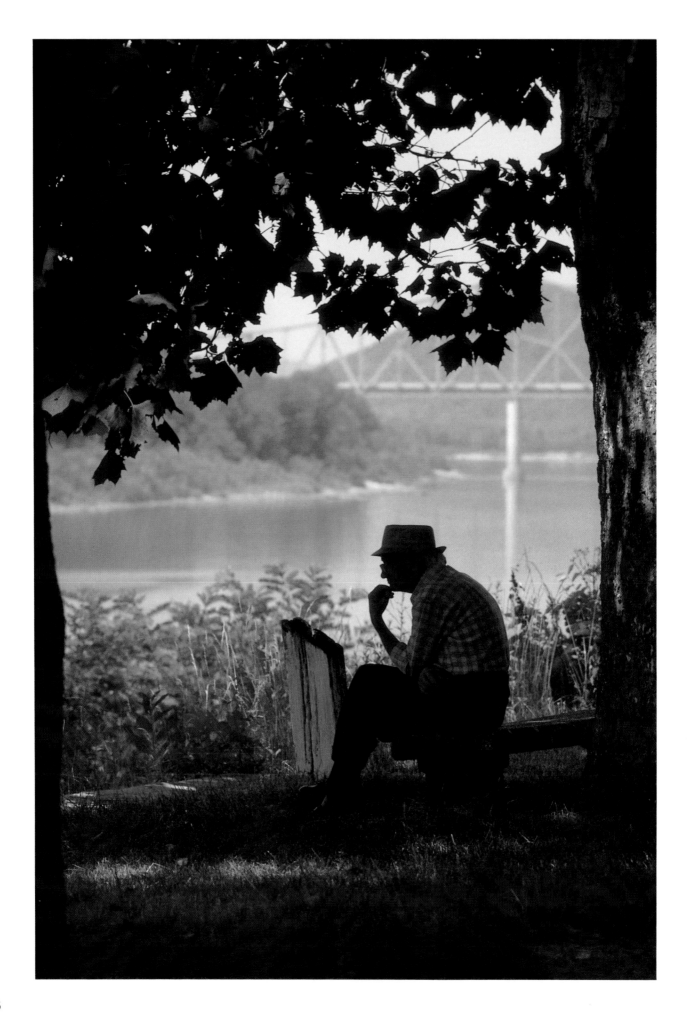

There is no good place on the Ohio for your boat to break down. If you're out in the middle of the river without power and a big barge looks as though it wants to share the river with you, you'd better be able to walk on water. Or swim like hell. Or be in a canoe. You don't paddle a cabin cruiser very fast.

But if you have to break down, Portsmouth, Ohio, isn't a bad place to do it. Why? Because the place is full of good Samaritans. A breakdown, face it, is embarrassing. A nice-looking cruiser and two guys in it splashing around, praying for help, and finally making it into the Shawnee Boat Club marina, where some members wander down, sympathize, and ask you to tie up for the night as their guests.

"Nothing to do about it tonight," says Doug Whitman, a retired Norfolk and Southern employee who now runs a bar in Portsmouth. David Spears, lawyer and municipal judge, who's at the club with his wife, Jeannie, agrees. "We'll get you something to eat and you get some sleep, and we'll find someone to work on it in the morning." Other club members wander down to view the disaster and soon a party is going.

Sure enough, early next morning Doug Whitman comes down and says a repairman is on the way. He says he'll find a trailer to take our boat to the hospital. This is unusual. Few clubs welcome itinerants and offer showers, cokes, ice, gas, phones, no matter what the trouble. A nice introduction to a town.

And not an uninteresting town. Founded at the mouth of the Scioto River in 1803, Portsmouth flourished on the sand, clay, and iron deposits nearby and on traffic from the river that was a boon until 1937, when the river came crashing over the old floodwall and almost ruined the town. There's a new floodwall now.

But in the years after World War II, the steel mills that brought prosperity to Portsmouth began to falter, and the town's growth stalled and receded. Like the people in other river cities, the people of Portsmouth have tried to find alternatives, but haven't. There are pretty homes in Portsmouth, and downtown buildings that retain their old grace and dignity. The streets and sidewalks are clean, the homes are solid-looking, the children on their way to school have a fresh, crisp look.

But there's a certain air of tired hope about towns that have seen better days and are trying hard to come back, towns where the once-fine hotel is now a senior-citizens' residence and the bank building is being considered for a museum, something to draw tourists. The best-looking buildings are old, of another era. Portsmouth is like that.

Don Walker, retired from the steel mill, now works part-time as a carpenter at Flanary's Nursing Home and wears a T-shirt advertising Doug Whitman's bar. "Doug's Place," it says. "Warm Beer, Lousy Food, No Atmosphere." Don saw Detroit Steel sell out to Cyclops, he

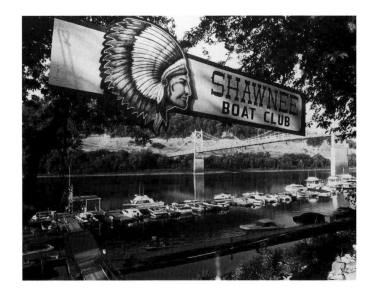

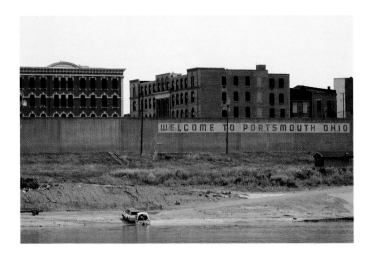

says, and saw Cyclops close down in 1980. "They put a hit on this town when they did," he says, shaking his head. "The coke plant is still operating, but that's all."

Two years back, a coal barge got loose from its tow and "just plain wrapped itself around the pier of that bridge," says Don. "Captain Beatty and a salvage crew came up and cut it in two and got it off. Wrapped around like a horse shoe. Five barges sank in all. They worked a week to get it clear. The river was up. Swift.

"I'd say the N&W [railroad] is the biggest employer now. What there is left. They've taken about 90 percent of what there was. Seems like everything is just leaving the town. Why? I don't know. It's a good town. A pretty town, good place for a town to be, up on this bluff. At one time the mill had over 5,000 working. Then in 1970 they did away with the wire mill, and in '75 with the hot strip, which took care of the cold strip, and then in '80 they closed the rest. I don't know why. People just seem to be moving on."

"Yeah, that's about right," says Doug Whitman. "Fishing's good—sauger, white perch, some bass. Every now and then you get a spoonbill. We throw them back. Pretty good town. Out in the west end, we're restoring a lot of old homes. They look real nice.

"But I tell you a funny thing. I run a bar, you know. Pretty good business. Ought to be fun, but it's usually not because these guys that hang around get in fights. I don't know why. They're good guys. Friends of mine. Just seem to be quick-tempered, ready to fight. Maybe it's just being out of work, or not seeing anything better coming on."

Up there on the bank to our left is Vanceburg, Kentucky, which has at least one distinction: According to local historians it is the only town south of the Ohio to have a statue to a Union soldier. The statue stands atop a tall marble shaft on the lawn of Vanceburg's courthouse and is adorned with the names of Lewis Countians who died in the Civil War, and with the words: "The war for the Union was right, everlastingly right, and the war against the Union was wrong, forever wrong."

Vanceburg, with a population of 2,200, is the county seat of Lewis County, which was named for Meriwether Lewis, of the Lewis and Clark Expedition. (Meriwether—a great name.) According to Dennis Brown, who runs radio station WKKS and helps out at the *Herald* when they need him, business is pretty stable and depends a lot on the United States Shoe Company, which with its component plant employs about 600 people.

"Pretty good place," he says. "Not a lot to do. People usually go down to Lexington for a big night, to see the Big Blue [University of Kentucky teams]. This is Big Blue country."

It's also hot Republican country, according to Property Valuation Administrator Wayne "Zeke" Secrest. "Al-

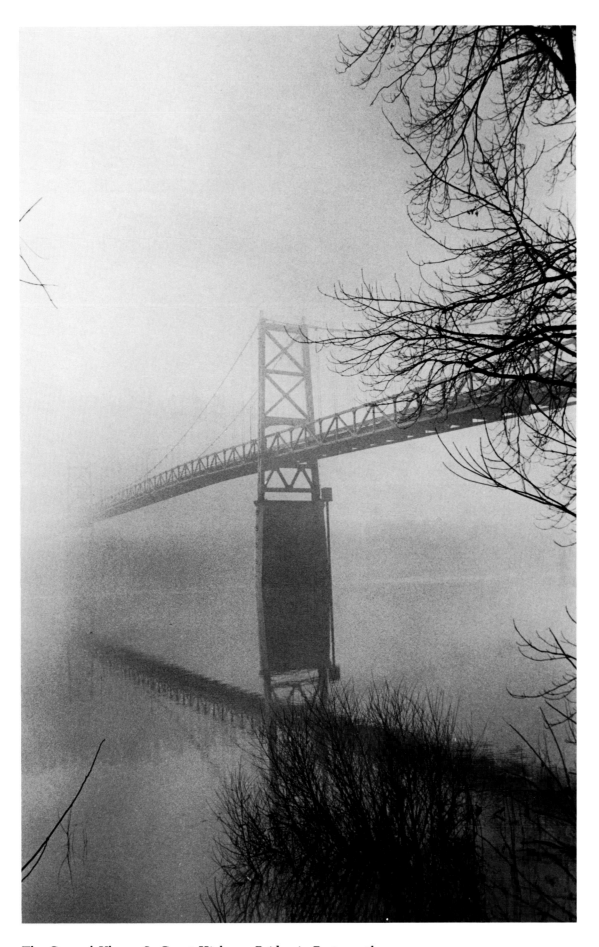

The General Ulysses S. Grant Highway Bridge in Portsmouth.

ways has been, always will be, I hope. What else is there to know? Well, the town used to be known as Alum City, from that hill across over the road there where they mined alum. And it used to have a button factory. Made buttons from mussel shells they took out of the river. Used to be lots of them." Pollution after World War II killed the mussels and ended the button business about the same time shirt makers started using plastic buttons. Progress?

We're now passing Manchester, Ohio, to starboard. You don't see a lot of Manchester from the river, but then you don't see a lot of it from the road, either, mainly because there just isn't an awful lot of Manchester to see. It was founded back in 1876 and flourished for a while on river trade, but today it's pretty much a farming community. And a comfortable place to live, according to Diana Applegate, who is city clerk and treasurer.

"The population stays pretty much the same," says Diana, "between 2,500 and 3,000. A lot of our people work out at the J.M. Stuart plant down toward Aberdeen, and at the Killen plant up the river. They're Dayton Power and Light plants. And we have our newspaper, the *Signal*. It's a hundred years old. Began in 1888.

"I guess people would say there's not a lot goes on, but then there's not much trouble, either. A little drunk driving. Kids speeding. A little burglary, some fights. There's not a lot to do here. If people want to spend a big night, they usually go down to Maysville and take the road down to Lexington. Some go to Cincinnati. Not much more to tell."

Across the river, not far from the Kentucky shore, lies Manchester Island, a good-sized island covered with big trees and with a sandy shore that slopes off sharply and makes it easy to tie up a boat. We decide to tie up for the night. Lots of good firewood and a nice beach for swimming. We cook ashore and leave some scraps from dinner, and during the night hear a weird, spooky sound, like an animal choking and trying to holler. Makes my skin crawl. We shine a light on the shore, and what looks like a large cat bounds off into the woods. We decide to wait until next morning to investigate, but find only a few tracks. Probably was a cat.

Below Manchester Island the Ohio flows gently between green wooded shores until, as we approach Aberdeen, Ohio, the four towering stacks and mammoth cooling tower of the J.M. Stuart Generating Station loom above the trees, dominating the landscape. This is one of the newer and more powerful of the dozens of generating plants that at times seem to line the Ohio. It takes water from the river to create steam power and cool the huge boilers fired with the low-sulfur bituminous coal from the hills of Eastern Kentucky, shipped to the

river and delivered by the long strings of barges now tied along the banks.

Stuart's four units, completed in 1974, can generate 2,400,000 kilowatts of electricity, enough to supply the power needs of twenty-four nearby counties. For all the production that's going on inside the hulking buildings, there's no smoke, no dust, almost no noise. Men in blue coveralls and yellow hard hats move purposefully about, checking the humming generators and turbines.

Beneath the overhang of the massive red-brick buildings at the river's edge, barges low in the water with their black pyramids of coal are pushed into place by the small tugs that take charge of them as they're dropped off by the big tows. Giant rotary scoops descend, rumbling and clanking from the plant overhead. Turning like undershot waterwheels, they scoop up the coal from the barges and dump it on conveyors. These carry it to pyramidal piles that contain an average of a million tons each, enough to run the four Stuart units for two months. The big scoops unload a 1,500-ton barge in 45 minutes. The tug then moves in, removes the empty, and pushes another barge into place.

The four units burn 5,000 tons of coal per unit each day. From the storage piles, the coal goes into a crusher where it's reduced to a fine powder. It's then pressure-fed into the boilers, where it burns at 2,500 degrees, changing water in each boiler into 4,400,000 pounds of steam. This steam hits the turbine blades, which turn the electricity-producing generators, then it's cooled by water from the river, which is discharged into a creek built for that purpose. In three units the condensed steam is recirculated for use in the turbines. In unit four the steam's heat is added to circulating water in the condenser and pumped to the 370-foot cooling tower, which can cool 216,000 gallons of water a minute, 311,000,000 gallons a day.

Water discharged through the creek is only slightly warmer than the water of the Ohio, but local fishermen say the fish, especially catfish and carp, prefer the warm water and collect around the return, especially during colder months. Local nimrods fish here in all but the coldest weather.

Even when coal is low-sulfur and burned as a powder, it gives off ash, and the three stacks are equipped with electrostatic precipitators that screen out 99.5 percent of it. The ash screened out is mixed with river water and pumped to a settlement basin where, as the name suggests, the ash settles out. The water is then returned to the Ohio.

If you want electricity, you'd better have plenty of water handy.

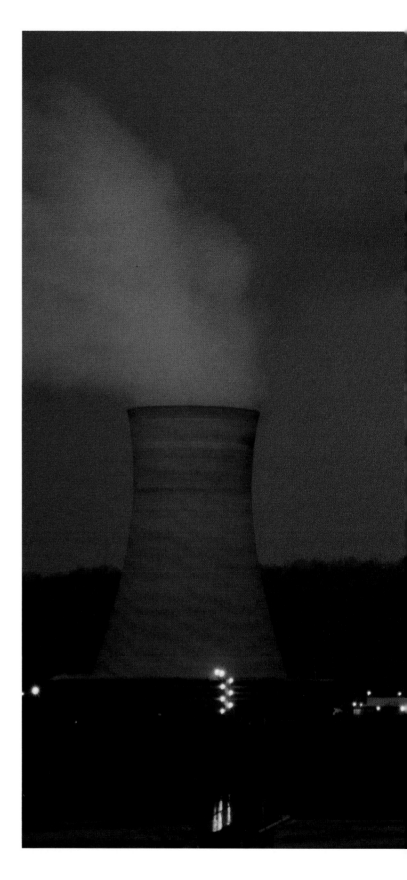

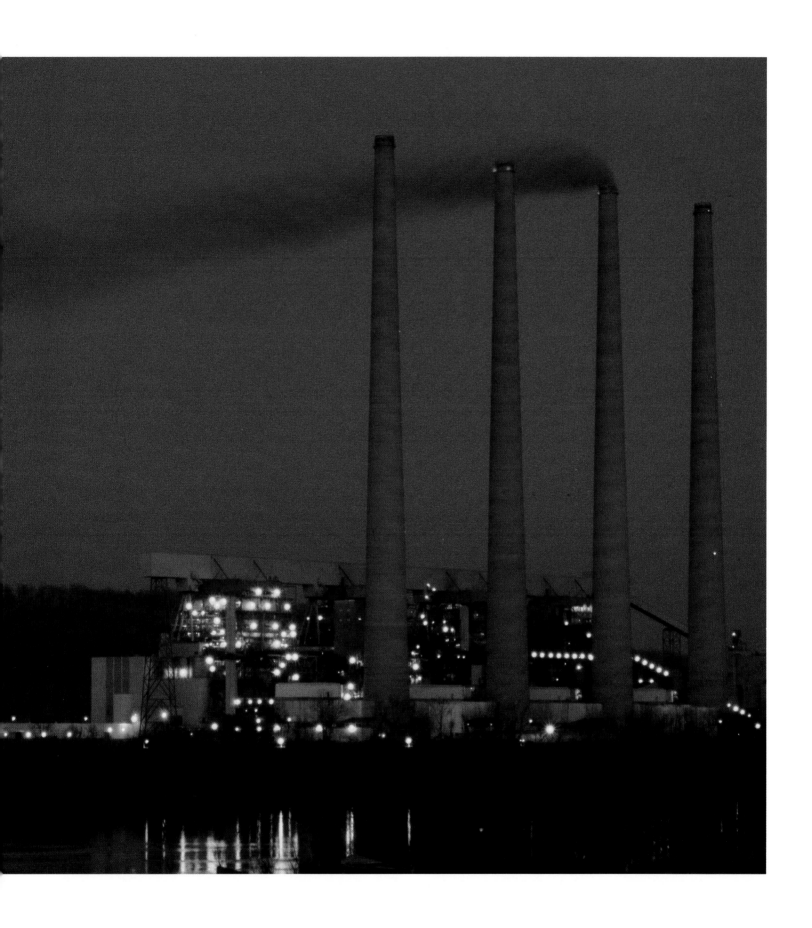

Inside the J. M. Stuart Generating Station. At right, a worker operates the giant rotary scoops (opposite page) that transfer coal from barges to conveyors, which carry it to storage piles.

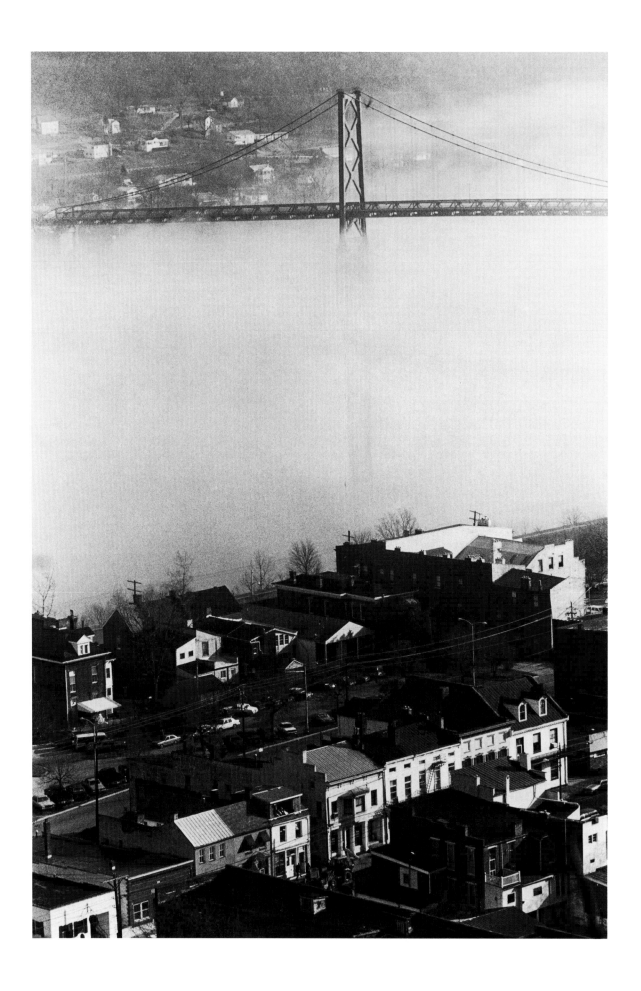

You have to go ashore to appreciate Maysville, Kentucky. From the river you can see a few houses on the hill, two or three church spires, but not much more. At the river's edge there's a park of sorts, a floodwall, little to suggest that is was an important town in the development of the frontier. But once you've walked along Main and Sutton and Court streets, seen the graceful townhouses marching up the hill, the imposing courthouse, the library and museum, you realize that Maysville is quite a town.

Maysville's relationship with the river has been a sometime thing. The area attracted its first settlers when Simon Kenton discovered a large limestone spring east of what is now the business section of town and a stream, named Limestone Creek in 1773 by Captain John Hedges. Kenton and Thomas Williams made a corn crop near the creek in 1775 and later built a fort on the hill to the south of town, though Indians burned it.

Kenton, one of the ablest of the early frontier scouts, was only a boy of eighteen or nineteen when he came to Limestone. At the time he was running away from Virginia where he thought he had killed a man in a fight over a girl. Actually, he had just knocked the man unconscious but, fearing the law, he fled into the western wilderness, changed his name and became famous as an explorer and Indian fighter, and was credited with saving Daniel Boone's life twice in a single day. He blazed a trail from the Ohio into Central Kentucky known as the Limestone Road. Lexington's Limestone Street today marks the extension of Kenton's old trail. The town, however, was named not for Kenton but for John May, who got a land grant after 1782, built a cabin where the town now stands, and saw a settlement take shape.

For years after it was incorporated in 1787, Maysville played second fiddle to Washington, which lies a few miles to the south beyond the top of the hill on the slopes of which Maysville is located. At first glance, Maysville appears to march down the hill to the river, but in fact it started at the river's edge and moved up toward Washington. Then, as the steamboat revolutionized commerce, Maysville marched back down to the river and became a major port.

But with the coming of the railroads, the decline of the steam packet, and the growing importance of the automobile, Maysville lost interest in the river, especially after floods wrecked much of the lower town. The floodwall now protects the town but in a sense cuts if off from the river, though a park is now being developed east of town, there's more interest in boating, and Maysville is again turning its face toward the river.

Maysville is an unusual town in small ways. When the town wouldn't start a zoo, businessman Andy Duke started his own. Quite a zoo. And women play a big part in things in Maysville. Kitty Hutchins runs an unusually active library. Jean Calvert runs the museum and can

recite local history by the hour. For years the local newspaper was run by Martha Comer, and she and Mayor Harriett Cartmill fought like dogs and cats. Most people have forgotten what they fought about. But it's good to have the mayor and the editor fighting. Keeps things stirred up.

For years Maysville was full of talk of getting a new motel and widening the bridge across the river to Aberdeen. They got the motel, but the bridge is the same old bridge. There's a lot of traffic between Maysville and Aberdeen; people from Aberdeen work over in Maysville, and a lot of Maysville people work upriver at the Stuart generating plant. A lot of Kentuckians still cross the bridge to take the Ohio road down to Cincinnati, insisting that it's better than the one on the Kentucky side. This gripes the people of Maysville. They say Kentucky promises every time there's an election to improve the road to Cincinnati, but no one ever does.

If you remember *Uncle Tom's Cabin*, you will recall how Eliza escaped from slavery in Kentucky to freedom in Ohio by crossing the frozen Ohio River, leaping from one ice floe to another until she made the northern shore. Ripley, Ohio, is supposed to be the spot where she went ashore, and there is some foundation of fact under the legend. Sometime before the Civil War, the Reverend John Rankin came from Tennessee and built a home on a hill overlooking Ripley and the Ohio, and at the top of the hill placed a light to guide runaway slaves to his home, which became an important station on the Underground Railway. Federal law at the time required anyone finding a runaway slave to return the slave to the owner, and anyone caught assisting the slave could be jailed for a long term. The slave would almost invariably be whipped.

One of Rankin's more touching stories is that of a young slave mother who reached the frozen river in the bitter darkness of a winter night, clutching a baby to her breast. Though the ice threatened to break at any moment, she saw the light at the Rankin home, waded out onto the melting floes, and made her way to the Ohio shore and the Reverend Rankin's hilltop home, where one of his sons led her through the night to safety farther north.

Harriet Beecher Stowe, who wrote *Uncle Tom's Cabin* is said to have visited Washington, just south of Maysville, where she heard stories of the escaping slaves and saw families torn apart when slaves were sold to different buyers. She was so outraged by the inhumanity of the practice that she wrote the book that stirred the sympathy of a nation for the slaves and helped to bring on the Civil War. In Eliza, the young slave mother gained a measure of immortality.

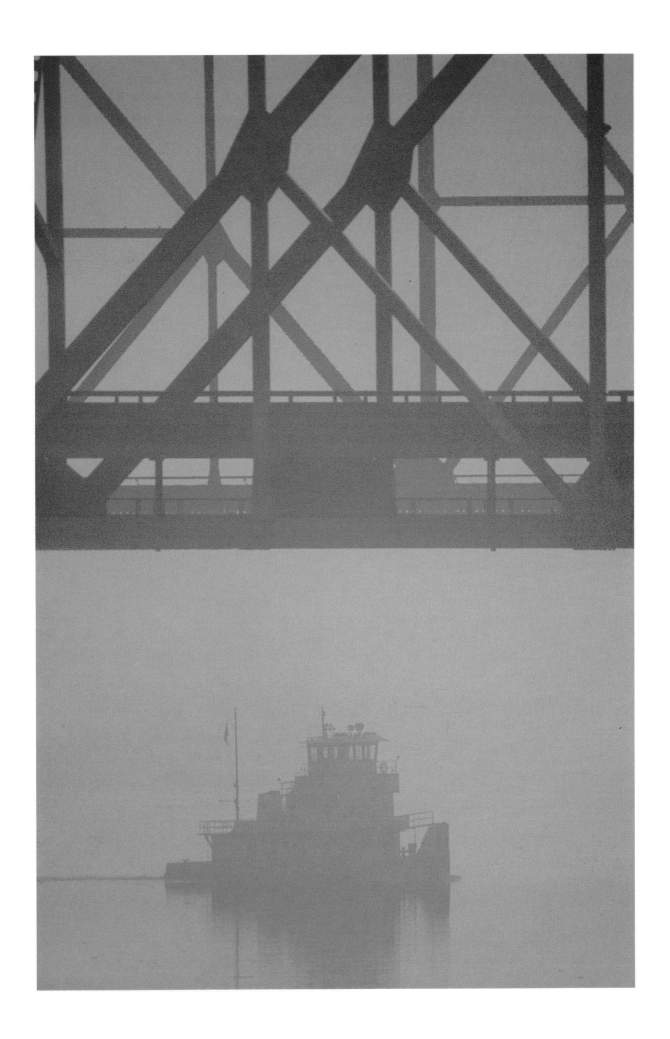

Gertrude Schweier and her home, the Robert Davis
House, built in 1797.

A couple of hours downstream from Maysville, Augusta appears suddenly on the Kentucky shore, and from a certain angle it looks as if it had sprung, full-blown, out of the early nineteenth century. On Riverside Drive, which runs along the bluff overlooking the Ohio, stands a two-block row of renovated historic homes, so reminiscent of earlier river days that the town has twice been used by movie companies to portray Mississippi towns of the Mark Twain era.

Beshear's Tavern, toward the end of the street, is said to be the first three-story residence in Kentucky, for what that is worth, and behind it stands a log cabin said to have been the home of Simon Kenton. The Marshall House, at 205, was the home of W.C. Marshall, grandfather of General George Catlett Marshall, World War II army chief of staff and author of the famed postwar Marshall Plan for the reconstruction of Europe. And at 203 West Riverside stands the Robert Davis House, built about 1797. It's in the Davis House, or at least half of it, that Gertrude Schweier runs the last surviving riverside boarding house.

"Robert Davis, founder of the town, got into debt and had to sell the house," Gertrude recites in practiced fashion. "Two families bought it and built that brick wall there to divide it. I guess you could say this house and the house next door are both the Davis House, but I say this is the Davis House.

"My husband was disabled in the war, so we couldn't farm, you know, so we moved into town. We rented this place at first and took in boarders, most of them river people, starting in when? Slips my mind. And then I've had the Rotary Club every Monday night for eighteen years. They have dinner and meet here.

"I bought the place in 1960. I've got nine beds and charge twelve dollars a night. I think that's fair, don't you? Not too much, I don't think. Fair. But I don't get many boarders any more. Last I had was two men with the Highway. It's handy, you know. No place but this to stay between here and Maysville. Augusta isn't very big, you know. How big? Not very. Small enough that everybody knows everybody else's business, or thinks they do.

"Here. Here's a clipping from the *Cincinnati Enquirer*, back in 1984, see? Says Schweier's Boarding House draws river folks and has a sign—that's it right over there—says, 'If you don't like what's on the table, go home and eat.' That's what it says.

"See what this clipping says. 'It's a tradition for towboats to sound a horn when passing,' and that's right. At least they used to. I used to know all the rivermen. Captain John Beatty, oh, he's an old friend. And Captain John Smith; he's with Captain Beatty. So nice. Full of fun.

"Tourists? Yes, we have some, quite a few, especially since all these senior citizens are loping around like they do. There goes a tour bus now, just full.

Marietta, Ohio

"Oh, well, but things aren't like they were on the river, are they? No. Nothing's the same. Sometimes I wish things could be a little more like they were. Not a lot, just a little. Floods? Oh, I've seen a lot of floods here. When they were building Markland [dam] the river came up over that mantel there. I've seen it in this house three times, as I recall, and I can tell you this, I don't want to see it any more. I'll tell you the truth of it, I've seen all of that river I want. That river just puts a damper on things. The young folks don't seem to care for it, and the old folks, well, I'd say they got tired of fighting it, that's all. It's nice to look at if it isn't in your front room."

The Rotarians like to eat, and Gertrude doesn't send them away hungry. When she loads the board, it groans—fried chicken, mashed potatoes, sweet potatoes, cream gravy, tomatoes, cucumbers, salads, hot rolls and butter, apple pie, ice cream—the works. "I like to cook," says Gertrude.

Here at Augusta, Confederate General Basil Duke in 1863 led his forces to a collision with those of Colonel Joshua Bradford and beat them, but with such a loss of men that he was forced to give up his plans to attack Cincinnati. Stephen Collins Foster, who wrote "My Old Kentucky Home," "Swanee River" and other sentimental ballads, is said to have stayed in Augusta for a while. Perhaps he did, although if Foster stayed everywhere he's reported to have stayed, it's no wonder he drank a lot and never went home.

Augusta has another distinction, too. It has one of the last surviving ferries on the Ohio, running from the foot of Water Street across the Ohio to Brooksburg, Ohio. The *Ole Augusta*, under Captain Donald Brevard, runs every half-hour, more or less, carrying as many as four cars or two trucks and, at reduced prices, anyone who happens to be afoot.

The trip takes about ten or twelve minutes and affords a great view of the Ohio. Lean, tanned, and tow-headed, Brevard doesn't find it monotonous. "It's a good job," he says. "I've done lots of things, but I'd rather do this. You meet lots of people, most nice. I try to accommodate them. If I see someone waiting on the other side, I'll go get him, even if I don't have a fare. Rather have a fare both ways, of course.

"In winter you have to be a little careful, not let the decks get slick, but we can run in most kinds of weather. If the water gets too high for the cars to get on, I just run up one of the creeks and tie up until the water goes down. What do I do if I get in the way of a big tow? I don't get in the way of a big tow."

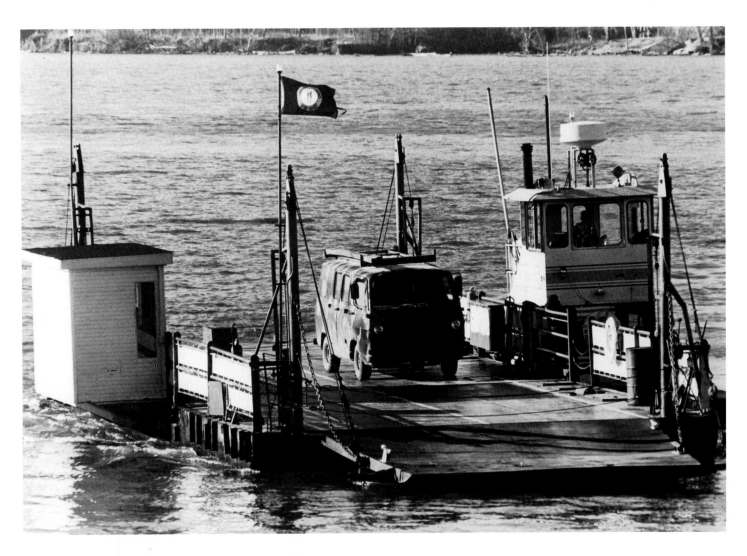

Captain Donald Brevard and the Augusta Ferry, one of the few remaining ferries on the Ohio.

Lock 35, just above Cincinnati.

Here, on the right bank a few miles above Cincinnati, stands the Zimmer nuclear-power generating plant, a monument to one of the more bizzare sides of the American character. It's a massive and beautiful thing, one of the most intricate power complexes ever devised by man. It took years to build and cost billions of dollars. And it does nothing. It produces nothing. It stands idle. But not, perhaps, for long.

Zimmer doesn't operate for any number of rather abstruse reasons having to do with the question of how it should be operated to be safe. We need the electricity, and our other means of producing it—coal, oil, gas, and water power—are running out. And here this thing is, the distillation of our knowledge, the fires of the universe harnessed for our use. And like other nuclear power plants around the country it stands idle. We shudder at this issue of our minds as at monster children we produce to our horror, unable to control or to trust what we devise, as we are unable, in the final reckoning, to trust each other or ourselves.

But plans are under way to convert Zimmer to coal- or oil-fired furnaces, and the impressive plant may soon be doing what it was intended to do—producing electricity.

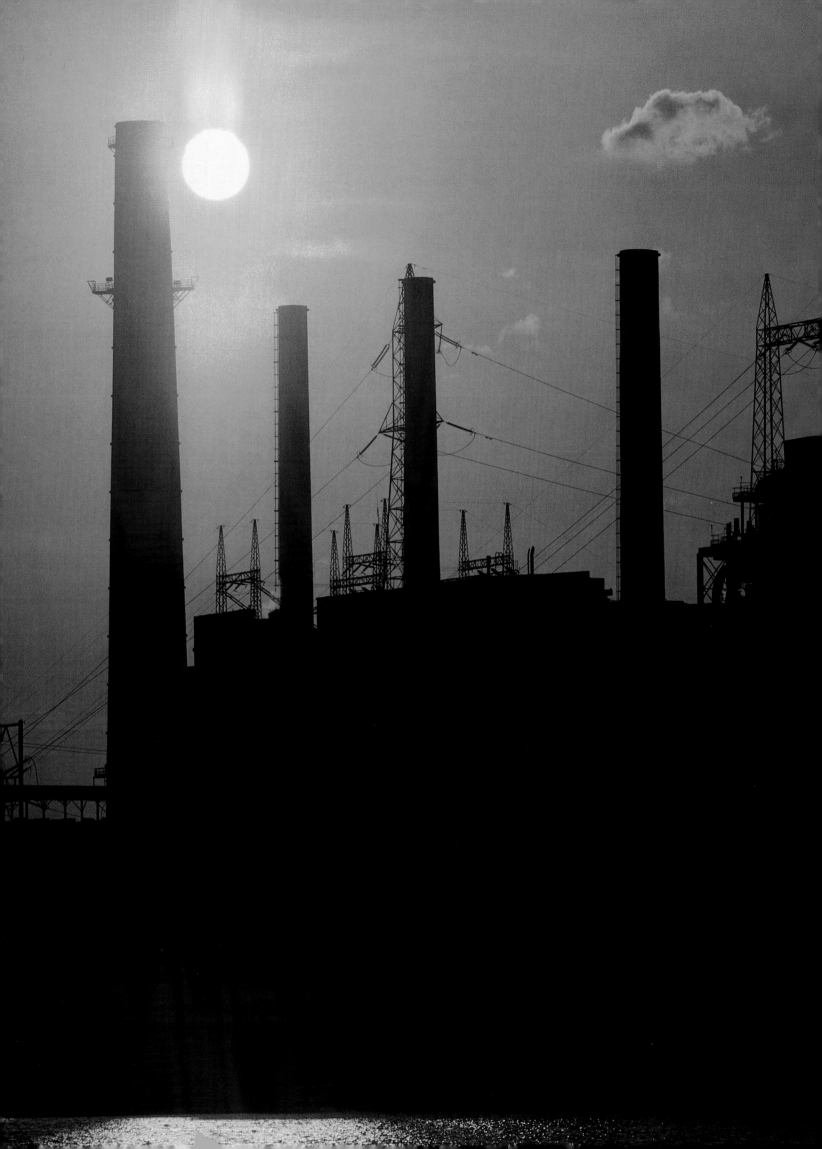

Cincinnati, Ohio, takes advantage of its position on the river. Its waterfront boils with excursion boats, towboats, pleasure boats, and, across the river, restaurants that are boats. It has a huge municipal wharf where people eat lunch, watch the traffic, or attend such outings as the Tall Stacks Celebration, which features sternwheelers, most of then diesel-powered. Riverfront Stadium, where the Reds and Bengals play and citizens from up and down the valley become maniacs, looms almost on the river's edge.

This is as it should be. Cincinnati was born on the river and grew up because of it. In 1788, only a year after Marietta was founded, John Cleves Symmes established a settlement known as Losantiville, a name coined by eccentric Kentucky teacher and historian John Filson. Supposedly Filson used words from several languages meaning, according to one version, "the holy town," according to another "the town opposite the mouth" of the Licking River. Filson shortly afterward strolled off to the north and was never seen again, probably the victim of Indians. The name he coined didn't last long either, thanks to a General St. Clair, a member of the Order of Cincinnatus.

Cincinnati quickly spread along the river and up the surrounding hills, thanks in large part to river traffic. With the development of the steamboat, growth of river traffic was almost incredible. By 1840 boats traveling the Ohio and Mississippi carried only 3,000 tons of cargo less than all the ships of the British Empire. In that year England had 770 ships; 536 boats plied the western American rivers. In 1852, 8,000 steamboats arrived at and departed Cincinnati, almost one an hour, and the town became a major shipper of whiskey, flour, and pork. Indeed, meat-packing was such an important part of the growing city's economy that it was once nicknamed Porkopolis, and when the city celebrated its two-hundredth anniversary in 1988, officials commissioned a statue featuring a group of four happy, winged pigs as a centerpiece for the ceremonies. Several groups, apparently embarrassed by their proletarian, pork-packing antecedents, objected, but the pro-piggers prevailed, and properly; despite the piffling protesters, the pedestaled pigs proved particularly popular. Pig T-shirts, pig statuettes, pig souvenirs of all kinds sold like hot dogs, and the statue now has a permanent home in the Bicentennial Commons, Vox porci, vox populi.

Passenger traffic kept pace. The *Joe Fowler*, built in 1888 and later named the *Crescent*, carried 152,400 passengers a total of 327,000 miles during its sturdy career, and Cincinnati became a busy passenger port. Among the better-known travelers who stopped off were Charles Dickens, who declared it the most beautiful American city outside of Boston, and Henry Wadsworth Longfellow, who named it the Queen City of the West, a title still in some use.

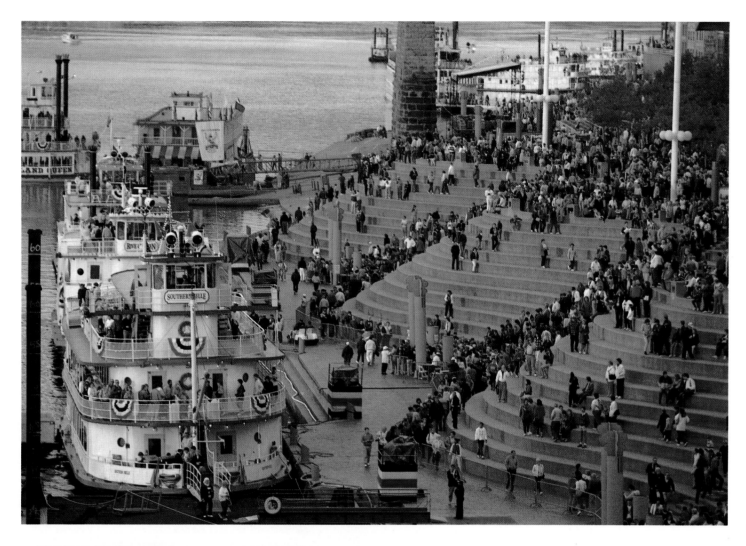

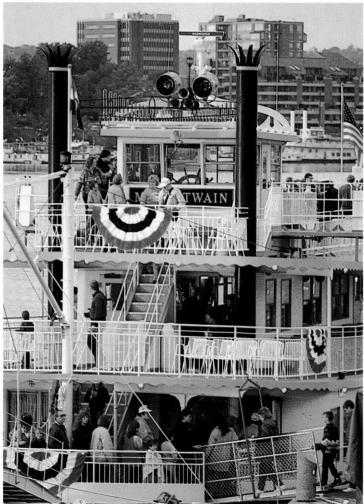

The Tall Stacks festival in October 1988 brought more than a dozen riverboats to the Queen City landing as part of Cincinnati's 200th birthday celebration.

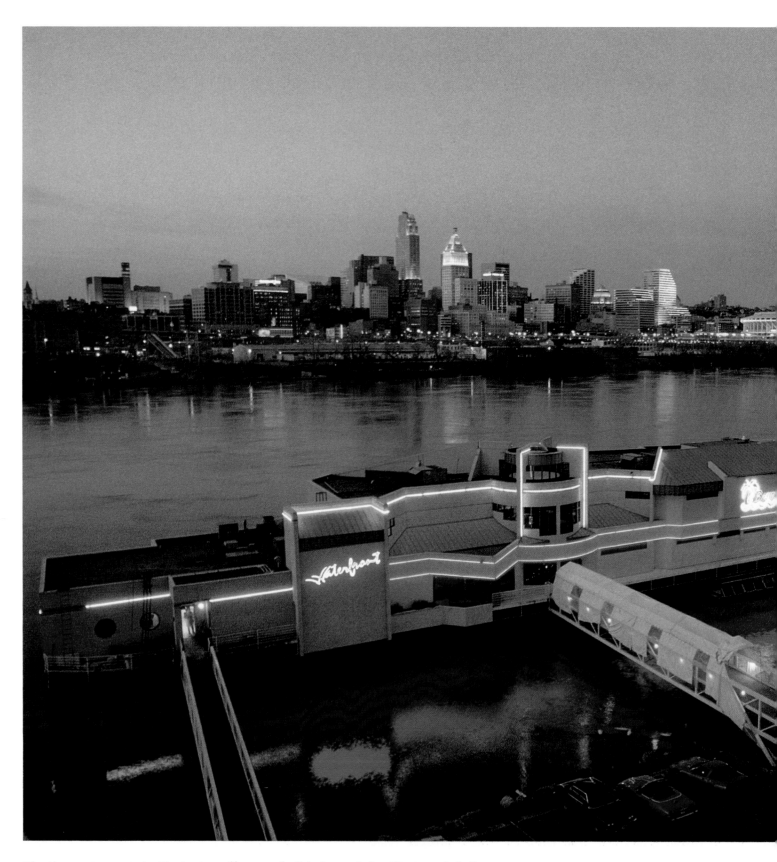

Floating restaurants in Covington offer wonderful views of the Cincinnati skyline.

Not all experiences with the river were so pleasant. In 1838 the *Moselle*, a brand-new packet, took on passengers at Cincinnati, pulled out into the stream, and promptly blew up, killing 150 people. The boiler explosion was so violent that the body of the pilot was blown clear across the river, landing on the Kentucky shore. As late as 1922, six closely-packed boats awaiting departure at the wharf caught fire and burned to the water.

Such disasters were not confined to Cincinnati. At Pittsburgh, the *Island Queen* exploded and burned at the dock. Near Warsaw, Kentucky, on the night of December 4, 1868, the *America* and the *United States*, luxury sister ships belonging to the same Cincinnati company, collided and burned, with great loss of life, apparently because the pilot of the upbound *America* misunderstood the signal of the downbound *United States*, turned from the channel on the Kentucky side, and rammed the *United States*. There was a story at the time, since become legend, that a U.S. senator aboard the *United States* was thrown into the water, calmly swam ashore, caught a train, and was back in Washington in time to read of his tragic death in the accident.

Cincinnati today is a many-faceted city and something of a regional tourist haven, known for its food, shops, athletic teams, and cultural events. Fans from Kentucky and Indiana, as well as Ohio, pack Riverfront Stadium to watch the Reds and the Bengals, and about as many come to hear the Cincinnati Symphony Orchestra or see performances of the opera in stately Music Hall. (For years before Music Hall was renovated, the opera, known as the Summer Opera, played in the amphitheater of the Cincinnati Zoo, often to the accompaniment of the nearby animals. The producers of *Aida* complained that they couldn't get the fool lions to roar on cue.) Now in the summer the Symphony Pops Orchestra tours valley towns, and the Symphony offers outdoor concerts at Riverbend, a park upriver from the downtown area. The showboat *Majestic* still offers performances of melodramas on the waterfront, and Riverbend presents frequent rock concerts; the acoustics are so good that hundreds of boats line the shore.

But to a lot of people Cincinnati means primarily food. Only San Francisco has more four- and five-star restaurants, and Cincinnati's La Maisonette has had five stars longer than any other restaurant in America. It's not for penny-pinchers. But while the tab is high, the menu, the wine list, the ambiance, and the service justify it. An experience. Pigall's is only slightly behind, as are the Celestial on Mt. Adams, the Gourmet Room atop the Terrace Hilton, LaRonde, and the dining room of the Cincinnatian Hotel. For something less expensive but very good, there is La Normandie, downstairs from La Maisonette, and there are several restaurants that boast of their chili. Cincinnatians claim the world's best chili;

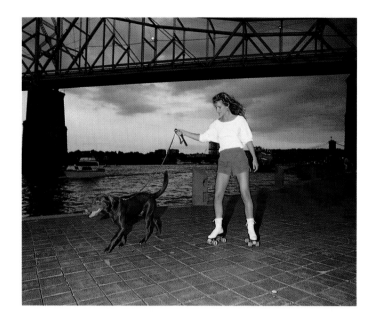

so do the people of Knoxville, Tennessee, though in the opinion of experts any of it is capable of producing a proper heartburn.

But every day, noon and evening, hundreds hurry across the Ohio to floating restaurants on the Kentucky side. Why do they prefer the Kentucky side? Because it offers fine views of the Cincinnati skyline, especially at night. The Mike Fink at Covington and Crockett's on the Newport side are first-rate. Mike Fink, in case you're dying to know, was born at Fort Pitt in 1777, worked for years on flatboats, and garnered a reputation as a brawler. His favorite boast was, "I'm a Salt River roarer, half horse and half alligator. I can outfight. . . . " Historians have concluded that much of the Mike Fink lore, like that of many other frontier characters, was invented. Fink later drifted out West and became a trader.

Cincinnati offers variety—a great zoo, four first-class museums, and a fine nature park. Mount Adams, just north of downtown, is an artsy-craftsy center with good restaurants, interesting galleries, and apartments offering splendid views of downtown and the riverfront, though not at give-away prices. An extensive regentrification of the somewhat rundown and low-income region along the river west of downtown has converted hundreds of units into desirable and sought-after upper-middle-income apartments with river views. This has not delighted the previous occupants, who say they were forced out of housing they can no longer afford.

But one thing that makes Cincinnati special is the fact that it has not let suburban malls destroy its downtown. Fountain Square is the real heart of the town and gives it a distinctive character. Office workers sit around the fountain and eat lunch. Mobs form here to welcome home the Bengals from the Superbowl. It is a gathering place after concerts. And it is in the center of a very much alive downtown that offers antique shops, men's shops, women's specialty shops, department stores, hotels, theaters, and restaurants. And shopping is made more comfortable by the skyways, many air-conditioned, that connect the stores. It is a convenient town with a lot to do, a lot to see.

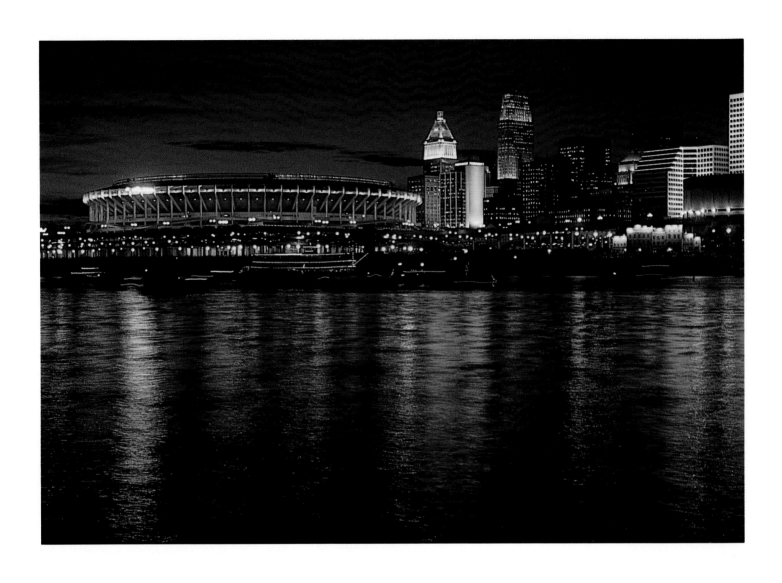

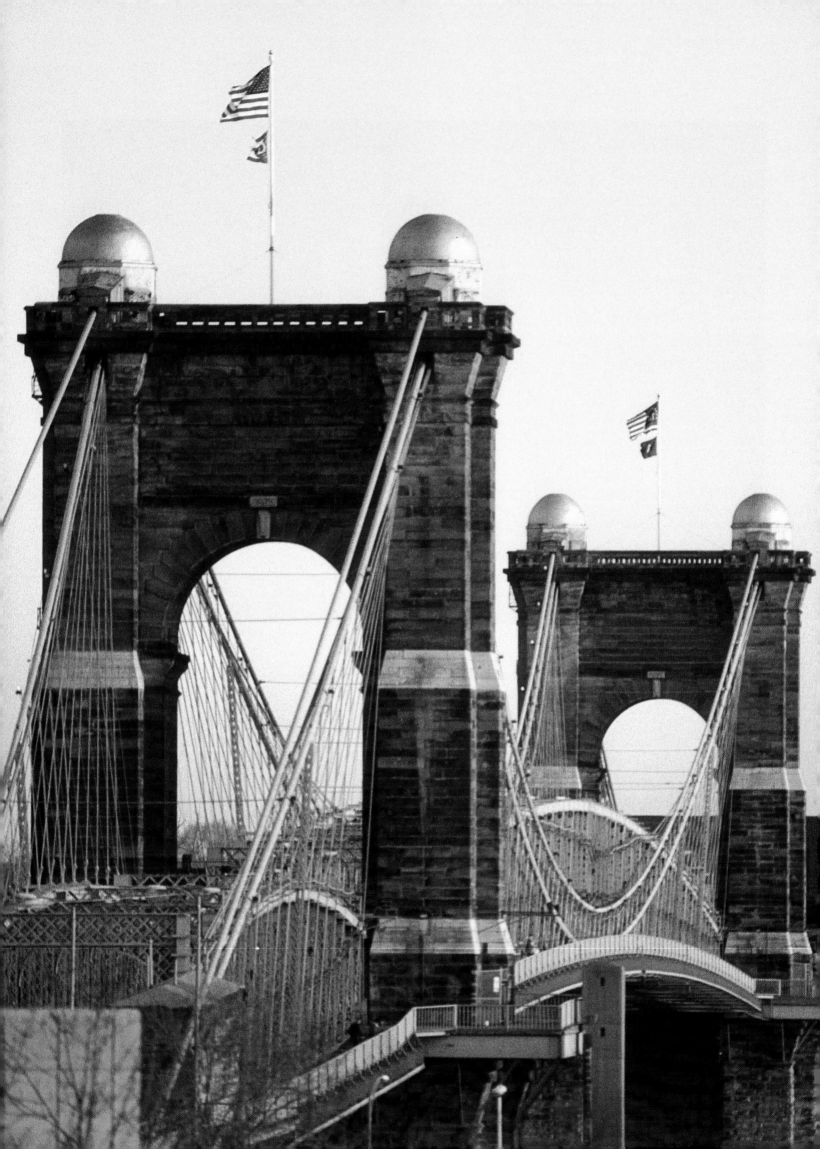

Covington, Kentucky, had the soggy fortune to be located across the river from a much larger city and was thus doomed forever to be referred to as "the town across the river from Cincinnati." It deserves better.

The Covington area was settled at about the same time as Cincinnati but for some reason didn't grow as rapidly. Like Cincinnati, it was largely shaped in its early years by German immigrants and still shows the German influence. A lot of the old breweries that used to characterize the town have gone out of business or been bought by bigger firms. But the center of town, which has been spruced up in recent years in an effort to attract new business, is known as the Mainstrasse and features such things as a bell tower with mechanical figures that used to come out every hour and enact a version of "The Pied Piper of Hamelin." It has been out of operation for a while but may be back.

More impressive are the two churches for which the town is noted—the Basilica of the Assumption, which is sort of a smaller Notre Dame, and Mother of God church—and a startling collection of beautiful old homes that have been restored and that represent some of the finest American architecture.

The heart of the four square blocks of old homes, all on the Register of Historic Places, is Riverside Drive, just above the river and east of the Roebling suspension bridge. This is interesting because the homes, most of them built by prominent merchants in the middle of the nineteenth century, slowly deteriorated until the neighborhood became almost a slum. Then a group of Covingtonians, including architect John Kunkel, began buying the old homes, which were still structurally sound, and renovating them, refurbishing them, and turning them into apartments, duplexes, and single dwellings. A walking tour of the area is popular, though the homes are private residences and not open to the public.

Homes along the river are increasingly popular with young professionals from Cincinnati looking to Covington for reasonable housing not far from downtown Cincinnati by way of the historic Roebling Bridge. The bridge has, of course, a history. There was a storm of opposition when it was first proposed. Rivermen saw its piers as a hazard to boats. The people of Cincinnati objected wildly, fearing that too many of their fellows would flock across to cheaper real estate. They would not approve a straight approach from downtown to the bridge, fearing the easy route would tempt too many Cincinnatians to stray. Engineers swore a suspension bridge would collapse (as a prior Roebling bridge across the Licking River from Covington to Newport had done). But Roebling persisted, finally getting both backing and permission, and the bridge opened in 1866. It not only proved safe and, to this day, serviceable, but was the prototype for

The Mother of God Church, Covington.

Opposite: The Roebling Bridge, completed in 1866.

an even more famous bridge Roebling built soon afterward—New York's familiar Brooklyn Bridge.

Covington has benefited in recent years, too, from the clean-up of its neighbor across the Licking River, Newport. Until the 1960s Newport, serving the purpose of so many smaller towns across the river from a larger one, was known as sin city. Self-professed decent citizens, led by ministers, waged vocal, if not especially effective, war against whole blocks of downtown where, they charged, local law officers looked the other way while night spots offered gambling, strip shows, after-hours booze, and young girls willing to sell that which was nearest and dearest to them for the money of lustful men.

It was not a one-sided battle. Conventioneers would assemble in Cincinnati, conduct their business, and then stream across the river in the late hours to spend money on entertainment, and the entertainers did not give up their income without a tussle. In time, of course, purity won out, the soiled doves of evening were put to flight, and decent women and other church folk could walk the streets of Newport without fear of untidy incident. The reformers triumphed despite an embarrassing episode in which the reform candidate for sheriff was found in a compromising position with an exotic dancer by the name of April Flowers. To admiring reporters, Mlle Flowers displayed, among other things, a Kentucky Colonel's commission acquired for her by a devotee of terpsichore.

It all blew over and purer days followed, the dullness broken for a time by a mayor known as Johnny TV Peluso, a colorful entrepreneur who had unusual ideas for promoting tourism and business in Newport. His career went into eclipse, sad to say, when the law put the arm on him for unusual accounting procedures and he was obliged to withdraw from public life.

Ah, yesterday.

We've been following the Ohio River with the state of Ohio on our right since East Liverpool, almost 450 miles upstream, and before we say farewell to beautiful Ohio and hello to Indiana, let us salute North Bend, Ohio, there on our right. Not many people do. North Bend tends to get lost among the larger towns surrounding it, but it is noteworthy for one particular reason: two presidents of the United States were born or lived in North Bend. William Henry Harrison moved here from Virginia. His grandson Benjamin, also president, was born here. And now, forward to Indiana.

The pleasant town of Aurora, Indiana, just a few miles downriver from Lawrenceburg and Petersburg.

The river below Cincinnati is what you might call busy—Sedamville, Bromley, Riverside, Constance, Andersons Ferry, Stringtown, two railroad bridges, two highway bridges, Delhi, Fernbank, Addyston, North Bend. Then relative quiet for about nine miles before Lawrenceburg, Indiana, appears on the right bank, and on the left Petersburg, Kentucky, just below a couple of railroad bridges and the span for I-275.

Lawrenceburg, just over the Indiana line, is a substantial town, and its waterfront is lined with huge distillery warehouses and industrial buildings. Petersburg is more modest. Indeed, Petersburg is not the metropolis of Northern Kentucky. You hardly notice it from the river, and there is no one in City Hall to give us official figures on the town's size or population. In fact, we can't find anyone at City Hall. Are you sure this is City Hall? Well, that's what the woman said.

"A wild guess, I'd say 500 people," says Darleina Abdon, who holds forth behind the meat counter of the Petersburg General Store, which seems to be somewhat the center of activity. Darleina seems to know what she's doing, slicing cheese and ham, selling chicken salad ($2.89 a pound), and cole slaw (89 cents) while carrying on a running conversation with two customers and handing out information. "It's grown lately. They're putting in those condominiums down the road there about three miles. We get some new people every now and then."

Phyllis Hodges, who owns the store, is a Petersburg booster. "I like it here," she says happily. "Moved here from Florence. Most of our people work in Florence or Cincinnati. We're only thirty, forty minutes from Florence. Or they farm.

"Petersburg was the first settlement in Boone County, you know. We think we're probably a little older than Cincinnati. We're celebrating our two-hundredth anniversary. The town was built on a big Indian settlement. You can still find Indian mounds out on the river bank.

"We've been a lot bigger than this. We had the first telephone in Boone County, the first library, first elementary school. It closed two years ago. It's a community center now, the building. Did you see the big white house on the hill where you come into town? That was finished two days after the end of the Civil War. This was the biggest town in Boone County then, and we had a distillery, three grocery stores, three restaurants. Steamboats used to land here. There was a lot going on.

"What happened? Who knows? They taxed the industry too heavily is a guess, and they moved out. Then the river traffic slowed. It's funny. We used to have a doctor, a barber, a millinery shop, two taverns. We were a real town.

"And we're working to get it back. People are moving out of the big towns, you know. They prefer the quieter, more secure life of the small town—if it isn't too far from

the things cities offer, and we fit that description. Thirty minutes from Cincinnati, all of the way on I-275. It's a real nice place to live."

Why are we stopping here? The only thing in Belleview, Kentucky, that catches the eye is the bank on the street leading to the new Charles Kelly School. It's the name—The Fifth Third Bank. How can you have five thirds? Or were there four Third State Banks here before this one? "Where," I ask the lady in the teller's booth, "did that name come from? How can you be the fifth third? Are you the Third National Bank? Third State Bank? The fifth Third State Bank in the state?"

The teller regards me as though I were simpleminded, which may be the case. "No," she says. "It used to be the Boone State Bank, and it got merged with the Fifth Third Bank of Cincinnati. So now it's the Fifth Third Bank of Boone County."

"Oh." Well, that settles that.

Notices tacked in front of the teller's window inform anyone interested that the restaurant needs a cook—thirty to forty hours a week, $3.75 an hour. Also a dishwasher.

"You come back," says the teller.

Lawrenceburg, Indiana.

From the river, Rising Sun—the Indiana town, not the daily occurrence—catches the eye, a long row of old, stately homes situated on a high bluff. That is mainly what you see from the river, and it is very impressive, like a little antebellum city stuck off by itself.

There is also a park along the river, and people in the town are trying to revitalize Main Street, according to Cathy Hastings, who works at the newspaper office.

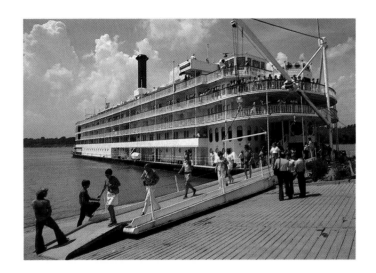

"We've got some things going," she says. "Excursion boats out of Cincinnati bring in tourists from May to October, and we have a power boat regatta, trying to build tourist business. But generally, we're a farming community. I'm not a native, though. If you want to know about the town you better go see Helen Ray."

She is right. Helen Ray lives in a dignified restored home on what was once Main Street and is now Front Street, one of the row of homes facing the river, and knows a lot about the town.

"The town used to sit on both sides of the street," says Helen Ray, who turns out not to be a native, either, but from New Jersey by way of North Carolina, but who admits to knowing about as much as most people about the town.

"How big is Rising Sun? Oh, about 2,500 people when they're all home in their own beds," she says. "It used to be bigger. There was a woolen mill, a grocery, a blacksmith shop, a bakery, a rooming house—you know, the usual businesses—all over on that side of the street," she gestures toward the bluff overlooking the river. "But when Markland Dam came in, the river level went up and a lot of the bank fell off. Then when they let the wickets of the dam down, the current just sucked the earth from the banks, here and across in Rabbit Hash. Then the flood of 1937, it hurt both towns. Bad. It's hard to believe that the river was five feet deep right here in my house, as high as it is.

"Well, the government put rip-rap [a carpet of large rocks] on the Rabbit Hash side, but we can't get them to do anything about us over here. Don't ask me why. We've lost as much as fifteen feet of the bank here in a single year. We have talked to the Corps of Engineers until they know us by our first names, but they just say we don't qualify for help. We're dumping creek rock along the bank, trying to hold it, but as you can imagine, it takes an awful lot of creek rock to make any impression on the river.

"Rising Sun was an Underground Railway stop during the Civil War—you know, a place where they'd smuggle slaves from the South to the North. They came ashore at night down there at the foot of Fifth Street and were smuggled through tunnels leading under or through these houses right here.

"This was Indian country here, too. They've done a lot of archaeological digs around here. There were mound builders. And our courthouse is being restored. It was

built in 1832 and is the oldest courthouse in Indiana in continuous use. Nearly every one of these homes along Front Street here has a history. My house was built by Shadrach Hathaway—now there's a name for you. Wonderful architect. It was once a post office and then a funeral home.

"How did the town get its name? I knew you would ask that. Everybody does. I don't think anybody knows. Some say when the first settlers came here they landed during a rainstorm that lasted for days, and they pitched their tents to wait it out. Finally one morning the sun came up all big and drying things up, and they hailed the bright sun as an omen. That is probably just legend. I always say we got our name from the same place Rabbit Hash got its. Nobody knows."

It's easy to get from Rising Sun to Rabbit Hash, Kentucky, if you have a boat. It's a long swim if you don't. Rabbit Hash consists principally of about a dozen homes, some of them quite attractive, the General Store, and the name, which prompts about as many questions as that of Rising Sun.

"Yes, everybody wants to know where the name came from," says Mrs. Sally Scott, who is running the General Store. "I don't think anyone knows, really. Here," she points to an old newspaper article tacked to the wall beside the front door, "this is one version." The story says that Mr. Meeks, who ran the ferry here, told some men from Cincinnati that the flood had run all the rabbits out of the bottoms and up into the hills, where people were killing them to eat. About the only thing you could find around to eat after the flood, said Mr. Meeks, was rabbit hash. The men decided to call the place "that rabbit hash place."

There are other versions, one about as good as the next.

"Rabbit Hash used to be a lot bigger," says Mrs. Scott, shaking her head. "There was a whole row of houses, buildings down by the river, but the flood of 1937 just wiped the town out, washed that whole street away. You couldn't tell all those places were ever there. And they just never built back. The people who ran this store, for instance, just closed the door and walked out. People just didn't want to risk that experience again."

(The flood of '37. There used to be a row of houses there. We used to be bigger. After that, the town sort of died down. How often have we heard the words along this river? The river giveth, the river taketh away.)

"We used to have a ferry that ran to Rising Sun. When I was a child we had a doctor, a dentist, a barber. It was a regular town. Of course, everything was different then, even the river. Before Markland Dam was built, they raised crops on the bottomland that was where the river is now. The dam flooded it.

"There's a funny story about the town's name. In 1879 the U.S. put a post office here and named it Carlton. I don't know how they chose that name. Maybe someone in the Post Office Department was named Carlton. Anyhow, they found that all of the mail intended for here got sent to Carrollton because the people around here pronounced Carrollton Carlton. The U.S. had to change the name back to Rabbit Hash, and it's been Rabbit Hash ever since. It brings in a lot of people we wouldn't get otherwise. Not much business, but some nice visitors."

If you would like to visit Warsaw, Kentucky, which isn't a bad idea, your best bet is to go downriver about a mile west of town and go up Craig's Creek to Dan's Marina. You can get gas, ice, whatever, at the marina. Dan's Restaurant is just across the road, and it's a short walk along U.S. 42 into town.

Dan's Restaurant has a good smell, a fine view of the river, and a happy-looking manager named Joy Higgins. "How you doing?" calls Joy. And you're doing better, especially after sausage and biscuit, and coffee with personality. It appears popular with the customers, who are arguing about the road that runs across the top of Markland Dam from Kentucky to Indiana.

"Built about seven years ago," says a blonde young man at the counter. There's a murmur of dissent. A tall, solidly-built man, smoking a pipe, comes in and sits down. "Built three years ago," he says. Everybody nods. The man with the pipe is obviously somebody.

A man in a cap with "Big Blue" written on it comes in. Big Blue is the University of Kentucky team, and it's not a good idea in these parts to speak poorly of it. "How you doing?" asks Joy Higgins. "Fine as frog hair," says the man.

"You'll have to go into Warsaw and talk to Captain John Beatty," Joy tells us. "I guess he's the most famous man on the river today. Any time there's something wrong, they call for Captain Beatty. Barges get loose or a boat sinks or anything. He got those barges off when that tow broke up down at Cannelton and those barges caught fire and drifted into the dam. That was something."

"His biggest job, though," says the man with the pipe, "was that chlorine barge that caught in McAlpine Dam down at Louisville. It got loose and crashed into the dam, halfway through and was just hanging there. They were afraid it was going to crash through and rupture and release all that chlorine gas. Evacuated a whole section of Louisville. Captain Beatty steadied it, pumped all that gas into another barge, then snaked it out."

"Oh, he's the most fascinating man you ever met," says Joy. "Grew up on the river. For a while he owned the Mike Fink up in Covington, restaurant there on the river, only it wasn't the Mike Fink then. Called the Captain Hook. She, Mrs. Beatty, ran it for him. Hated it,

Joy Higgins at Dan's Restaurant, Craig's Creek, Kentucky.

but ran it because he loved it. One night he told her he was going to sell it. 'Oh, thank the Lord,' she said. 'You've made me the happiest woman in the world!' 'Well, God,' he said, 'why didn't you tell me?' And she said, 'No, not as long as it made you happy.' Oh, they're a wing-ding couple."

The man who is fine as frog hair asks if Katherine has any pie left in the kitchen. "She just baked some," says Joy. He allows as how he might force down a piece of coconut cream. "You want any?" asks Joy. "How about some banana cream?" A sausage, biscuit, and banana cream pie breakfast sounds good. Is good.

"Warsaw is an old river town," says Joy. "Used to be called Fredericksburg. The Historical Society is restoring some of the old houses; I live in one of them. We'd like to get something started, a tour of old homes like they have in Madison. Our big problem has been that we've got no industry. Now we've got a new plant coming to make auto accessories."

"It'll help," says the man with the pipe, whose name is Dan Webster. He's the owner of Dan's Restaurant, which he leases to Joy Higgins, as well as of Dan's Marina and the fuel pumps. He also owns the ice-house next door, and on the way to the ice house we pass Dan's Real Estate office and the office of Dan Webster, CPA, which is next door to Dan's DooDads, which sells anything the others don't.

Dan smiles and says no, he isn't the mayor and police chief. "I was on the city council for a while," he says, "but in a small town, business and politics don't always mix too well. I leave the politics to Marcia, my wife. She was a political science major. She's also on the school board.

"Craig's Creek was a real creek when my father bought the land here. Then Markland backed up the water over the bottomland so he started the marina. It's done fine except for the time a barge got caught in the dam in 1967 and they had to drain the pool getting it out. All this was just mud bottom then. I didn't see it. I was in Vietnam. Chu Lai."

"You go in and talk to Captain Beatty," says Joy Higgins. "You can't talk about the Ohio River until you've talked to Captain Beatty." We say we will.

It's easy to spot the Beatty home. It's a long, low house facing the road about a mile west of Warsaw, built of fieldstone ("People gave it to me. Didn't buy any of it," says the Captain), with small portholes instead of windows across the front. Beatty can stand on his back patio and throw a rock into the river; he could, that is, if the bank wasn't lined with six barges, three carrying cranes, and two tug boats. One of them is the *Clare E. Beatty*, built in 1940 but looking brand new under a new paint job. The other is the *Ben Franklin*.

"You could say, yes, I've been on the river all my life," says Beatty, sitting at his family-room table, which

Opposite: Scrap work at Captain Beatty's marine salvage and specialty towing company, Beatty Incorporated, in Yankee Landing, Kentucky.

is a circle of glass over a ship's wheel. "Built my first boat when I was four. Built it out on Manchester Island out of some roofing tin. I was born over in Ironton, Ohio, February 1914, but we were living out on Manchester Island at the time, in a tent. A little later we moved up to Sciotoville, where my father was working, and lived in a shantyboat.

"I helped my mother, who was cook for a salvage crew, but I got my first real job as waterboy on the road, then grease monkey. Then I got a job with Capt. Wheaton on a mud scow, but got fired because I was under age to work. I started working with derricks with my father up in Cincinnati and just naturally went into salvage work. People would just call me and say, 'We've got four down up here. Can you get 'em out?'

"They sink for a lot of reasons. Barge will get loose, snap its wires, and go drifting off, hit something and sink. Collision. Barges tied up along the bank will get loose. A coal barge will be riding low, you know, full, and wind waves will come over the bow and swamp it. We used to have to get the coal out first, or whatever it was carrying, but I've got a crane now will lift the end of one of those 1,600-ton barges.

"That Louisville job. Yes, I guess that was one of the hardest. We just had to get that chlorine barge out that was caught half-way through the dam. Just couldn't let it go over the dam. If it had, those tanks holding the chlorine—there were four of them—they would have broken the straps holding them and come out of there, and that would have just wiped out New Albany, that's all there was to it. It was touch and go there for a while, I tell you. We just had to get it out of there.

"Cannelton, yeah, that was something. Wonder it wasn't worse. Yeah, I've seen the river on fire, the oil on it, the whole river burning.

"Change? Oh, Lord, it's almost unbelievable. More tows, more pleasure boats, a lot more. A lot of them are just status symbols, never leave the dock. And the banks of the river, they've been changed from one end to the other. The speed of the towboats, and the speed of the high-powered pleasure craft, too. There was always a natural caving, but the new boats create a wake that just tears the bank away. I've lost about a hundred feet of bank right here myself. That's why I park those barges along my riverfront, to stop the wash.

"I know things change, but I tell you I don't like change being forced on us without being consulted. The Coast Guard tells me I can't tie up more that twelve barges unless it's a designated landing. Things like that. I think they're just taking on powers to justify their being around. It's a mammoth job to find a landing. Lord, this place of mine here was a designated landing before they were here, before there was a Rivers and Harbors Act, since back in the 1700s.

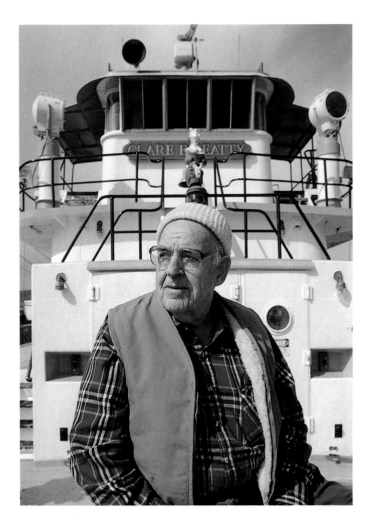

Captain John Beatty.

Downtown Vevay, Indiana.

"And then there's the dams. And I've helped build almost every one. The sad thing is that when a new one goes in, old ones are torn down. And then the people leave that you've been waving to for years. Gone."

Hauling, salvaging, building boats and barges, repairing boats, rebuilding engines ("I just repaired the *W.P. Snyder*, you know, and took it back up to Marietta. Tell you, I got up to Augusta and I turned the *Snyder* around and pointed it right at Gertrude Schweier's house and blew the whistle, and here came Gertrude, waving to beat hell")—Beatty has done "about everything there is to do on the river." When will he quit? "Never thought of it," he says. "I'm only seventy-five. Slowing down a little, I admit. I've stopped hard-hat diving. But not that much. What would I do if I quit?"

It's interesting to speculate on how these towns along the Ohio got started. For example, how in the world did a bunch of Swiss decide, back in 1800, that they would all sell out, pack up their belongings, leave their homes, and sail for America, sally out into the wilderness, sail down this wild river and suddenly say, "Hey, there's a nice-looking spot; let's stop here."

But apparently that's what happened. Well, there were a few people here before them. Heathcoat Pickett settled down the river near Plum Creek in about 1790. George Ash came in 1795 and later ran a ferry across the river to what is now Ghent. And around 1798 Robert Gullion, Griffith Dickason, and Ralph Cotton were the first of about fifty Revolutionary War veterans to settle here. But things didn't really get rolling until the Swiss came in around 1805 and named the town after the one they had left in Switzerland, Vevay. A post office was established in 1810 and in 1814 the Indiana legislature officially created Switzerland County.

The Swiss liked the hilly land overlooking the river and thought it would be a good place to raise grapes. It was. They put out vines brought from the old country and for a century produced good wines, along with the usual farm crops and small manufactures, until a blight wiped out the vineyards shortly after the turn of the century. Paul Ogle, who runs the Ogle Haus, a sort of resort and restaurant overlooking the Ohio here, has planted some new vines in hopes of reviving the wine culture. Ogle is a progressive sort.

Later a band of Scots settled around Pleasant Township. Just before the Civil War the Mount Alpheus Spiritual Community arrived, settled, fluttered, and failed. A Free Love Society came in but didn't last long. Perhaps they discovered the old bachelor's truism that there's nothing more costly than free love.

Many of these early settlers built fine homes overlooking the river, many of which are still standing and open to the public on a walking tour. There are some really impressive homes. Edward Eggleston, author of

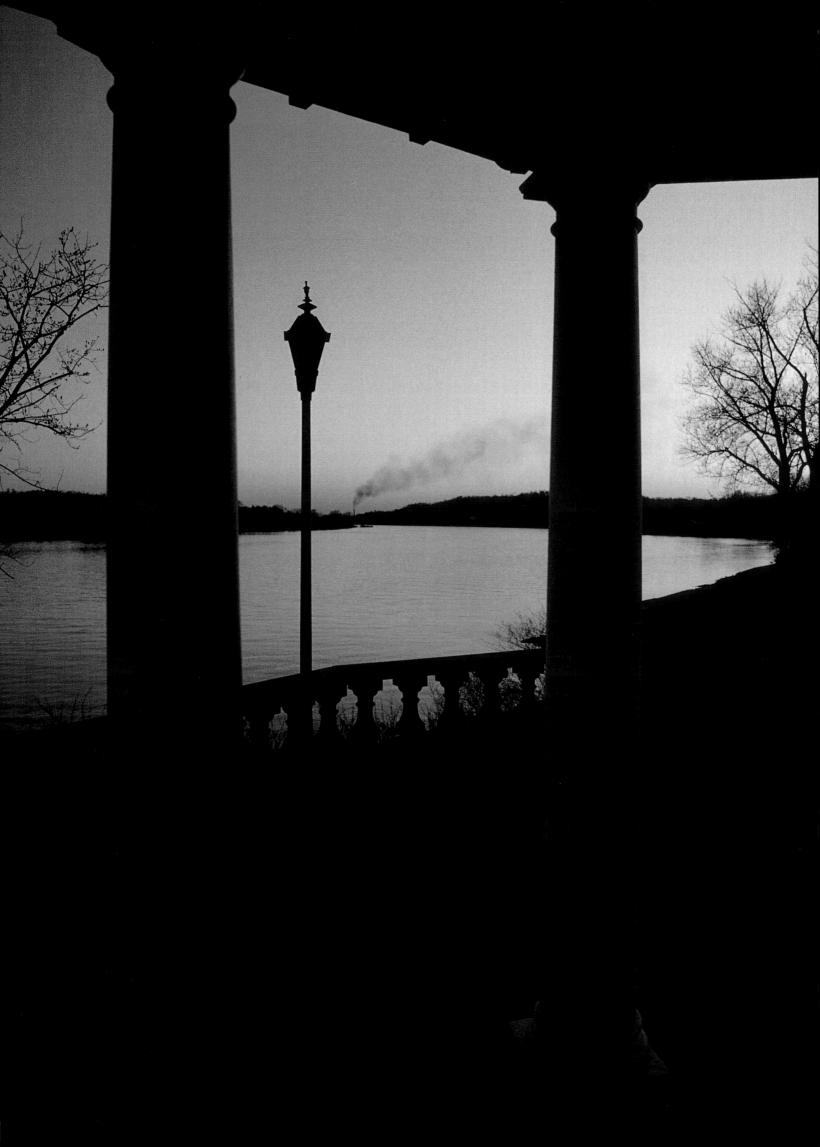

The Hoosier Schoolmaster, was born here. His home is on the tour.

Beginning in 1972 Vevay had a summer Wine Festival that became enormously popular and drew throngs. Shops sold local foods and wines, and there was a huge vat into which the locals piled grapes which they stamped into something—grape juice, foot wine. No one cared. It was a lot of fun, and visitors would sit on the curb eating bean soup and drinking wine and then get in the vat and help stomp out the juice. Boats would be tied up along the banks for miles.

But there is always someone to louse up a good thing. After a few years motorcycle gangs started coming to the festival, getting drunk, riding up and down the streets, making noise and antagonizing people. There wasn't much the city fathers could do. They discontinued the festival. They restored it in 1988 and had a good, orderly crowd. There's no admission fee. A lot of fun.

The Hoosier Theater summer schedule, which runs from June through September, draws a lot of people to Vevay, too, with a series of Broadway plays and revues. The Ogle Haus gets into the act with a theater package offering (you aren't going to believe this) dinner, theater tickets, and overnight accommodations for $43 a person. At least, that's what it was in 1988. You can't get a sandwich for $43 in the Big Apple.

"It's just a charming little town," says Ann Farnsley, who lives and has her art studio in one of the big old homes overlooking the river. "I wouldn't say we have an art colony here, but we have a lot of talented people, artists, musicians. For example, there's Linda Stair, who works at the Historical Society. She's a graduate of the Cincinnati Academy of Art."

Farnsley's father, the colorful and popular Louisville mayor and congressman, was a great promoter of Vevay, bought the house in which Ann Farnsley now lives and paints, and helped to publicize the festival.

"People like Vevay," says Ann Farnsley, who left Louisville to study and paint in New York. "Coming here from New York was a little culture shock, I admit, but it's so peaceful, and there are so many interesting people. If we want a big night out, we can always drop up to Cincinnati or go down to Louisville. Usually we just go out to the Ogle Haus. Our musicians play there, or at local bars. And we have tourists, except in the winter. It's, well, it's quiet in the winter."

Carrollton, Kentucky.

Across the river from Vevay is Ghent, Kentucky, about a mile upstream of the big Kentucky Utilities Ghent power plant. Ghent was famous for a while as the home of James Tandy Ellis, who wrote dialect stories known as the "Uncle Rambo" stories about the Bluegrass region of Kentucky. Somewhat similar to the "Uncle Remus" stories, they were written in what was then called Negro dialect and were very popular. They would get him run out of town today.

Ghent was settled about the same time as Vevay by thirteen families who came down from Pittsburgh and laid out a town that they named McCool's Creek Settlement. But in 1816 Henry Clay came through, just back from Europe, where he had served as a member of the commission that negotiated the Treaty of Ghent ending the War of 1812, and expressed the opinion that the town was too fine a place to be known as McCool's Creek Settlement. He suggested they call it Ghent in memory of the welcome treaty. The people were happy to oblige. They would have called it Cow's Tail if Clay had suggested it. They loved Henry Clay.

From the river you don't get a favorable impression of some towns because they "turn their backs on the river," building homes and offices to face the courthouse square or residential streets so that from the river you see only the backs of buildings. Carrollton, Kentucky, is one of those. It has a fine, dignified courthouse with a tall, beautiful clock tower, and a number of beautiful old homes, including the Butler Mansion, now a museum in the nearby Butler State Park.

Yet it's certainly a river town, located at the confluence of the Ohio and the Kentucky, and there are boats on trailers all over the place. It was a busy steamboat landing during the last century, and the 1937 flood put water almost to the ceiling of the first floor in the courthouse.

Carrollton is an in-between town—not very big, not terribly small (4,500), not rich but not noted for poverty, with chemical and metals plants hiring 1,000 people or more. It wasn't one of the first towns on the river, having been named in 1838, but it's old enough to celebrate its 150th birthday recently.

Carrollton got a break when the state created General Butler State Park right on the city limits. It is a scenic place with a nice river view, a beautiful lodge, and, strangely, a ski run, which usually surprises people from the North who are not expecting a ski run at this altitude. There is a lot of wildlife in the park (not counting the skiers), especially deer, and if you can catch a ride to the lodge, the food is good and reasonable.

The Kentucky Utilities Ghent power plant.

Below Carrollton the river widens, with hills rising on either side. Then under a bridge, with the tall spires of power plant smokestacks ahead. On our left Milton, Kentucky, and on our right Madison, Indiana—one of the gems of the Ohio.

The sky has become overcast, and a sharpening breeze ruffles the river as we approach the city wharf and wade ashore to tie up. On the bank, sitting in camp chairs beside a shiny van, sit two solidly-built, casually dressed men past middle age who seem totally at peace with their world. They're fishing, with the unruffled demeanor of men who have retired from the struggle and are able to accept life in comfort and without too much regret.

Between them sits a mournful dachshund who barks nervously as we approach. "Don't pay any attention," says Wilbur King. "Actually, Butch likes to be petted." This is true. Butch seems suspicious, but relaxes when stroked and soon lifts his head to get his throat scratched. "He doesn't get much petting since his mistress died." There are years of pathos in the words.

Harry King's line twitches, but he's unimpresssed. "Look at that," he says, smiling. "He'll leave when I pick it up. Little striper, more than likely. There are large-mouthed bass in this river, although I haven't caught any lately. But they're there. The river's a lot cleaner than it used to be. Used to be you couldn't eat what you caught. They still spill something now and then, but it's cleaner."

"Yeah," Harry agrees. He glances at the sky, looking downriver. "Looks like we could have some rain. Coming around to the southeast. Get some storms from there."

The river has always meant a lot to Madison. The first settlers came down the river just months after Marietta and Gallipolis were founded, and in 1809 John Paul arrived by keelboat and laid out a town along the bluff above the river, naming it for President James Madison. For years Madison was a booming city, halfway between Cincinnati and Louisville, and in 1821 became the capital of Indiana, known as the Gateway to the Northwest. That was part of the trouble; too many people moved on through the gate to the northwest. And in the 1850s the railroads began spreading their steel webs across the land, replacing the steamboats that had given life to Madison. Cincinnati, Indianapolis, and Louisville became a short ride away and offered attractions that little Madison could not match. Madison's growth slowed, and Indianapolis became the new state capital.

But Paul and his early Madisonians had built a well-planned town of solid buildings and beautiful homes. Madisonians are quietly proud of their town, and they have reason. Today all of the blocks of downtown Madison are listed in the National Register of Historic Places, and the town draws a steady stream of tourists. The old railroad depot now houses the Madison Historical

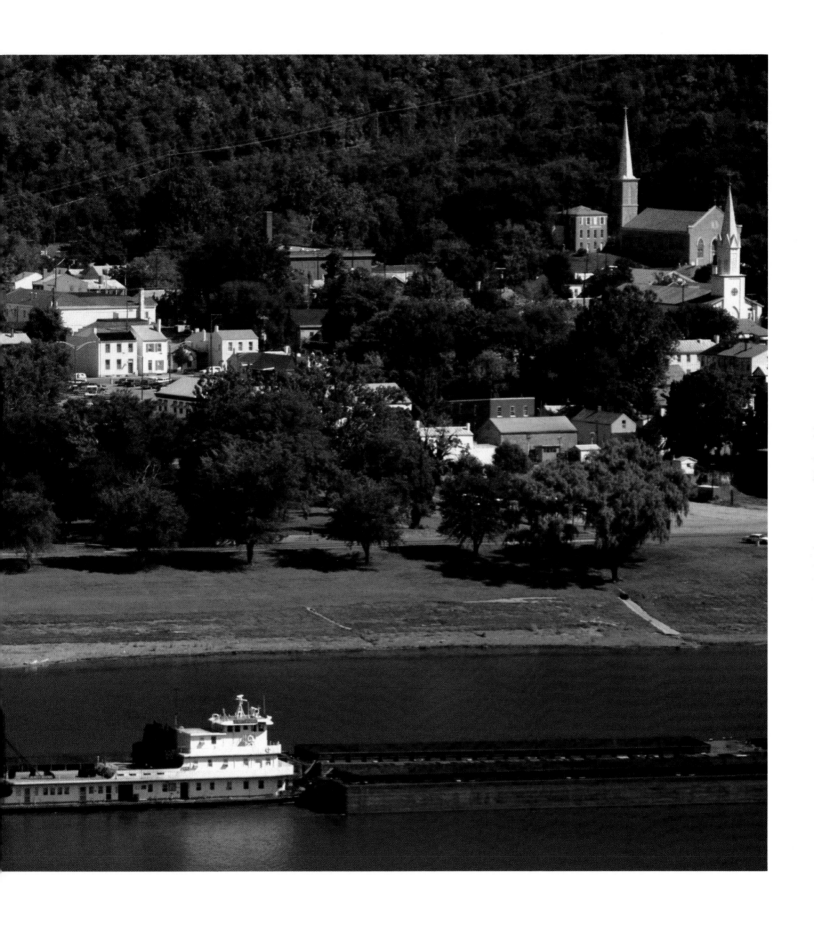

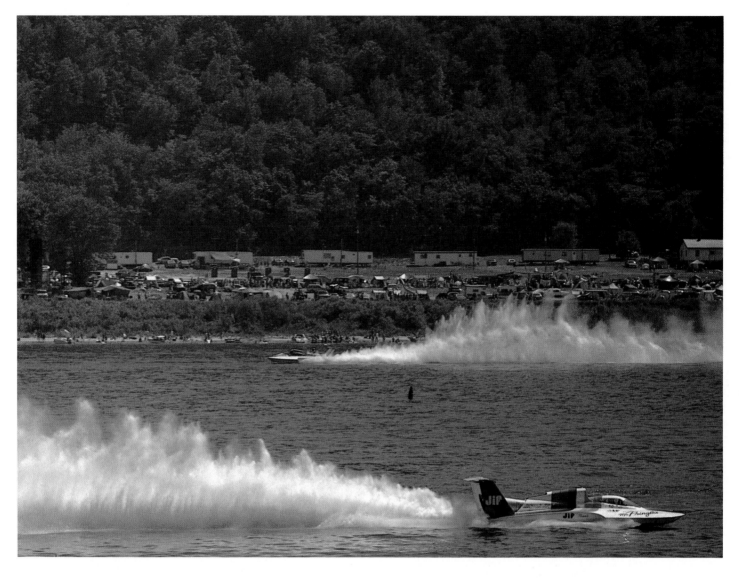

The annual Madison Regatta draws thousands of
spectators who line the shores (along with a dizzying
array of pleasure craft) to watch the exciting speedboat
races.

132

Society. Even the downtown section is lined with old, stately homes—the Lanier House, the Shrewsbury House, the Schofield House. Even the library is on the public tour.

Actually, there are two Madisons. The part along the river is scenic and historic. But there was not enough room along the river for the growing town, which climbed the hill and spread out as a rather ordinary midwestern small town of fast-food places, stores, shopping areas—the usual. The hilltop part undoubtedly helps to spark an economy that supports an unusual library, a handsome welcome center, and a country club remarkable for a town of this size.

The river brings the annual Madison Regatta, which draws thousands of spectators to line the riverbanks and watch the speedboats. It's one of the best known regattas along the river but isn't universally loved in Madison.

"Oh, a lot of people like it," admits Wilbur King, with a shrug. "Personally, I don't think it does much for the town. The town will spend about $20,000 to get ready for it, another $20,000 to clean up after it. Or more. A lot of people come in and drink a lot of beer and make noise, but they don't come up town, spend anything."

The King brothers aren't the only citizens who regard the regatta with less than mad enthusiasm. "Merchants say the people who come in even bring their own beer," says a lady at the Welcome Center. "A rowdy bunch. Make a lot of noise and mess."

While the Regatta gets a lot of press attention, there is more local participation in the Chautauqua of the Arts, a big arts and crafts festival held the last weekend in September. Even without the Festival, that would be a good time to visit Madison, with the leaves turning along its historic streets, the sky autumnal blue and the weather still warm. There are hundreds of booths, exhibits, food stands, and picnic tables, and thousands of people mill around—exhibiting wares, buying, eating, having a good time.

You want some handcrafted furniture? The Sampler booth has it. Juan Velez offers jewelry using filigree and braiding techniques. Alan Long is selling wildlife prints, Jeanne McLeish works in transparent watercolors, and Kathy Rutan operates a ceramic studio. Leather goods, tree sculptures, oils, linens—you name it, they have it. There are about 600 exhibits, believe it or not. And music and dancing and tours of the town. A ball from morning to night. It takes a whole weekend to enjoy it all, and boats are tied up for a couple of miles along the shore.

Another event worth seeing if you're around is the Christmas Candlelight Tour the last week of November. Trees are lighted all over town and there is a tour of public and private homes.

"Three or four times a year they'll have a tour of homes," says Wilbur King. "Of course, the people living in them don't want to have them open all the time. And you take an old horse like me. I've got a nice home. They've asked me to open it. But, living alone as I have since my wife died, I haven't kept the place looking the way I'd want people to see it. It's nice to have the visitors, though. They're a nice class of people, the ones who come to see the homes."

A little more than ten miles down the river from Madison, on the Kentucky side, is a small valley called Payne Hollow. And just upstream of the hollow, hidden among the trees on the hillside, is the home of the late Harlan Hubbard. It's too bad you can't meet him.

White-haired, blue-eyed, leather-thin, Harlan Hubbard was a painter of Ohio River scenes, a sensitive writer, and perhaps the last of the shantyboat artists. Not that Harlan was an unlettered riverman. He grew up and was educated in Cincinnati, studied painting in New York, and returned to paint and write about the Ohio. Then he married, and he and his wife Anna set off aboard their shantyboat on a five-year cruise on the Ohio and Mississippi, learning the river, absorbing its personality, living with it. Returning to Kentucky, they bought seven acres of land on a rise above the Kentucky shore of the Ohio, where they built a home of native wood and stone.

There they raised a large garden, caught fish, and lived in a simplicity that required little of the outside world. They were relatively isolated. Their home could be reached by a tortuous path down the steep hillside north of the small county-seat town of Bedford, though people wishing to visit could also come down the Indiana shore and ring a bell attached to a pole, usually bringing Harlan across the river in his john boat. As he got older and the river seemed to widen, he made a grudging concession to age and bought an outboard motor.

Their huge, bell-throated hound, Ranger, brought home rabbits, squirrels, and groundhogs, and Anna cooked and canned them, often feeding guests minced groundhog over rice, identifying the dish only after the guests had exclaimed over it.

In a small studio a few yards around the hill, Harlan spent his afternoons writing and painting. He was the author of books on the river and held exhibits in Madison, Milton, Louisville, and Cincinnati. In the evenings he would play the violin while Anna accompanied him on an ancient grand piano brought in at back-breaking effort.

On the hilltop across the Ohio from Hubbard's home, there looms the huge, towering bulk of the Marble Hill nuclear-power generating plant, dwarfing the hillside, seeming to glower over the valley. But it is a dead giant, never allowed into operation by opponents who protested its cost, what they considered its danger, its threat to the environment. And sometimes, on summer afternoons when Harlan Hubbard was hoeing in the hillside garden that furnished so much of his and Anna's pleasant diet, he would pause in his simple concert with the earth and look up at the chained marvel across the river and smile a wry smile and shake his head.

And so, with visits only from a few friends, schoolchildren or writers, the Hubbards kept the even tenor of their way, sufficient for each other. In 1986, tall, regal Anna died. Harlan followed her a few months later. An era of the river went with him.

We're passing Westport, Kentucky, on our left, or to port, if you prefer. There is not a lot here to attract the eye. It's hard to imagine that Westport was once a bustling boat-building town back in steamboat days. It is a pretty village, though, and likely to be bigger soon, with a large riverside subdivision taking shape on the downstream end of town. And there's still a big boat-launching ramp, a lot of boat activity, and a boat-repair business run by Larry Lewis on the rise just east of the ramp.

While we're absorbing the sights of scenic downtown Westport, upriver comes the Coast Guard buoy tender *Chippewa*, pushing a work barge. The *Chippewa*, which services buoys, lights, markers, and navigational aids in general, is not a glamour boat. But it's a busy one. It runs the length of the river servicing, repairing, and replacing the navigational aids that mark the channel and guide river craft.

With the aid of navigational charts issued by the Corps of Engineers you can follow these aids without much trouble and stay in the channel, where the water is deepest. Buoys mark the channel where fairly precise guidance is needed. You should keep green buoys to your right going downriver, or "out," and red buoys to your right coming upriver or "returning." "Red right returning" is a handy expression used by pilots. The Coast Guard also places triangular markers on shore to help pilots steer by day and lights to help guide them by night.

Life on the *Chippewa* would be a snap if things weren't always happening to the navigational aids. Floods knock buoys around and get them out of position. Storms knock down markers. Lights burn out. Each spring the Engineers "sound" the river, that is, take soundings of it, and award contracts for dredging out silt or obstructions that have collected. It's up to the Coast Guard to check and see that the buoys are moved to mark the new channel. It doesn't make a lot of difference to a boat like ours, which draws about three feet. But when you have a boat that draws nine feet and the water outside the channel is six feet deep, it's nice to be sure where the channel is.

There weren't any navigational aids on the Ohio before 1875. Pilots steered by trees, rocks, hills, or houses, and by watching the ripples and eddies that warned of snags and shallow water. Then in 1875 the U.S. Lighthouse Service installed 175 beacons and buoys on the Ohio. There are about twice that many today, maintained by the Engineers and the Coast Guard.

The *Chippewa* is a solid, no-nonsense boat, going methodically about its business, but the thirteen crewmen recognize the life-and-death importance of their work, and it's considered good duty. The river is never as rough as the ocean, and the *Chippewa* is usually fairly close to a town when nighttime comes or it's time for liberty.

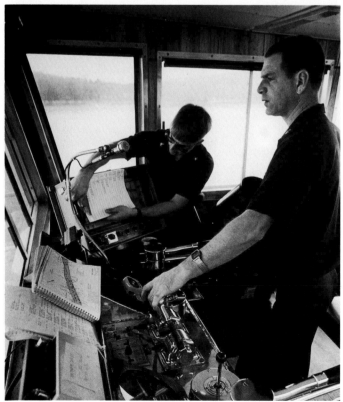

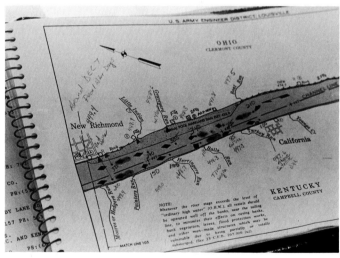

One of the many navigational charts used by the captain of the Coast Guard *Chippewa* to help in the placement of bouys and beacons along the river.

I know it's here somewhere. The chart says Louisville is on the left, Jeffersonville, Clarksville, and New Albany, Indiana, are on the right. But for the past six or eight miles we've been running past long lines of private homes, marinas, subdivisions, boat clubs, waterfront restaurants, parks, launching ramps, and now sand and gravel pits, warehouses, loading docks, oil storage tanks, electrical substations, barges, and on the right a huge boat yard, loading docks, homes with private docks, and small excursion boats, and restaurants. Now we go under a couple of bridges and there, at last, is Louisville, Kentucky.

You can't say that Louisville puts its best foot toward the river. There is an unimpressive wharf where a brightly painted sternwheeler, the *Belle of Louisville*, and a pink thing that could only be a floating restaurant, are docked. Streets and expressways lace the waterfront on several levels, and beyond them loom a couple of hotels and what appears to be the average, middle-sized, midwestern city, wrapped in a glass coat of many colors— a black-glass building, a blue-glass one, a white building, and an unusual pink one.

But as someone said of Wagner's music—that it's better than it sounds—so is Louisville better than it looks from the river. As its residents attest, it is a relaxed, varied, livable town of tree-shaded neighborhoods, beautiful parks, reasonable housing, a vibrant cultural community, and a downtown that is making a stubborn comeback after being hospitalized by suburban malls. Louisville isn't a bad town to visit, either. In addition to the usual motels, including two huge ones at the airport, it has five downtown hotels, two of which are better than most, and a whole clutch of top-flight restaurants. On the river there are the Captain's Quarters, about six miles east of town, and the Islands, the pink structure at the wharf, which are adequate. But on dry land there are Vincenzo's, Café Metro, Timothy's, Casa Grisanti, Equus, Detricks, and Jack Fry's—all offering varied, sophisticated menus and reasonable-to-high prices. Others, such as the Bristol, Rick's and Kunz's are not quite as good, not quite as expensive.

The town also boasts a new, beautiful Center for the Arts, a symphony orchestra that plays in Carnegie Hall, ballet and opera companies that attract national attention, and an Actors Theater whose series of original plays each year draws metropolitan critics and frequent Broadway performances. It has a public library system nationally known for its innovations, a substantial zoo, six colleges, two seminaries, and three FM stations that broadcast classical music. Some say it is still basically a beer, baseball, and basketball town, which is true to an extent, but the culture is not a facade.

Some visitors express disappointment—even resentment—that Louisville isn't southern in accent or attitudes. And it isn't. At Derby time it puts on a show of

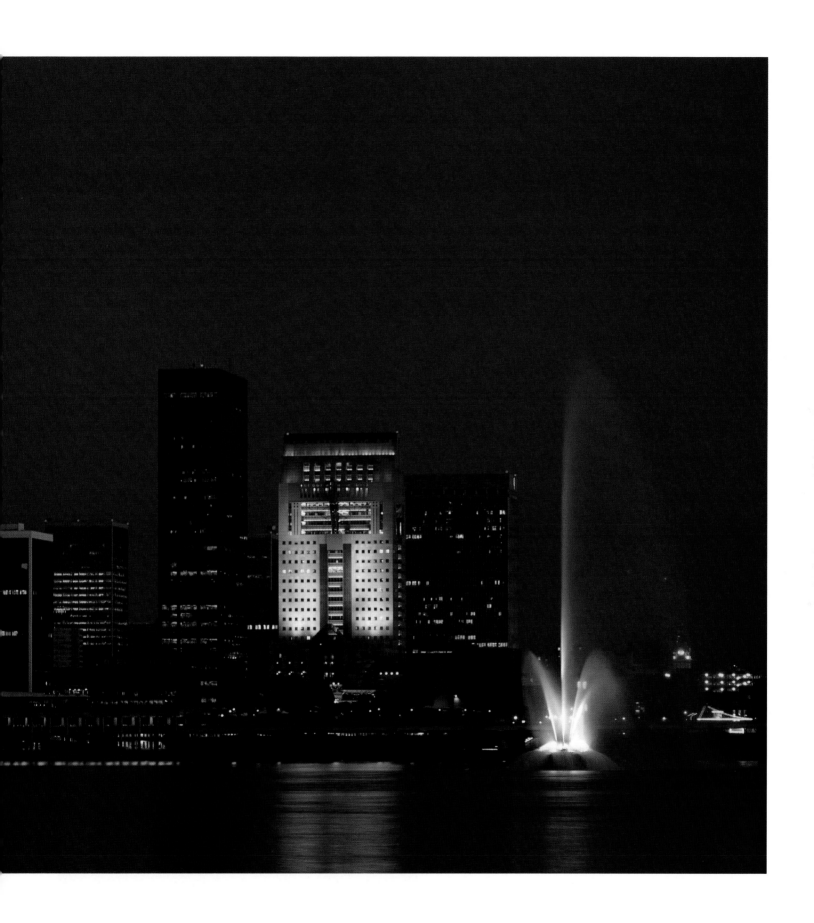

Above: The Zorn Avenue Pumping Station near Louisville. The white building and tower on the left house an art gallery which hosts a variety of social affairs year round. *Right:* The annual sternwheeler race held in conjunction with the Kentucky Derby adds to the festivities of the week-long celebration.

southernism with country ham (a wonderful dish,) mint juleps (an inferior drink), beaten biscuits (which have been described as tasting like the center cut of a cue ball), and bourbon whiskey. (Did you know that by federal law, only whiskey distilled in Kentucky can be labeled bourbon?) Kentucky Colonels put on white suits and string ties and hold a massive bash. But none of this conceals the fact that Louisville is a midwestern city in a state that stuck with the Union in the Civil War. Easterners think Louisvillians sound southern, southerners think they sound northern, westerners think they sound eastern. Louisvillians think they sound fine.

And Louisville is, probably more than any other major city on the Ohio, a river town. It is significant that its transit system is known as TARC—Transit Authority of River City. As many as 10,000 pleasure boats are licensed in the area, the Jeffboat Company boat works across the river in Jeffersonville has been a major builder of tows, barges, and wartime naval craft since World War II, and the town's major festival, the famed Kentucky Derby, is actually a week-long party that features a race between Cincinnati's *Delta Queen* and Louisville's county-owned *Belle of Louisville*. Both boats are loaded with screaming passengers for the race, and as many as 350,000 people picnic and party along the banks of the six-mile race course. Some cynics say that the race is fixed so that the more powerful *Queen* will not win every time, but everyone knows that old riverboat captains would never cheat.

But there are curious aspects to Louisville's relationship to the Ohio. Louisville came into being because of the river. It grew because of the river. Perhaps the most famous event in its history occurred when the river almost destroyed the town in 1937. But the very feature that made it a river town keeps it from taking full advantage of its waterfront as, say, Cincinnati and Pittsburgh do.

Louisville got its start when George Rogers Clark came down the Ohio from Pittsburgh and put a party of settlers ashore on Corn Island, offshore of what is now Louisville, in May 1778. Clark was not greatly interested in the settlement, but he had, in addition to the settlers, a company of soldiers with whom he planned to attack the British forts in the Northwest. His prospects would seem dim. Not all of his men were wild about their ambitious mission. He had some volunteers from Jim Harrod's fort at Harrods Town (now Harrodsburg) but had to send some of them back to help protect the fort. He had been given no money by the government and had to use his own money and borrow to outfit his men.

The odds seemed only to excite Clark. Running the rapids at the Falls, he set out just as the sun went into eclipse (which didn't cheer the men noticeably), sailed down the river, and left his boats at the mouth of a small creek near deserted Fort Massac. From there he

The Falls, with McAlpine Dam stretching up and down the Ohio for more than a mile, walling off the rock ledges and rapids, and creating a smooth, clear passage for river traffic.

marched overland and attacked Kaskaskia on the night of July 4. He took it without firing a shot, then sent Joseph Bowman on to conquer Cahokia and several smaller settlements, and then marched on Vincennes, which surrendered on July 30.

Clark returned in triumph to Corn Island to await further orders, only to learn that British Colonel Henry Hamilton had retaken Vincennes on December 17. Again he headed, with about 300 men, down the Ohio, turned up the Wabash—then in flood—and staged his famous march across the frozen, flooded Illinois countryside, fording the swollen creeks and icy fields, though he and his men had only the flimsiest clothing. Defeating the British, he won control not only of Vincennes and the Northwest forts but of the Wabash River area, in one stroke making the British wary of attacking Washington's western flank.

Clark had also founded Louisville and what would later become Clarksville and New Albany, Indiana. Actually, however, Louisville would not have amounted to much had it not been for the Falls. They were, of course, nothing more than a boulder-strewn stretch of limestone ledges, stretching across the river to form a series of rapids that let the river drop twenty-five feet in about two miles. At high water they could be navigated by keelboats and even the later steamboats, but normally they were a hazard that forced captains to unload above the Falls, ship cargo around them by wagon, and reload below. It was a tedious, expensive process and people soon began agitating for a canal around the Falls. A bitter fight erupted between Louisville and New Albany, Indiana, over location of the canal, with Cincinnati interests supporting the New Albany bid, primarily to hamper growth of rival Louisville. Kentuckians scoffed at the Indiana proposals, charging that their plan would cost a million dollars, whereas the Louisville interests proposed to build the canal for $400,000. In 1825 a permit was granted to the Louisville and Portland Canal Company to build a Falls bypass. Three lift locks were built at the lower end of the canal, each 190 feet long, 52 feet wide, and 42 feet high, each having a lift of eight feet, eight inches. Then, as now, overruns occurred. The project finally cost $1,019,277.

No sooner were the locks in operation than it became obvious that they were too small to accommodate the big new steamboats being built, and the steep tolls charged by the private operators outraged shippers. But it was not until the Civil War showed their inadequacy that the government finally took over the canal in 1870 and began a new dam and locks. The new locks, completed in 1879, were 372 feet long and 80 feet wide, with lifts of 14 and 12 feet. These, too, soon proved too small, and at the turn of the century reconstruction was begun again as part of the overall plan to provide a nine-foot channel throughout the length of the Ohio. The new locks and

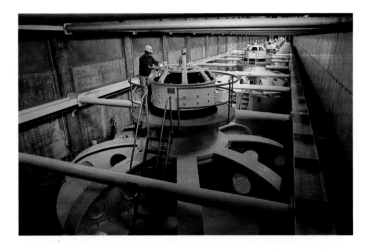

The Louisville Gas & Electric Company's hydroelectric plant, located just south of the McAlpine Lock and Dam.

dam, named for engineer William McAlpine, were dedicated on October 23, 1929, by President Herbert Hoover, who as an engineer had an intense interest in the river system. After the dedication, poor Mr. Hoover returned to Washington on October 29, just in time to hear of the stock market collapse that brought on the Great Depression and destroyed his career.

The end of the packet era was as dramatic as its beginning. Railroads, carrying more freight and passengers farther and faster and to more places, began replacing the colorful riverboats soon after the Civil War. The iron horse was not as romantic as the riverboat, or as comfortable or as elegant, but it was more efficient. It did not have to go only where deep rivers flowed, and soon people were going down to the depot to see the train come in as they had once swarmed the wharf to see the boat come 'round the bend. The coming of highways and the automobile only drove the nail into the coffin of the river packet.

While railroads spelled the end of the passenger packets, the steamboat survived until the 1940s as a pusher of barges. But development of the steel barge and the diesel towboat retired the sternwheelers and gave new impetus to river shipping. By 1930 tows were pushing 20 to 30 million tons of cargo a year on the river. Again, enlargement of the McAlpine locks was necessary, a project completed in 1968. Today McAlpine is the only dam in the Ohio system to have three locks—two of the new 1,200 by 105 foot chambers, and one of the old locks, still capable of operation.

McAlpine Dam not only relieved the bottleneck at the Falls but gave the river system its strangest dam. For the greater part of its length it stretches not across the river but up and down the river for more than a mile, walling off the rock ledge known as the Falls of the Ohio. At its downriver end the dam runs across the river to Shippingport Island, impounding water for the Louisville Gas & Electric Company's hydroelectric plant there. And on the other side of Shippingport the two-mile-long canal stretches from Louisville's waterfront to the locks.

The fact that the Ohio's channel runs a few yards off Louisville's shore dictated the location of the canal and locks on the Louisville side, but it has also hampered the town's efforts to take advantage of its waterfront. You can't very well have swimming, boating, and sailing in water used by dozens of large towboats every day. You can enjoy the sight of the Falls Fountain, given to the city by the Bingham publishing family, but the Coast Guard won't let people go out to look at it close at hand. No sense in getting carried over the dam.

During the heyday of the steamboat, Louisville's economy and social life revolved around the wharf. Crowds swarmed to the docks to see the big packets, and newspapers carried schedules of arrivals and departures, usually including the nature of cargoes. Wagons

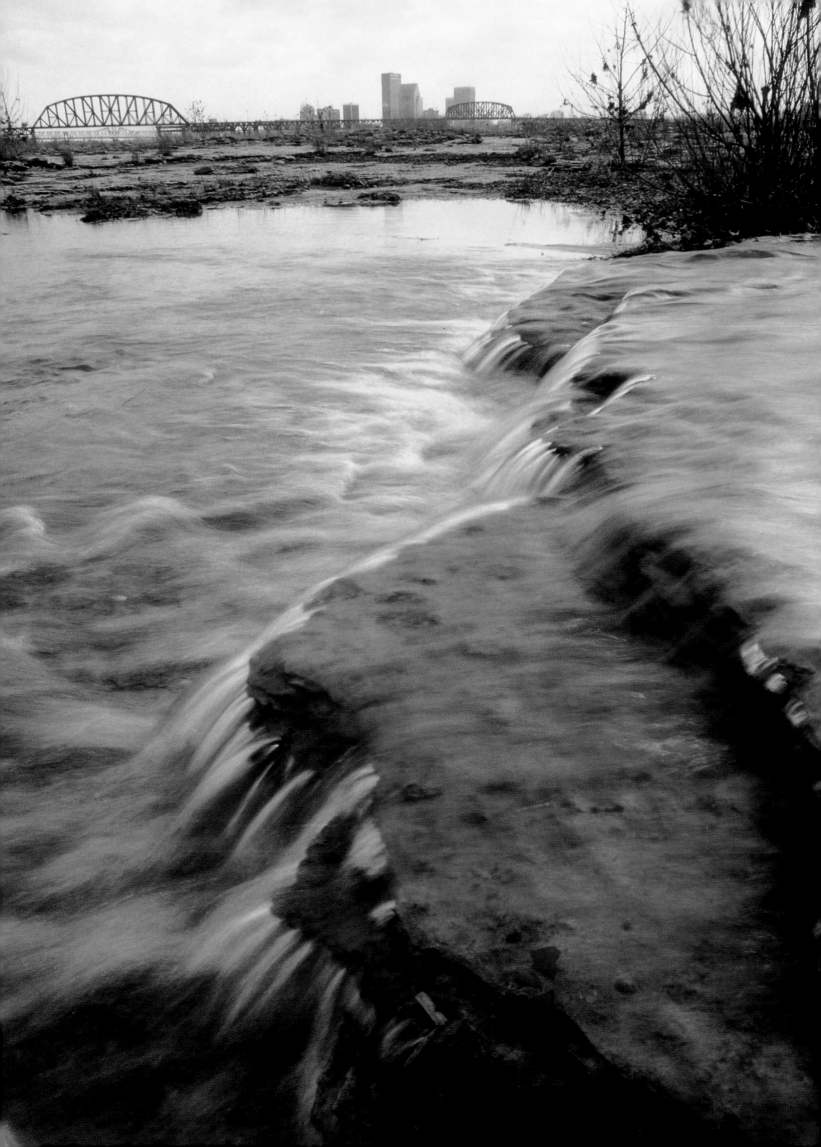

carrying tobacco, corn, and cotton for the boats jolted through the streets leading to the river, competing for space with carriages filled with elegantly dressed passengers. The puffing sternwheelers were the height of fashion, with their luxurious staterooms and elegant dining salons, where smartly dressed gentlemen could enjoy an after-dinner game of cards over brandy and cigars (and possibly fall victim to the riverboat gamblers who became part of the river lore).

But with the coming of the railroads, the day of the packet faded, as did interest in the river. Louisville's attention was brought back sharply, however, when the Ohio went on its historic rampage in 1937. Three-quarters of the town was under water, as were 76 square miles of the country outside the city; 175,000 people were evacuated, 90 deaths were blamed on the flood, and property damage amounted to $50 million, an astronomical sum for the time. The current floodwall, built to turn back water three feet higher than that of 1937, has not been fully tested.

If you have the time, go ashore in Jeffersonville and catch a cab down to the land below McAlpine Dam, where an interstate park is being developed by Kentucky and Indiana. It is a strange park, completely under water at flood time, but interesting nonetheless, especially to nature lovers. At the park you can reach down and touch the ossified remains of thousands of small creatures that lived here 375 million years ago when this region was part of the vast inland sea. Making the area a park will protect these fossils, and none too soon. For years people have been coming here and carrying off these remains of prehistoric times.

Edged with algae-stained pools and often littered with debris deposited by the river, the park is not immediately impressive to the casual visitor. But it is surprisingly rich in wildlife. Raccoons, weasels, groundhogs, and muskrats slip through the thickets. Bass, sauger, catfish, carp, and sunfish can be taken from the pools and rapids. Bird-watchers troop across the flats in all seasons to make counts of redwing blackbirds, plovers, larks, gulls, egrets, great blue herons, geese, ducks, ospreys, and even eagles.

Jeffersonville, Clarksville, and New Albany, Indiana, are good towns to visit. New Albany was once a major steamboat construction center. Jeffersonville, like Newport across from Cincinnati, has had the misfortune of being a "town across the river" from a larger one. For years it suffered a lurid reputation for offering the sins and delights of the flesh in the night hours. Louisville newspapers periodically decried the alleged presence of big-time mobsters, gamblers, and prostitutes. In time, of course, a cleanup campaign chased the juicier elements out of Jeffersonville, even as the army had prodded Louisville into cleaning out its sinks of sin.

There are things to see. Jeffersonville's Howard Museum, a monument to pioneer boat-builder James Howard, contains models of many of his famous boats and a good history of commerce on the river. Clarksville is developing the major portion of the Falls Park and its interpretive center, while downstream is the Living History Museum and the George Rogers Clark homesite. It was here that the warrior, grown old and sick waiting for military orders that never came, harrassed and slandered by political enemies (the infamous James Wilkinson chief among them), fell and injured a leg. It developed gangrene, and the doctor decreed that it be amputated. There were no anaesthetics then, so Clark reportedly hired a drum-and-fife corps to march around the house to drown the sounds of his screams, drank a bottle of whiskey, lay down on the table, and calmly bade the doctor to his task. He never uttered a sound as his leg was cut off.

Clark was never repaid the money he spent to arm and equip his men for the historic campaign to the Northwest. He had hoped that his old friend Tom Jefferson would call him to lead the expedition to the Pacific, but his brother William got the assignment instead and stopped by to see him. Clark embraced him, wished him well, and watched, his heart breaking, as William and Meriwether Lewis pushed off down the Ohio to history and fame.

Finally, when death was near, the government sent him a sword inscribed to the hero of Kaskaskia and Vincennes, and granted him a pension of $400 a year. But by then he had sold most of his land to pay his debts. His last days were spent at Locust Grove, the Louisville home of his sister, Lucy Croghan, on a bluff overlooking the Ohio, down which he had sailed to victory, glory, and heartache.

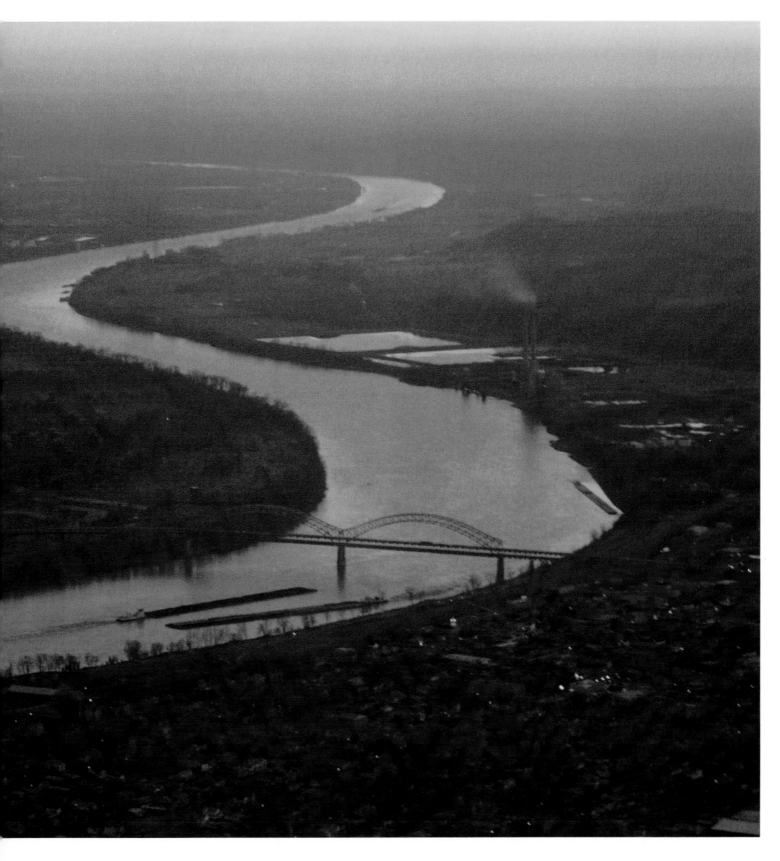

The Ohio as it winds past New Albany, Indiana, on the right, and Louisville suburbs on the left.

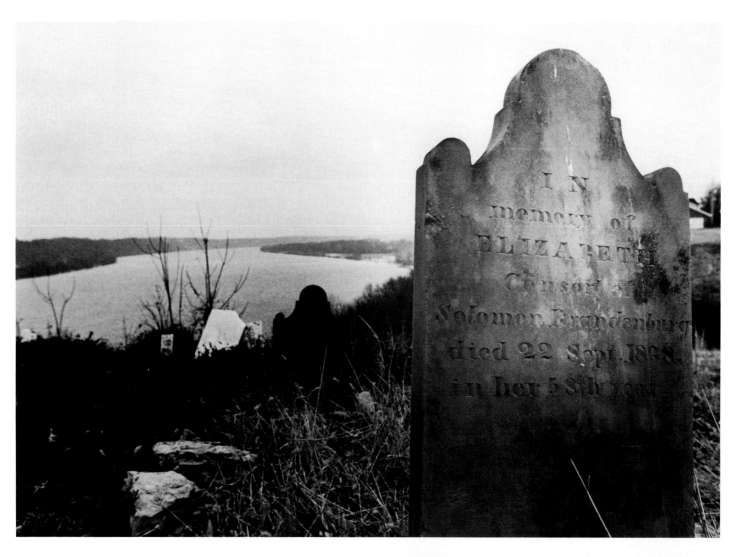

Time and circumstance pushed Brandenburg, Kentucky, into the public eye and the history books at least twice. On July 7, 1863, Confederate General John Hunt Morgan arrived here from Tennessee with his raiders, commandeered two steamboats at Brandenburg, and crossed the Ohio for a campaign through Indiana into Ohio, where he hoped to capture Cincinnati and Columbus. Crossing the river, he fought a skirmish (but not much of one) with a Union gunboat that fired a few shots, said it was out of ammunition, and left. Morgan landed his men and burned one of the steamboats. The people of Brandenburg were furious. They weren't too fond of Morgan, anyhow.

A far worse experience was the tornado of April 3, 1974. People were just getting off work and heading home on a warm, humid spring afternoon. It had been a shifting, edgy day, with erratic winds and low-hanging clouds, when suddenly, whipping up from the southwest, a tornado slashed through town, flattening almost half the homes and obliterating Main Street. There was no warning. A Kentucky state trooper saw the twister and called a warning to his post, but the tornado struck before the warning could be relayed. Thirty-six people were killed, twenty more seriously hurt. The century-old courthouse was so badly damaged it had to be abandoned. Main Street never quite recovered. If you had not seen the town before, you could not tell now where the tornado struck, but memories are still raw and bleeding.

One more item of historic significance. On a Saturday afternoon in July 1859, Big Joe Logsdon threw a six-pound ax over the courthouse. The local newspaper didn't say why he did it. Just said he hauled off and th'owed it plumb over. Bunch of people hanging around, and somebody probably said he couldn't do it, so he did. One good thing; he didn't hit anybody. Everybody was talking about it.

There's a good restaurant on Main Street, down toward the river. Great soup. And on a small cliff about fifty yards downstream from the foot of Main Street there's an Indian petroglyph, a turkey carved into the rock. Or so they say. Hard to tell what it is. I have an idea Indians could do better.

Downtown Cannelton, Indiana.

Probably no town on the Ohio got hit harder by the 1937 flood than Hawesville, Kentucky, which lies just across the river from Tell City. It's a pleasant little town with a big Southwire Aluminum plant on the river, and a scenic view of the river and Cannelton Locks and Dam from the high bridge connecting Hawesville to Cannelton and Tell City.

When the 1937 flood waters went down, the people of Hawesville got together and petitioned the Corps of Engineers for a floodwall. The Corps looked over the situation and decided they couldn't help much under the federal laws requiring localities to share project costs. The town, they informed the people of Hawesville, would have to put up $28,000. But the town had fewer than a thousand people, and the assessed value of all property was less than $300,000, not enough to support a bond issue. This might have discouraged the average community, but the people of Hawesville took a deep breath and began passing the hat. They got only one contribution of as much as $2,000, but in four years they raised the required amount. And in 1953 Hawesville got its floodwall.

Cannelton, Tell City, and Troy, Indiana, sit in a row along the bank below Cannelton Lock and Dam, and if you go ashore and drive through them you might think they were one town. Cannelton begins where the east end of Tell City leaves off, and Troy begins just beyond Tell City's west end. In fact, the Tell City Industrial Park is in Troy; there wasn't enough flat land in Tell City. Cannelton is the seat of Perry County, but Tell City, with 8,000 people, is as big as the other two combined and the commercial center of the county.

As Tell City historian Charles Schreiber says, Tell City is different from most towns in that it was planned from the start. In the 1850s a group of Swiss and Germans living in Cincinnati decided they would like to have a town of their own. They raised $160,000—not small change for that time—and formed the Swiss Colonization Society. They sent scouts down the Ohio to look for likely sites, the only stipulations being that the land be a hundred miles below the Falls and not cost too much. Up and down the Ohio they went and finally went ashore at what is now Tell City. They would have settled across the river in Kentucky, where the land was higher and better, but they refused to have anything to do with a state that permitted slavery.

So they went to the Indiana side, bought a large block of land from a Judge Huntington, and named it Tell City in honor of the Swiss hero William Tell. The scouts looked over the land, mostly forest and swamp, laid out a town for 50,000 people, and on the Fourth of July 1858 the first boatload of settlers came down the Ohio from Cincinnati on the steamboat *Prairie Rose*. Today a fine statue of Tell stands on the south lawn of the City Hall,

A misty morning on the Ohio near Jeffersonville, Indiana.

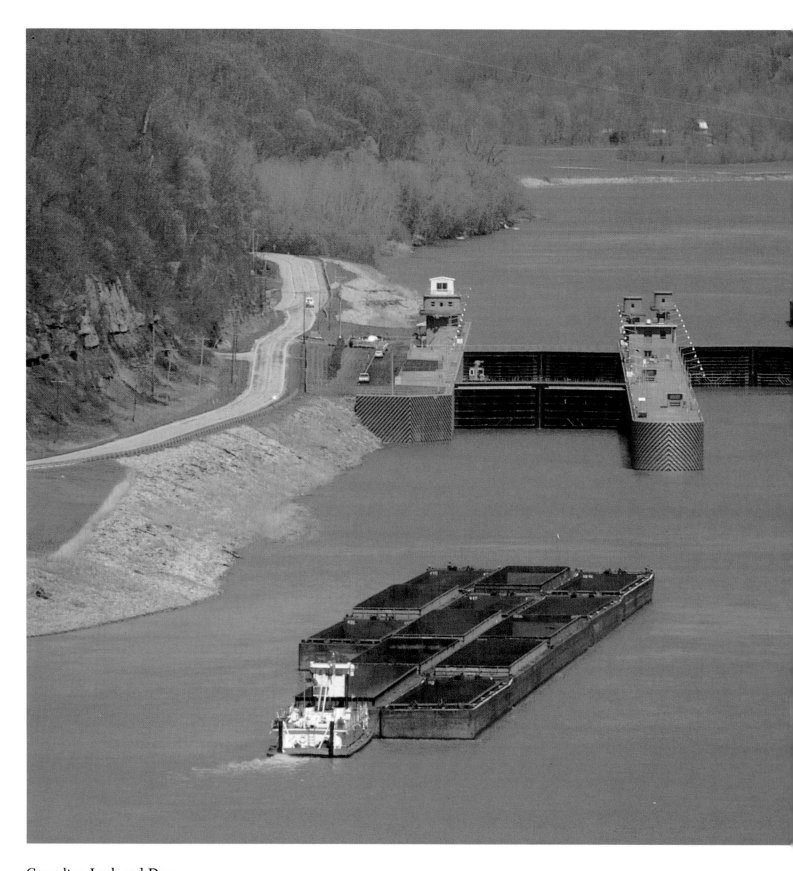

Cannelton Lock and Dam.

which is a very impressive building on its own, looking more like a courthouse than the average city hall.

Tell City never reached the 50,000 population mark, but it has always been a clean, solid, attractive river town. The Swiss, ahead of their time when it came to industrial promotion, put together a fund from which they lent money to any dependable person who wanted to start a business, looking particularly for mechanics, small farmers, brewers, and manufacturers. The town flourished until after the Civil War, when the national depression wiped out a bunch of businesses. But the town bounced back, Cannelton and Troy grew slowly, and today the trio seem to be doing very nicely. The fearful flood of 1937 battered Tell City but prompted the building of a floodwall, which has protected the town since. The town was again hit a hard lick a few years ago when Maxon Marine Industries, which built barges, closed. But it still has Tell City Chair Company and General Electric, which between them employ about a thousand people, and there are high hopes that Maxon will reopen.

If you get ashore, you might like to go down to Troy and see the Christ of the Ohio statue located in a small, scenic park overlooking the river. Fine view.

Owensboro, Kentucky, lies just downstream from Puppy Creek Bar and across the river from Yellow Bank Island, which boasts, as your intrepid travelers can attest, mosquitoes so large they carry off eagles. Owensboro was originally known as Yellow Banks because of the striking layer of yellow clay in the soil along the riverbank. Now a bustling city of 56,000, it is a good business town, intent on industry and growth, with a steel mill, power plants and distilleries, and a processing plant for the region's big soybean crop.

And, as you can see as you approach, it is an important river port and a big fleeting center. Barges line the banks, and tugs rumble and snort around them, cutting them out of tows moving on the river, tying them together along the shore, moving them out to become part of other tows being made up here. Barges line the river above and below the town proper, serving the mills and power plants. Pleasure boats crowd the downtown marina, and the biggest hotel sticks out over the river.

Owensboro has achieved some renown for its Museum of Fine Art, of unusual quality for a town of this size, and for a natural history museum, three colleges, and an exceptional library. It has also achieved a measure of fame as the Home of Barbecue. At least so it claims. How or why it developed this distinction is not clear. Not being an afficionado of barbecue, I can only assume that there's a hot-eyed rivalry among cities to become the barbecue capital. But according to Owensborans their barbecue is special, and they make a big thing of their version—minced mutton doused with sauces of various degrees of individuality and served on bread, biscuits, or cornbread. Restaurants such as the Moonlight Inn and Old Hickory Pit Bar-B-Q make generous claims for the excellence of their products and are strongly supported by the locals. When, where, and why barbecue was first spelled Bar-B-Q is lost in the fog of gastronomic history. But there is a whole festival here devoted to barbecue, the International Bar-B-Q Festival, with teams of cooks producing thousands of pounds of mutton, chicken, or pork. Also barrels of burgoo, another Kentucky concoction, composed principally of vegetable stew and whatever beef, pork, chicken, or mutton happens to be left over after the company goes home. This bacchanalia takes place on a chosen weekend in May, and as many as 30,000 people have been known to attend.

Thousands more attend the Owensboro Regatta, another speedboat race staged on the Ohio. The Executive Inn, which sticks out over the river, draws still other throngs to hear imported night club acts and country singers, who are not as noisy as the speedboats.

Always something going on in Owensboro.

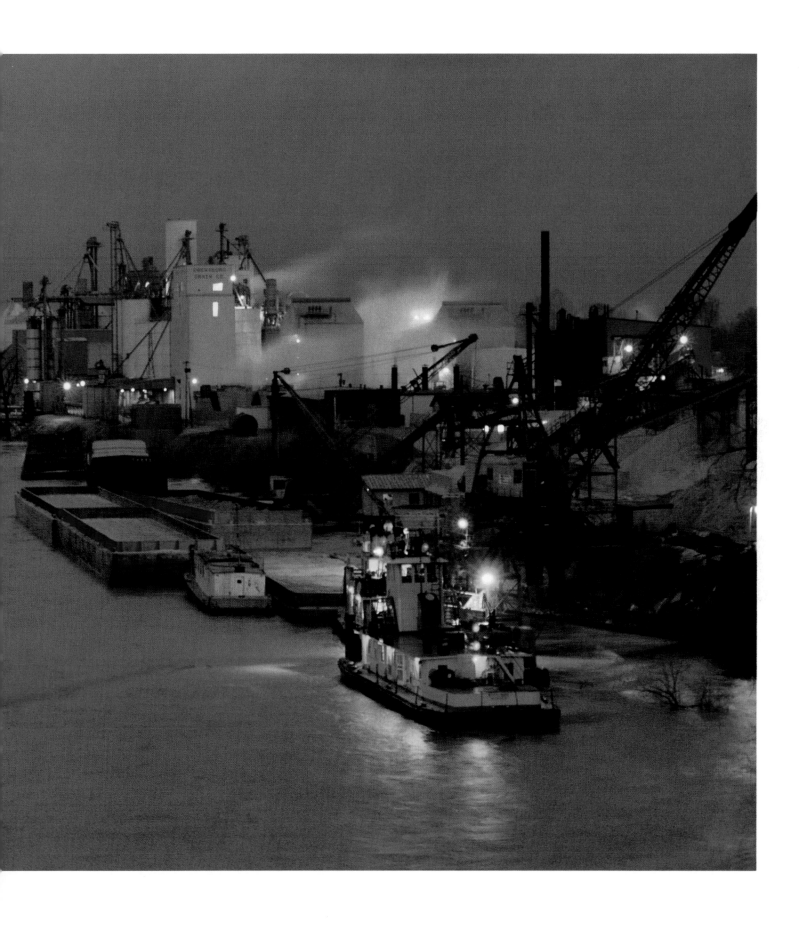

The annual flatboat race in Evansville — reminiscent of the good times had on Scuffletown Island.

A few miles below Owensboro and just above Newburgh Lock and Dam lies scenic Scuffletown Island, which is mentioned here as an excuse to tell you how it got that name.

In the old keelboat days, before the Corps of Engineers started serious work, the river during dry summers often shriveled up so that a thirsty horse could drink it dry. Boats would run aground, especially on sandbars, and have to sit there until the rains came. Here at Newburgh, Indiana, there was a large bar in the river, and sometimes a fleet of boats would be stranded there. When this happened the crews, having nothing to do, would go ashore, have a few, and start fighting. Actually, they didn't go ashore in Newburgh so much, since the Newburghers didn't approve of their manners. They took over an island in midstream, which was eventually named for their jolly outings or "scuffles."

This explains at least part of Newburgh, which sits on a bluff just downstream from the dam. Newburgh is pretty small and, being situated only a few miles from Evansville, is often described as a suburb, though the people resent the designation. Whatever it is, it is an attractive little place and in the summer something of a tourist center, with a row of nice gift and antique shops, some pretty homes, a scenic waterfront, and the Scuffletown Saloon and Restaurant, named for the famous days of mayhem among the crewmen. The Scuffletown is not the rustic establishment the name would imply but a first-class eating place with a good and extensive menu and a restful atmosphere.

People get a misleading impression of Evansville, Indiana, if they see it (as many do) only from the U.S. 41 Bypass that cuts around the eastern edge of town, a garish strip of factories, filling stations, motels, and fast-food places. The impression is not fair—to Evansville or to the visitor. Approached from the river it is better seen for what it is, a charming town of wide streets, beautiful homes, and impressive public buildings, libraries, schools, and parks, and an interesting waterfront.

Evansville was founded in 1812 by Colonel Hugh McGary, a colorful and eccentric character who became a sometime hero and part-time nut in Revolutionary Kentucky. Frequently in trouble (for everything from leading a stupid and costly charge at the Battle of Blue Licks to racing horses down the main streets of Kentucky towns), he crossed the Ohio, found a scenic bluff above a long bend in the river, and bought 200 acres from the government, hoping to develop a great city and make a few bucks. His fortunes were no better than they had been in Kentucky. He went bankrupt. But the town he founded, and named for his friend and wartime companion Colonel Bob Evans (not the one with the restaurants), grew—and soundly—aided by a flourishing river traffic.

The author camping (and fighting off mosquitoes) on Yellow Bank Island, with the lights of Owensboro, Kentucky, in the distance.

161

The Dress Plaza Esplanade in Evansville, Indiana.

As river trade developed, Evansville became the Ohio River terminus of the Erie-Wabash Canal, one of the waterways connecting the Great Lakes with mid-America. The canal didn't amount to much. The town did. The city fathers decided early on that they would have to have an attractive city to compete with larger cities for railroads and business, and they planned accordingly, building wide streets and impressive buildings. The most notable of these is the Vandenburgh County Courthouse, easily the biggest and grandest of any in the Ohio Valley, a remarkable piece of baroque architecture that rivals many state capitols, a towering structure of granite and marble festooned with ornate sculpture and a massive, glittering dome. The interior is a symmetry of graceful stairways, lofty ceilings, and floors of colorful marble.

Unfortunately time caught up with the grand old building, and in 1969 the county moved its offices to a more modern and efficient—and immeasurably duller—structure, leasing the old beauty to the county commissioners for whatever use could be found for it. Luckily there are some tenants—a theater company, a few shops and boutiques, the offices of some local attorneys. They should be successful. It's fun just to wander around the place.

The same can be said for Evansville itself. It has a residential section of restored townhouses on brick-paved streets near the river, a riverside park that is a visual treat, a library building that is a beauty, and a tree-shaded residential area out toward Newburgh that is a joy to drive through. The view of the river from the city park is fine.

It's a short, easy run from Evansville down to Henderson, Kentucky, with a wide channel and attractive countryside on both banks. A good wharf in Henderson makes it easy to get ashore. There is also a sign on the wharf warning boat owners not to use the wench. An inspection of the premises fails to turn up a wench, and we can only assume that Henderson, a literate community with its own college, has slipped into typographical error.

The men who founded Henderson in 1797 had big plans for a big city and laid out the place to suit, with wide streets that are still a point of pride. The town was named in 1801 for Colonel Richard Henderson, who came up from North Carolina in 1775 and bought up most of eastern and southern Kentucky from the Cherokees for 10,000 pounds. He hired Daniel Boone as interpreter, and the Cherokee chief's son, Dragging Canoe, purportedly told Boone, "You have bought a fair land, but a cloud hangs over it." A prophetic statement. Henderson lost his shirt.

Representing the Transylvania Land Company, Henderson began selling off lots in what must have been the

Owensboro, Kentucky

biggest subdivision in history. Unfortunately for him, Virginia also claimed the territory and made Kentucky a county, invalidating Henderson's purchase and leaving many customers with faulty titles. As compensation, Henderson was granted 200,000 acres around what is now Henderson County, and in 1810 the men who founded the main town in the region gave it Henderson's name. That didn't help Henderson much, and he died broke.

Henderson (the town) had 183 people when it was incorporated, among then John James Audubon, a mill owner and general store keeper. Audubon was not a business success, mainly because he wandered around the woods and riverbanks watching birds instead of minding the store. But while he was failing as a merchant, he was becoming America's most famous naturalist and painter of birdlife. His paintings are still treasured, and one of the nation's most prestigious wildlife organizations, the Audubon Society, bears his name. So does a lovely 692-acre park on the outskirts of Henderson that boasts, strangely enough, besides 126 Audubon prints, a fine collection of sea shells. It contains a stand of virgin beech timber and two small lakes preferred by migrating birds.

Though Audubon made no fortune here, his years in Henderson were happy ones. "Your blessed mother and I were as happy as possible," he wrote his son. "The people here loved us and we them." Hendersonians still pride themselves on their hospitality and on what they consider a more genteel and cultured way of life than their upriver neighbor Owensboro. The town has grown from 183 to about 14,000 and from time to time has flourished on trade in tobacco, furniture, wagons, steel, and aluminum.

Another famous Hendersonian was W.C. Handy, a riverboat roustabout and general wanderer who wandered into Henderson, married a local girl and, in his own words, changed from being a hobo to being a professional musician. He had some modest talent. He was instrumental in developing the blues as a jazz form, and he wrote more than a hundred blues songs and spirituals, the most famous among them being the immortal "St. Louis Blues."

Henderson throws a couple of festivals a year, a Big Rivers Arts and Crafts Festival and the Henderson Flatboat Days, which features a race of home-made flatboats, a frog-jumping contest and, for those so inclined, a bed race.

Sitting on a high bluff above the river, Mt. Vernon, Indiana, has a good, solid look about it and turns out to be a good, solid midwestern county seat town, with a good, solid courthouse and four city parks and playgrounds that attract their quota of small fry. A few miles down Road 69S, Hovey Lake draws more than its quota of birdlife and fishermen.

Downtown Henderson, Kentucky.

Hovey Lake is an unusual piece of water. Geologists say it was part of the Ohio River until about 500 years ago, when the river changed its course, cutting across the base of a big bend in the river and leaving a sort of horseshoe that became Hovey Lake. It's a good fishing lake and has a large stand of cypress, the only one in Indiana. Ducks and geese by the thousands flock here during the winter months, joining the ospreys, herons, owls, hawks, egrets, cormorants, and even bald eagles that make the place a bird-watchers' favorite.

Below Mt. Vernon, the Ohio twists around like a snake until you get below Uniontown Lock and Dam, where the bulk of Wabash Island hogs the center of the river, with the channel going along the Illinois side. To the right of the island is the mouth of the Wabash, around which a lot of history, song, and folklore has revolved. It's a scenic river farther up, but you can't tell much about it from here.

Even if you didn't know you were coming up on Cave-in-Rock, you'd spot it at once—a high, flat-faced cliff jutting up on the Illinois shore, with a huge, dark hole more than twenty feet high near the bottom. It is part of a state park that has a fine array of birdlife and an overlook on top of the cliff that affords a fine downriver view. A scenic spot, though if you are aware of its history you tend to get a feeling almost of foreboding as you walk its trails.

In the years around 1800 the region between Yellow Bank (now Owensboro, Kentucky) and the Mississippi was favored by a grisly collection of robbers, turncoats, cut-throats, and thieves who preyed on river traffic and then holed up in convenient lookout spots along the shore. Cave-in-Rock was the most notorious. Outlaws congregating here became such a threat to shipping that the merchants of Pittsburgh finally gathered a small army and sailed down the Ohio to clean them out.

Samuel Mason set up shop here for a while. Mason began his career by murdering his son-in-law, decided he had a talent for the trade, and wound up waylaying travelers on the Natchez Trace before two men delivered his head to a judge in Natchez for the reward. One of the men, interestingly enough, was Wiley Harpe, the younger of the two Harpe brothers, the bloodiest pair of demented butchers to roam the frontier rivers.

Micajah "Big" and Wiley "Little" Harpe, in company with several women whom they had married or collected along the way, came up from North Carolina through Tennessee to central Kentucky, killing or robbing along the way such diverse victims as a young Tennessee minister, a guest at a tavern near Knoxville, Tennessee, a peddler and two travelers in southern Kentucky, and a young Virginian who had asked to join them for safety (poor judgment, that).

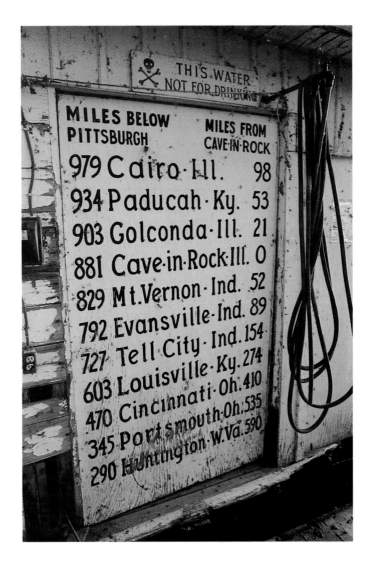

Hunters head out at dawn.

The Harpes were detained for a while by the law in the Danville, Kentucky, jail, where Susanna, one of their ladies, gave birth to a baby girl. But the brothers wearied of inactivity and left through a hole they had arranged in the jail wall. They traveled on to Cave-in-Rock, where they were welcomed by lesser practitioners who admired their work. But the Harpes proved too imaginative even for the merry band in the cave. One evening, as the outlaws sat around a huge fire at the mouth of the cave, the fun-loving Harpes took a captive, tied him to the back of a horse, and forced the horse to leap from the cliff into the flames below, carrying his hapless rider with him.

The other murderers, considering this poor form, said the Harpes were free to leave, and the little band headed for Tennessee. Stopping for the night at the home of a friend, Moses Stegall, they found Moses away. During the night they killed Stegall's wife and baby and a guest who had just stopped by, and burned the cabin. Stegall returned, gathered a posse, and took out after the brothers, overtaking them on the second day. Wiley escaped through the woods but Micajah was paralyzed by a bullet and, while dying, casually recounted a hideous string of murders, declaring that he regretted only the time he took Susanna's baby and dashed its brains out against a rock in Mammoth Cave. Stegall took his knife and began cutting off Harpe's head, though the head's owner was still quite alive and chided him for his clumsy knife work.

When the job was eventually done, Harpe's head was put in a sack and impaled on a stake on the Nashville-Henderson road, at a site since known as Harpe's Head. Wiley Harpe, after a brief career in Tennessee, tried to claim the reward for Mason's head and was discovered and hanged.

The river and its countryside are secure now, and we continue downriver with no concern greater than a fear that we may run out of gas. But it is hard to shake the eerie feeling of the cave or to avoid a certain awe when we remember those early settlers who risked so much, endured so much for the hope of a better tomorrow. It is hard to imagine now, in this peaceful land, the dangers they faced, when every stranger was a potential assassin, every stretch of the river a death-trap, each season, each change of weather the carrier of fear.

Why did they come, risking everything, challenging the savage wilderness in the stubborn hope, the blind insistence that somewhere around the bend lay El Dorado? Or was it only the irresistible impulse, with the vast, empty country waiting out there ahead, to go and see, to dare, hoping beyond hope to find something long sought beyond the next hill, the next bend of the river?

We've seen a lot of commercial fishermen here on the lower river over the past couple of days. There are more of them than you might think; about 500 commercial fishing licenses are sold each year for the Ohio, and the fishermen take more than a million pounds of fish— no one knows exactly how much, since there is no official reporting. Most of them are small-timers, firemen or farmers who put out their nets or lines during off-time, and they aren't about to tell anyone how much they catch or sell; things like that get back to the IRS. But in the big lakes, such as Kentucky or Barkley, 25 to 30 commercial fishermen, with $500 licenses and thousands of dollars in equipment, take from 750,000 to 800,000 pounds of buffalo, catfish, and carp a year. Curiously, a lot of people in the South and border areas don't like carp, catfish, or buffalo, but there is a big market for them in the East and upper Midwest. Fishing is good on the Ohio. The river, except around the bigger cities, is getting cleaner, and fish taken from it are certainly edible. Some fisheries officials think the river is underfished.

The town on our right now is Golconda, Illinois, a strange name, since the original Golconda was a glistening city in western India, the capital of a rich Moslem kingdom. This Golconda doesn't contain any evident material wealth—or Moslems, for that matter—but it does enjoy a fine view of the Ohio. The river is broad here, with several pretty streams entering on both sides and a chain of tree-covered islands—Pryor's, the Sisters, Stewart's—along the reach above Smithland Lock and Dam, which itself is probably the most impressive structure on the river. It's three-quarters of a mile across, cost almost $200 million to build, and contains enough cement to build 150 miles of interstate highway. Its twin locks, on the Illinois shore, are each 1,200 feet long, giving the dam the world's largest pair of navigational locks. The usual Ohio locks contain one 1,200-foot chamber, one 600-footer.

Below the dam the river's channel swings to the right, while on the left shore, just opposite the head of big Cumberland Island, the Cumberland River enters the Ohio after flowing down from its headwaters in historic Harlan County, Kentucky, through Tennessee and western Kentucky, where it is impounded to form Lake Barkley. At its confluence with the Ohio sits Smithland, Kentucky, another of the many towns whose origin, growth, and decline were tied to the river and whose fortunes shifted with the flow and change of the river's channel. The story of Smithland is also linked to one of the most grisly episodes in early American history.

"Smithland was the biggest town on the lower Ohio," says Mrs. Grace McCandless, who, according to the women in the clerk's office at the courthouse, knows more about the history of this region than anyone. Mrs. McCandless has a file cabinet full of data and can tell

you about the three Smithlands, and about the Sunday morning in 1936 when one side of the main street, sidewalk and all, just slid into the river, and about the old Clark Hotel, whose register showed visitors coming to Smithland from New York, Chicago, New Orleans, even London.

"There were three Smithlands, you know. Zachariah Cox founded the first one about three miles downstream in 1796, but his plans went bad. Middle Smithland was Upper Smithland at the time and was built on land donated by Thomas Croghan, George Rogers Clark's relative, from land he had been given for his services in the Revolutionary War, but floods finally just wiped it out. Nothing left there now but farmland. The present town is the upstream one.

"Most people trace the decline of Smithland to the 1850s, when the railroad wanted to come through and people wouldn't give it the right-of-way. Legend has it that the people voted down a bond issue for the land, the right-of-way. And legend is all we have to go on; so many records have been destroyed by floods and fires. Almost none left. At any rate, the railroad went down to Paducah, which was a newer, smaller town, and built through there.

"The people here were aware of rail travel, of course, as we're aware today of travel to the moon, but they just didn't think it would ever be practical, certainly never replace the steamboat. And Smithland was the lower Ohio port. All freight, all passengers, all storage, all commerce was here. Lot of trans-shipment, warehouses, boat builders, boat repairs—everything was here. And there was all the commerce coming up the Cumberland from Nashville, going down to New Orleans or up the river. Naturally they thought people would never do without the steamboat. As a result, we had no railroad when railroads became so important, and trade, development went down to Paducah, which did have railroads. Packet travel survived but only for short trips—up the Cumberland, over to Golconda—until the 1930s.

"The Lewis episode? Oh, yes. Everyone is familiar with that. You can see the site of the Lewis plantation, Rocky Hill, just up the river a little way, this side of Birdsville. The hill, where the big house was located, is still called Lewis Hill. It's right hard to get up on the bluff where it stood, but you can get there if you don't mind rattlesnakes. And Lucy—Lucy Jefferson's—grave, with the statue, is there at the forks of the road. You can't miss it. Although Boynton says that Lucy really isn't buried there but farther up the road."

Boynton is Boynton Merrill, Henderson author of the prize-winning *Jefferson's Nephews*, the story of the family of Lucy Jefferson, Thomas Jefferson's sister, and Charles Lewis, a kinsman of Meriwether Lewis of the Lewis and Clark expedition. The family moved to Livingston County just upstream from Smithland shortly

after the turn of the nineteenth century, bought several thousand acres, and tried to duplicate the life they had known in Virginia. They brought with them twenty-four slaves, which were not common in western Kentucky, and built an imposing plantation house. Isham and Lilburne, Lucy's sons, were said to be aloof and eccentric, and made few friends when they took over the plantation.

On the evening of December 14, 1811, Lilburne sent George, a seventeen-year-old slave, to the spring at the foot of the hill for a pitcher of water. George, an unattractive and sometimes insolent boy given to wandering, dropped and broke the pitcher, and this sent Lilburne, who had been having trouble with his wife and had been drinking, into a fury. He seized George, tied him spread-eagle to the floor of the kitchen at the rear of the big house, built a roaring fire in the open fireplace, and called in the other slaves to witness George's punishment. With his brother in attendance, ignoring George's pleas and the screams of the other slaves, Lilburne took an axe and with one blow cut George's head almost off. He then handed the axe to a slave and forced him to complete the dismemberment, tossing the flesh into the fire and warning the other slaves that they would get the same treatment if they ever told of what they had seen.

Before dawn, as though a sign of God's wrath, the first shock of the historic New Madrid earthquake hit the region, causing the Mississippi to flow upstream for hours, filling a subsidence that would become known as Reelfoot Lake, and incidentally knocking down the chimney into the fireplace where George's remains had not yet been totally consumed. Lilburne quickly rebuilt the chimney, concealing behind the stones the unburned pieces of George's body. But again nature intervened. On January 23 and again on February 7, vicious after tremors of the earthquake again jolted the region. Again the chimney was shaken down, and this time George's head rolled out onto the lawn, where it was carried off by a dog, possibly Lilburne's dog Nero. A horrified neighbor, seeing the dog gnawing on the head, carried the news to the local authorities, and in short order the Lewis brothers were arrested and charged with murder.

Out on bail, the brothers climbed to the family cemetery, having agreed to commit suicide by shooting each other on the count of three. Should one of them fail, Isham showed Lilburne how to aim the rifle at his own chest and push the trigger with a forked stick, but Lilburne, practicing, fired the rifle and killed himself while his agonized brother looked on. Isham, though, apparently lost his nerve, did not follow through on the agreed suicide, fled the county, and was not seen in the state again. He was later rumored to have died in Mississippi.

"I can show you the place," said Gabe McCandless, who knows a great deal about the region himself, having been sheriff and clerk for most of thirty-two years. Minutes later, he was pointing out the small park at the junction of State Roads 60 and 137 and the monument to Lucy Jefferson Lewis. "There," he said, pointing to the foot of the cliff across the road, "that's the spring where George broke the pitcher. And here's the hill where the Lewis mansion stood. The property ran from here all the way up to Birdsville. Fine land."

The land along the river is rich-looking, the view from the hill splendid.

"That's why they built up there," says McCandless.

But nothing is left of Birdsville now, and nothing on the monument at the forks of the road mentions the horrible incident. Just as well.

"There's just bound to have been some insanity in that family somewhere," says Grace McCandless.

The Irvin Cobb Hotel.

"The lower Ohio is lined with towns that flourished for a while and then declined, towns like Birdsville, Carrsville, Smithland," says veteran Kentucky writer, journalist, and river buff Bill Powell. "And then, on the other hand, there's Paducah, Kentucky. It hasn't exactly boomed but it has survived and grown. And it's not just an Ohio River town, you know. Go up the Tennessee, which comes into the Ohio here, and you'll see a lot of activity—tugs, tows, barges, marinas, service and repair facilities.

"Of course, the flood of '37 just tore the guts out of Paducah, changed it in a lot of ways. Louisville, being bigger, got more publicity, but for its size Paducah was worse hit. Three fourths of the town was under water. Ninety percent of the buildings were hit. I guess more than three-quarters of the people had to be taken to higher ground. But the flood forced them to replace a lot of old buildings with new ones, replace old gravel streets with black-top. It forced us to build the floodwall, which can take a lot more water than in '37, and we can't imagine anything worse than '37. Of course, in '37 we couldn't imagine anything worse than 1913.

"The water got into the second floor of the Irvin Cobb [the hotel named for Paducah's most famous son, the author and humorist], can you believe it? The Cobb survived. It's still there, but not as a hotel. It's apartments now, though the Lions Club still meets in the ballroom. But you know, when the Cobb went, something happened to the town; the downtown changed, and when the downtown changes, a town changes. The old town dies a little. The Cobb was once the hub of everything. It was the place where the men who ran the town met every morning, drank coffee, talked, where a lot of things got decided, leaders were chosen. It was the place where you had your big social doings, banquets.

"It was part of a system that worked, and there was a grace, a certain charm about it that was Paducah. Now I don't think there is a hub. The big hotel now is J.R.'s Executive Inn, and it's fine but it's a lot different from the old Cobb. It's not the same. And, like a lot of places, Paducah is a lot of malls today. Downtown hasn't died; the radio and TV stations, the newspaper, banks, law offices, they're here. But it isn't the center of things. And there aren't any outstanding newspapermen like there were fifty years ago, men that people opened the paper to read, wanted to horsewhip. There aren't any big Democratic leaders.

"Paducah is still a river town. The floodwall sort of cut the town off, but it has that park along the waterfront, and there's a lot of life along the river still. Paducah was born on the river and grew up because of the two rivers and the railroads. It swallowed up all the little towns around. History says that William Clark founded the town in 1827. The land, all the land between the Tennessee and Mississippi on the Kentucky shore, was

Fleeting station in Paducah.

Boat repair work at the Paducah River Service Repair Facility, a subsidiary of the Walker Towing Corporation. *Above:* A workman welds a kort nozzle on a towboat. *Opposite:* Welding the flanking rudder of a tow in dry dock.

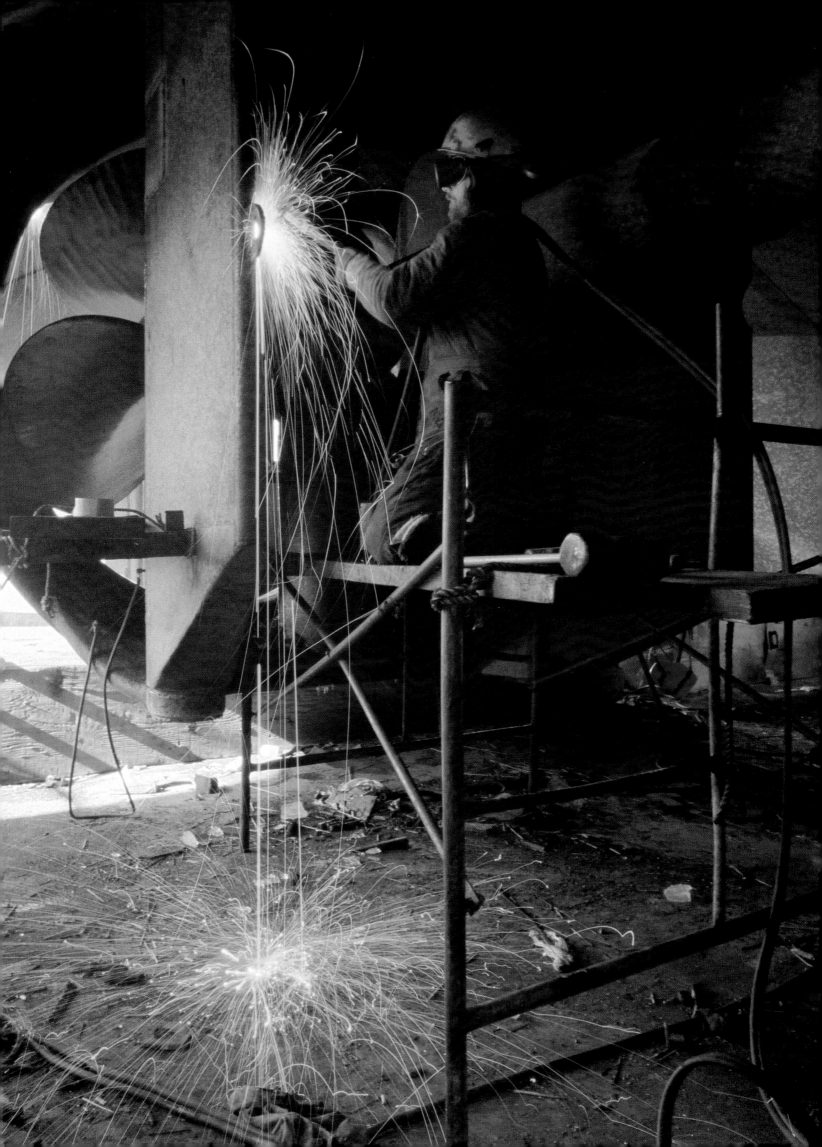

granted to George Rogers Clark for his wartime services, although he lost most of it.

"Legend says the town was named for the Chickasaw Chief Paduke, and there's a big statue of him here, but I truly believe that Fred Newman, a local historian, created Paduke. I never found any mention of him in history, or even in folklore. Newman had a lot to do with the Irvin S. Cobb mystique, too. He loved Cobb, who was a likable man. Cobb built the lore about Paducah, the friendly, folksy, southern town with its easy ways and charming people—which it was. What was it they used to say? 'Long on charm, short on cash.' Cobb always said he'd rather be an orphan boy on the streets of Paducah than rich twins anywhere else. Lord knows it's a pleasant place to live.

"The uranium enrichment plant is important to the economy here. So are Barkley Dam, Kentucky Lake, the big state parks. They made the town prosper. So did Barkley [the late Vice President Alben Barkley] and the things he brought in.

"Life on the river has changed. You just don't see people living on shantyboats any more. They've gone. You'd think that in a day when housing is so expensive, so many people are without homes, they would take to the river, but they don't. It doesn't seem to draw them as it did."

From Paducah to Lock and Dam 53, the last on the Ohio before its confluence with the Mississippi, the river is wide and smooth and good to look at. But the channel meanders all over the place, and it's a good idea to have a navigation chart at hand, for it's just above Dam 53 that the Grand Chain, a series of rock bars lying in shallow water, stretches along the river for five miles. The Grand Chain has been a hazard to river navigation since the earliest days. Before the outlaw gangs on the lower Ohio were brought under control, boatwreckers—robbers posing as river pilots—would offer to take unwary settlers or traders past the rocks; once on board they either killed the crew and took the boat or ran the boat onto a convenient rock in the Chain, where they could strip it at their leisure. It was the redoubtable Captain Henry Shreve who in 1830 blasted a channel through the huge boulders of the Chain and built a wing dam from the Illinois shore to increase water flow. Completion of the Olmstead Lock and Dam, planned downstream from Dam 53, will put plenty of water over the Chain.

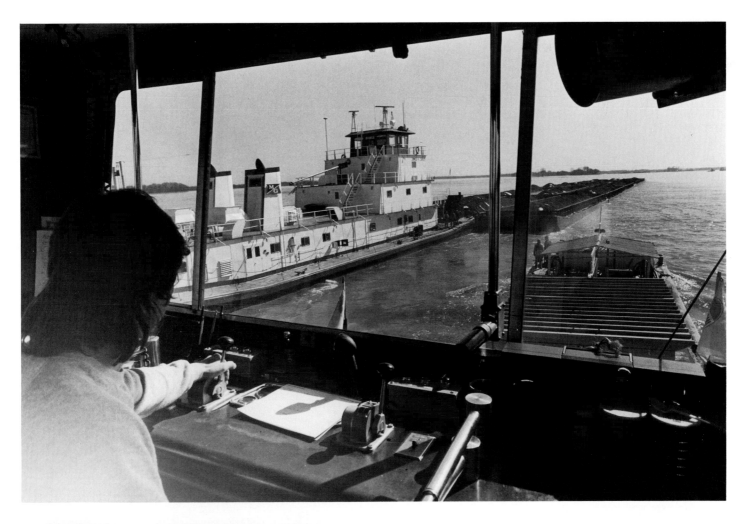

Above: Midstream refueling of a tow, courtesy of the Paducah River Fuel Service. *Left:* Hooking up the fuel line to the tow.

Five miles upstream from Cairo you pass America, Illinois, though you won't be able to tell it unless you look on the chart and see that the channel narrows to pass America Bar on the left, while America Point Creek enters on the right. You probably won't be able to spot America from the river. There's not much left to see. You'd do best to go into Cairo, take Highway 37 up the river past Mound City, Illinois, and turn right when you see a sign saying America Road.

There's a good gravel road that runs through farmland down toward the river, with a few homes here and there, some of them very substantial and attractive. In one place near the road there's a short strip of old railroad track that used to run down to Cairo. That's about all that's left of America.

But a vigorous little town and bright hopes flourished here at one time. When the town fathers established the town in 1821 they named it in hopes it would become a great river port and might one day, because of its central location, become capital of the United States. It was not to be. A big sandbar offshore prevented steamboats from landing at low water, and efforts to dredge it ran into the river's stubborn habit of making its own channel and piling silt where it chooses. Finally, with a sigh and a shake of the head, they abandoned work on the wharf where the commerce of a nation was to land. The general store closed, then the school, then the church. The train made its last run down to Cairo, the tracks were taken up. Family by family, America dwindled and died. But for the historical marker you might never know that a town grew here once.

There are so many places along the river like America—once bustling towns, now memories. And traveling along the river, through places men have built with hope and sweat, places that prospered, places that failed, one can almost read in their traces the old Biblical warning that man and his works are of but little duration. And yet in each deserted village, in each still factory, silent in its rust, are reminders of people who faced the collapse of their dreams, packed and moved on, lingering for a grieving last look before turning toward tomorrow. Always toward tomorrow.

The Ohio is a handsome river as it passes under the bridge at Cairo, Illinois, and heads for its confluence with the Mississippi. Not as wide as it is in places upstream, but deep and with a strong current, its waters a rich green.

There is a fleeting station on the right bank and a small park on the bluff above the point where the two rivers meet, but Cairo itself is pretty well hidden behind its floodwall. Cairo (pronounced Kayro, not Kyro) looks like a town that is trying to do better and having a hard time of it.

People here and across the river in Kentucky wonder why Cairo never amounted to more, situated as it is at the juncture of the two great rivers, the natural stopping point for commerce coming up from the Gulf or coming down from the Upper Midwest, heading up the Ohio, a natural trans-shipment point. It should be the center for fleeting yards, repair and service facilities, warehouses, rail yards, grain elevators, storage bins.

Somehow, it didn't work out. There used to be a lot of rail traffic through Cairo, and the old Customs House is a reminder of days when it was a port of promise. In the years after World War II the town seemed to be ready to surge, but then business fell off, unemployment grew, and in the 1960s the town was torn by bloody race riots that left a sour residue. Today, despite the efforts of its people, Cairo looks tired. The Customs House looks rundown, trash is piled up on vacant lots, and a dozen downtown store buildings are deserted. Nothing looks emptier than an empty window-fronted store.

A lot of people are optimistic, though. Nancy Wright, editor and publisher of the *Cairo Citizen*, delivers her message of hope with the conviction of a salvation preacher.

"There's a lot going on that you don't see just driving around," she says. "Basically, the town has a lot of potential. The citizens, the people here are trying to develop and promote tourism. There's so much history here, reminders of the Civil War, the great days of steamboating. We have a new bed-and-breakfast, Magnolia Manor, an old southern home—the Cairo Historical Society restored it. We've just gotten a grant to restore the Customs House, put Civil War relics in it. It's going to be very attractive.

"I tell you the reason I think we're going to succeed is the positive attitude of the people, lots of great people willing to try. Yes, we had some racial problems, but that's all forgotten—by everybody. Blacks and whites work well together here. Blacks take part in civic affairs just as do whites. We're having a style show tonight, a benefit, and we have black as well as white models. And we're trying to promote river trade. I know that's not something a few people can do overnight, but the potential is there, and the point is we're trying."

Above: Teresa Sullivan's Headin' West Antiques, Cairo.
Right: Four curious onlookers.

Bill White, the city building inspector, is optimistic, too, but guardedly so. "How many people do we have? Well, the sign out at the edge of town says 6,300, but I'd guess 56—5,700. Business? Well, it's been falling off a little in the last few years. Don't know that I can tell you why. I've always said this town ought to be bigger than St. Louis or Memphis, right here at the confluence. Ought to be a big river town.

"We've done better. At one time we had four trunk-line railroads—Big Four, New York Central, Illinois Central, Missouri Pacific. Amtrak goes through now but it doesn't stop. That would be a help. We have to go up to Carbondale to catch it.

"I think it was the floods, or fear of floods, that kept us from growing. In the early days we had lots of grain elevators, shipped a lot of lumber. We've lost that business. Our garment factory employed about a hundred. Some businesses downtown have closed. I think a lot of that is due to a lot of our people going over to Cape Girardeau [Missouri] and Paducah to the malls. They seem to like that, the malls. When I was a boy, the Customs House was the post office and federal court-room. Then they built a new post office and gave the old building to the city. But the city really doesn't have the money to repair and maintain it. But it's a good building. Some people are trying to restore it.

"The floodwall? Oh, it's been there since I was a boy. They raised it five feet after the '37 flood. The flood didn't hit Cairo. The C.C.C. camp boys and volunteers from around here put a cap on the wall and kept the town dry. We thought it was going to go, the waves lapping at the top, but it held.

"We've got a big welfare population, that's one thing. Blacks migrate up from the South, and they hit here with nothing and no jobs. And it's easy to get on welfare in Illinois. I'm not blaming them. We need jobs, that's all. Some of the blacks try awful hard, some like to be on welfare, just like the whites. A lot of it is just changing times, I guess."

Down the street, Teresa Sullivan runs Headin' West Antiques. You wouldn't think there was a big demand for antiques in Cairo, but she says business is good. Teresa is pretty upbeat about things in general.

"Cairo is a good antique town," she says. "People come here from Kentucky, Indiana, Ohio. There's a demand for good dishes, furniture. And this is a good town to do business in. It's a kind town. I've heard people say they're afraid to stop here because of the riots of the Sixties. That's ridiculous. That was twenty-five years ago. There's no tension here now. Blacks come here, they have no money, they can't find jobs, so they get on welfare. But when there are jobs, they grab them and they work. Blacks have been good to me. My father ran a store here for forty years, and I've been here for thirteen. I've got lots of black friends. I live across the river in Wickliffe and drive over every day. And here I am, a young woman running this place by myself. I often close up after dark, go walking out by myself. If I was afraid I wouldn't do that.

"I think things are going to pick up. When people get to know Cairo and the kind of people we have here, they'll see we don't deserve the bad image."

Down on the river, below the floodwall, tugboats of various sizes shove barges around, making up tows to go upriver. A boy and a girl sit on a picnic table in the park down at the point, swinging their legs, looking out over the point where the Ohio moves grandly to its meeting with the Mississippi.

And so the Beautiful River has come to the end of its thousand-mile journey. The waters that sprang from the plains near Lake Erie and surged through the hills of North Carolina and West Virginia, that carried tows and barges, bass boats and water skiers, dredges and excursion boats, that cooled the steel and turned the turbines of a hundred plants, flowing down through the heartland of America, surge now to join in the final journey to the sea.

Here, at this point of change, of ending and beginning, the river curves slightly to the left as it begins—a different river now—its different course to the sea. It is hard to see from here the Mississippi coming down from the Midwest, joining the larger Ohio there to the right. And it seems somehow inappropriate, this junction of the two rivers. Having followed this lovely, powerful stream along its course, we feel almost offended to see the mighty Ohio—which at the confluence has more than one and a half times the flow of the Mississippi—joined, diluted, dirtied by the sluggish, muddy waters of the smaller river. And in a final injustice, it is obliged to take the name of the lesser stream, as though a mighty highway should surrender its name when joined by a country road.

We have known this river, if only fleetingly, imperfectly. We have been privileged to follow the trail of history, of heroes and villains, those who sought riches and fame on the river, those who found on it a life. We are but a few of the millions who have come this way, but we have come here, and we will remember.

Overleaf: The confluence of the Ohio and Mississippi rivers at Cairo, Illinois.

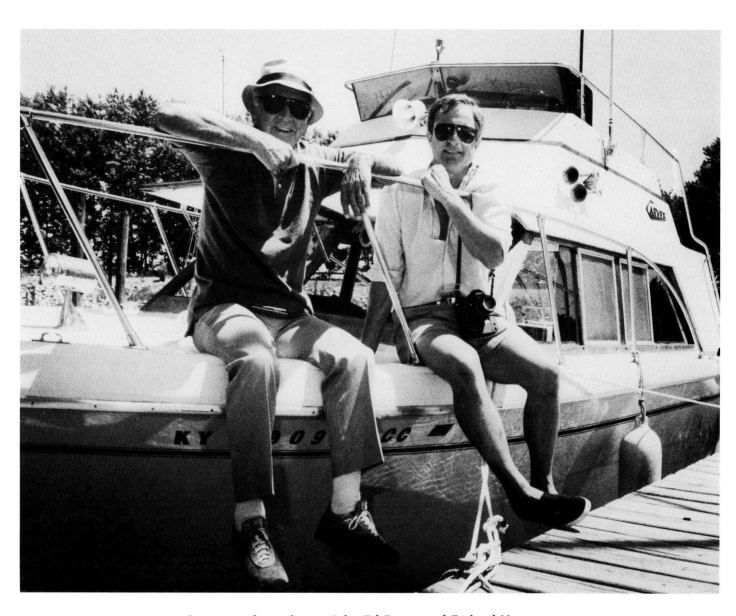

Our intrepid travelers — John Ed Pearce and Richard Nugent.
Photo by Sam Upshaw.

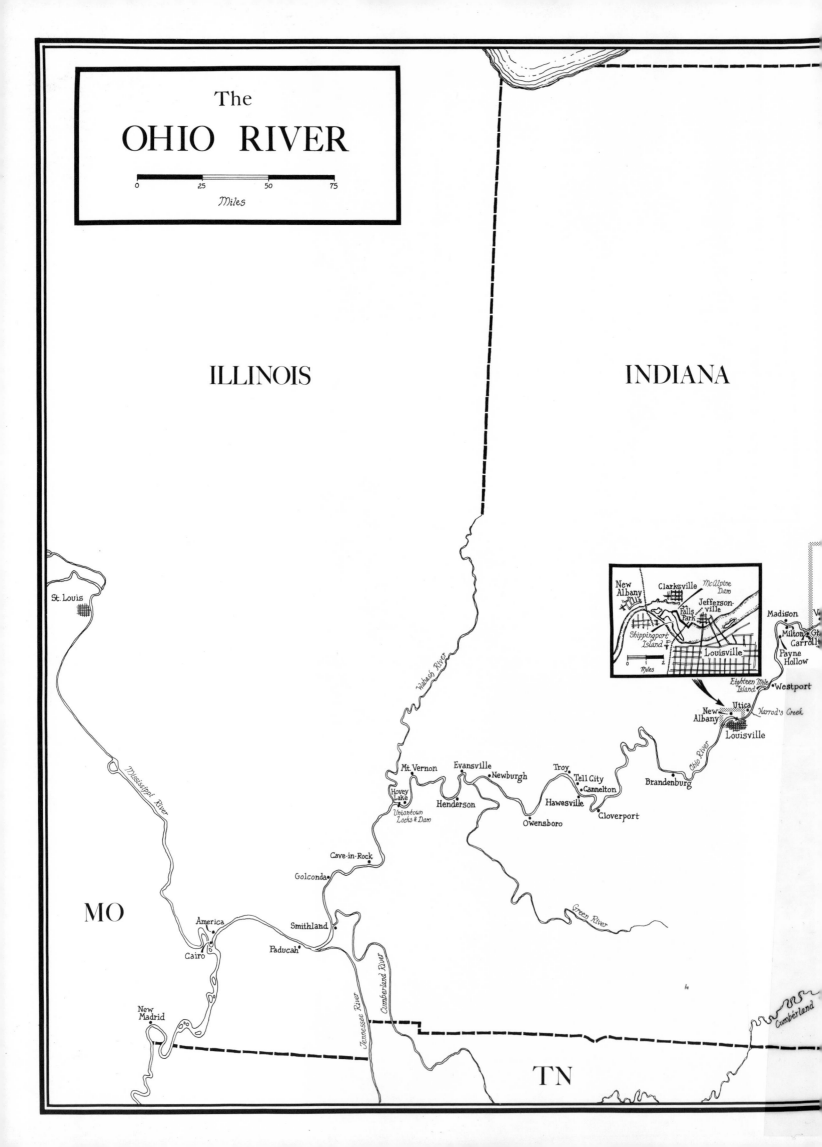

The
OHIO RIVER

0 25 50 75
Miles

ILLINOIS

INDIANA

St. Louis

Wabash River

Mississippi River

New
Albany
Clarksville
McAlpine
Dam
Jefferson-
ville
Falls
Park
Shippingport
Island
Louisville

0 1 2
Miles

Madison
Milton
Carroll
Payne
Hollow

*Eighteen Mile
Island* •Westport

New
Albany
Utica
Harrod's Creek

Louisville

Ohio River

Mt. Vernon
Evansville
Troy
Tell City
Cannelton
Brandenburg
Newburgh
Hovey
Lake
Henderson
Hawesville
Cloverport
Uniontown
Locks & Dam
Owensboro

Cave-in-Rock

Green River

Golconda•

MO

America
Smithland

Cairo
Paducah•

Tennessee River
Cumberland River

New
Madrid

Cumberland

TN